To Catch an Art Thief

To Buzzy for helping me
get through my undergraduate
writing assignments in Michigan.
Best wishes,

TO CATCH

AN ART THIEF

A Memoir on the Heyday of Art Theft

VIVIAN T-N HO

Cover painting by Vivian T-N Ho

ISBN: 1492275891
ISBN 13: 9781492275893
Library of Congress Control Number: 2013915922
CreateSpace Independent Publishing Platform
North Charleston, South Carolina

To my beloved little ones:
Casey, Micah, and Bambi

Acknowledgments

I am grateful for the advice and support of my late professor Gerhard O. W. Mueller, who reviewed the original manuscript several times. I would like to thank Dr. Linda Quilian, Ruby Blair, and Vivienne Palmer for their editorial contributions to the first draft and Create Space editors, Joel and Abigail, for helping me finalize this very time-consuming writing project. I sincerely appreciate the enthusiastic approval of the following thoughtful relatives and kind friends: Bich Ngoc Nguyen, Nguyen Tri Phuong, Tam Viet Ho, Jean McWhorter, Virginia Hill, Bill Clyburn, Cecia Matthews, Anita Rahim, and Cao Thu Cuc, who always made my day with her joyful words of encouragement. Lastly, I owe my artistic and scholarly accomplishments to my late mother, Phan Thi Thanh Thuyen, who instilled in me the belief in human possibilities and always encouraged my creative endeavors, and to my daughter, Vivi, who shared my dreams and supported my ambitions throughout her childhood.

A few cases of art theft described in this book took place before the 1985 robbery of the Marmottan Museum in Paris. The rest occurred during the heyday of art theft—approximately one decade after that incident.

Contents

Prologue — 1

1
The Crime — 3

2
Art Theft in New York City — 17

3
Rogues in the Galleries — 35

4
A New Breed of Criminals — 49

5
Portrait of an Art Thief — 69

6
The Trojan Horse — 87

7
The Missing Artifacts — 111

8
Partners in Crime — 129

9

The Hunt for Art Vultures — 145

Epilogue — 163

Appendix A — Survey of Profit Art Gallery Directors — 169

Appendix B — Coding Form — 211

Notes — 219

Index — 233

About the Author — 239

Prologue

There was a time when news of art theft at European and American museums was a shocking surprise and caught the world's attention. Until the notorious armed robbery of the Marmottan Museum in 1985, art theft was rarely known. A young artist and criminal justice graduate student from California arrived at Rutgers University in New Jersey on a late summer day in 1986. Her self-imposed mission was to explore the state of art theft and the investigation of this crime in New York City for her dissertation after her completion of the requirements for a doctoral candidate. Therefore, she had to gain access to protected art-theft files belonging to the New York City Police Department as well as art dealers' theft information.

The Crime

Old Crime in the New World

Theodore Donson, Esq., was visiting the print room of the Metropolitan Museum of Art as he had done so many times before. A furtive glance around convinced him that he was unobserved. With his pen he unrolled the tape he had placed around his portfolio. Hurriedly, he slipped several of the museum's rare prints inside. Just as he had deftly used his pen to remove the tape, he now used it to reseal the package.

With a rehearsed pace and confident gait, Donson closed the distance to the exit. The guard noted his familiar face and the package he presented with the seal intact. Betrayed by trust, he motioned Donson through without a second thought. All that the guard had missed, however, Detective Marie Cerile had observed. Scrutinizing Donson more closely than an osprey would a distant herring, Cerile had zeroed in on her target as soon as he surfaced as a suspect for a series of print thefts from the New York Public Library, the Museum of Modern Art, and even the Metropolitan.

To Catch an Art Thief

It was his flight record and his clandestine activity that had nailed him. Operating as a private dealer under the guise of his role as an attorney at a prestigious law firm, he had traveled repeatedly from New York to Zurich, Switzerland, an international hot spot for trade in rarities legal and illegal.

As Donson descended the front flight of steps outside, he heard a female voice behind him: "You are under arrest."

Recognizing the woman he had seen in the print room a few minutes earlier, he said, "You can't arrest me. I'm a lawyer."

"The hell I can't," Cerile responded.[1]

The detective's calculated declaration was too sudden, too firm. Jarring him from the dream that arrogance had encouraged, the click of cold metal snapped around his wrists and snagged the downy hair just above them. Even escape plan number two had been carelessly drowned in the tepid waters of the success he had enjoyed so many times before. Only now was he awed by his temerity. He had not the remotest clue that he had been under surveillance all the while. Only yesterday, in fact, he was gloating over what an easy way this was to make his fortune. Today, the seventh of September, 1972, was another matter; he realized that, like so many before him, he had been misled by self-interest and trapped by greed.

The boldfaced headline read "Attorney Under Arrest for Art Theft!" Donson pleaded guilty and was convicted of stealing two Dürer woodcuts and two Canaletto prints, altogether valued at $10,000. Professional disbarment, five years' probation, and psychiatric supervision were now but shards and fragments of the life and freedom he had staked for a wild card.[2]

Strange as it may seem, Donson's case is far from unique. In 1996, William McCallum, a New Hampshire assistant attorney general, was charged with receiving stolen property in his town of Londonderry and with theft in Hanover, home of Dartmouth College. He was fired from his job the day before his apprehension. Because the case involved a law-enforcement figure who possessed considerable legal experience

and the value of the booty was not significant, it was difficult to understand how and why he did it.

McCallum, a graduate of Yale University and Boston College Law School, had a promising career in the public sector. He had clerked for David Souter's successor on the New Hampshire Supreme Court before landing a job with the state attorney general's office in 1991. Despite his prestige in political circles, a friend of Mr. McCallum's estranged wife grew suspicious about certain office equipment in the McCallum home and alerted Hanover police who, in turn, obtained a search warrant. The investigation unexpectedly revealed that he was in unauthorized possession, not only of office equipment but also of valuable paintings officials at Dartmouth College had reported missing from their Baker Library in 1996: *North Moat, Autumn* by Horace R. Burdick, *Early Spring at Mount Washington* by H. H. Howe, and an eighteenth-century Italian etching by Giovanni Battista Piranesi. The police confiscated Dartmouth's artwork and 170 other fine art objects, including a George Inness landscape valued at $40,000 and believed to be stolen from Saint Paul's School in Concord, New Hampshire. The catch was estimated at over $100,000. According to his estranged wife, McCallum used Baker Library when she visited her mother's home located in the vicinity.[3] She and McCallum were in the middle of a divorce when he was arrested. McCallum was charged with seventy counts of receiving stolen property in three New Hampshire counties. Some thefts dated back to his college years at Yale University.[4]

In spite of the notoriety of these incidents, it was the heist at Boston's Isabella Stewart Gardner Museum that brought the public's awareness of the extent of this crime to the forefront. In this former residence of Mrs. Gardner, the wealthy, eccentric wife of a Boston businessman, resided some of the world's most cherished masterpieces— untouched by time, as if awaiting the return of their patron who had eternally locked the doors behind her in 1924. Mrs. Gardner treasured the art collection that adorned her home, a fifteenth-century Venetian palace reportedly acquired in Europe and transported to Boston piece

by piece after her husband's death in 1898. She spent the rest of her life caring for her world-class collection that was often accumulated on the advice of art historian and connoisseur Bernard Berenson, renowned for his exquisite taste. The museum was opened to the public in 1903 while Mrs. Gardner continued to occupy an apartment on the fourth floor. She lovingly stated in her will that nothing in the museum could be modified from her arrangement and if the trustees were to alter the layout of the first three floors that displayed the artwork, all of the contents of the museum, which included 290 paintings and 280 other artifacts, were to be sold.

But these paintings—passions of oil and tint, objects of dynasties long past—were soon to be disturbed from their secure nest by visitors of another sort and time and with an agenda that would change the sanctity of antiquity in this museum forever.

At one o'clock on a cold March morning in 1990, two men whose uniforms identified them as Boston police officers approached the elegant museum. They convinced the two guards that they had been dispatched to investigate a disturbance in the area. They then overpowered the guards and handcuffed, gagged, and forced them into the basement. With relative ease, the two police impersonators disabled the museum's state-of-the-art security system. They cut two canvases from their stretchers and left with two Dutch masterpieces—*The Concert* by Jan Vermeer and *Storm on the Sea of Galilee*, Rembrandt's only seascape—as well as nine other paintings and drawings by old and modern masters and a Shang Dynasty bronze beaker. Altogether these were valued at $200 million. The stolen paintings included a Vermeer, a Manet, three Rembrandts, five Degases, and a painting attributed to Rembrandt's pupil, Govaert Flinck.[5] The theft was not discovered until the cleaning crew arrived at eight o'clock in the morning.

News of the robbery, shocking the art community and focusing serious attention on the implications of a lucrative art-theft industry, spread throughout the country. But was it really newsworthy? After all, art theft had existed since the construction of the pyramids. Robbers

had consisted of the privileged as well as the poor and included Cleopatra and the mayor of Thebes in ancient Egypt, who reportedly plundered pharaohs' tombs.[6]

Wars also brought about the redistribution of artifacts in the world. In ancient times, victorious armies often ravaged the cities of conquered nations. They looted palaces and royal tombs and carried off art treasures as well as religious symbols, not only for monetary gain but also because the art represented the prestige, pride, and myth of the defeated country. In stealing these items, they believed the power of those conquered would be totally destroyed. History has witnessed the plunders of Caesar, Napoleon, Hitler, and Stalin; each absconded with art treasures that rewarded them in their conquests.[7] The headiness of their victories constituted the booty of greed and the spoils of war.

Although art has been plundered, purloined, and treasured in every nation, the theft of artwork did not lead to strong public protest in France until 1911, when the *Mona Lisa* was stolen from the Louvre. Its elusive artist created his masterpiece between 1502 and 1503, before accepting the patronage of King Francis I of France, and lived in the king's castle, Château of Amboise. Leonardo da Vinci remained there until his death in 1519. The artist kept his portrait for reasons unknown and took it with him to France, where it became a royal favorite. *Mona Lisa* hung in the king's palace at Fontainebleau and then at Louis XVI's Versailles and Napoleon's Tuileries before finally finding its permanent home in the Carré Gallery of the Louvre, where its mysterious smile has captured the hearts of generations of museum visitors.

On Tuesday, August 22, 1911, while artist Louis Beroud set up his easel and prepared to paint his model with the *Mona Lisa* in the background, he noticed that the portrait was missing. He immediately questioned museum officials and was informed hours later that the painting had been stolen. Parisian outrage prompted the French police to embark on an aggressive search for the painting.[8] Still, they could find neither *Mona Lisa* nor its thief.

To Catch an Art Thief

Two years later, when everyone had almost given up hope of recovering the painting, Parisians received news of the arrest of an Italian in Florence trying to sell the *Mona Lisa*. Word spread that Vincenzo Peruggia, a former employee of a French contracting firm, who had been assigned to build the glass case for *Mona Lisa*, had, along with two of his countrymen, Vincent and Michele Lancelotti, stolen the painting on August 21, 1911.

The trio had entered the Louvre on Sunday afternoon as visitors, hid themselves in the closet where copyists' supplies were kept, and waited. On the following Monday morning, when the museum was closed for repairs and maintenance, they emerged in museum workmen's clothes and tiptoed along the Grande Gallérie into the deserted Carré gallery. There, Peruggia detached *Mona Lisa* from the wall. Stopping in the Visconti staircase, the thief took the picture from its large frame and slid it under his coverall. The trio walked past the guards without creating any suspicion; the theft took about twenty minutes.

In the fall of 1913, Peruggia contacted a Florentine art dealer, Alfredo Geri, and offered to sell him *Mona Lisa*. The dealer invited him to take the painting to a hotel in Florence, where waiting police officers apprehended the thief. At Peruggia's trial, his lawyer, Giovanni Carena, claimed that his client mistakenly believed Napoleon had stolen *Mona Lisa* from Italy and that for repatriating Da Vinci's masterwork, he should be treated as a hero rather than a criminal. But the judge was not convinced and sentenced him to one year in prison.[9]

Infrequent, intermittent thefts of valuable works like the *Mona Lisa* reveal that until the middle of the twentieth century, art theft was rare only because art collecting was limited by the constraints of the market. In fact, before the birth of Impressionism in the middle of the nineteenth century, private art galleries promoting artists did not exist. Painters were either supported by their patrons or earned money from commission work and from the sales of their products to art and antique dealers. As middlemen, these dealers also took commissions to sell artists' works in the courts of Europe and the homes of

aristocratic families and wealthy merchants. In the sixteenth century, the European royal monopoly of art acquisitions became an aristocratic fashion. An international art market that allowed powerful ministers and financiers to surpass their princes' wealth by their art acquisitions soon emerged in Flanders and the city of Antwerp.[10]

In spite of increasing enthusiasm for art collecting, the art market was not as well developed as it is today. In England, art was overseen by the Royal Academy, the Society of British Artists, the British Institution, and two watercolor societies.[11] Similarly, in France, the quality of artwork was judged by the Académie Royale de la Peinture during its annual exhibitions at the Salon.[12] However, due to the Académie's repeated refusals to display Impressionists' works at the official exhibitions because of their outrageously unconventional style, Impressionist painters displayed their products at the Salon des Refusés, so called because it exhibited the works of all artists whom the Académie had refused. This special show was initiated by Napoleon III in 1863 to give the works of artists who did not conform to the standard of the Salon a chance to be seen. Farsighted art dealers like Durand-Ruel and Vollard recognized the genius of these struggling artists as well as the new trend in art and purchased the works of poverty-stricken Impressionist painters.[13] By promoting art scorned by the establishment, they slowly helped create a new, unrestricted art market that eventually brought an end to the Académie's reign in the French art world.

Still, the purchase of art was largely a hobby of the rich and not commonly regarded as an investment. Collectors held on to their acquisitions,[14] and any public disclosure of the prices of artwork was considered distasteful. In the nineteenth century, perhaps in an attempt to solve their lack of old-world culture or to immortalize their names, American millionaires like J. Pierpont Morgan, Benjamin Altman, George Jay Gould, Andrew Mellon, George Blumenthal, and W. C. Whitney paid exorbitant sums for European art and made magnificent gifts to American museums.[15] Renoir once told his son, "We

perhaps owe it to the Americans that we did not die of hunger."[16] Nonetheless, the nineteenth-century art gallery still retained the character of an antique and curiosity shop.[17]

With the recovery of the American economy after World War II, speculators started to look for new investment opportunities. The art market was found more lucrative in the 1950s, and art dealers learned to use the media to advertise their sales. Television cameras entered auction rooms, and sensational sales became front-page news as art acquired its market value.

The sale, however, that clearly marked the transformation of the art market and captured the interest of criminals took place at Sotheby's on October 15, 1958. The auction included seven paintings from the Goldschmidt collection in Berlin: a van Gogh, a Renoir, two Cézannes, and three Manets. Within fifteen minutes, the entire collection was sold for £781,000 ($1.72 million), and the Cézanne, *Boy in a Red Waistcoat*, alone sold for £220,000 ($616,000). Journalist Hugh McLeave thoughtfully remarked, "A page had been turned in the history of art—and art thefts."[18]

The Blooming Art Market

Though the art market originated in ancient Rome and flourished during the Renaissance,[19] its remarkable popularity is a contemporary phenomenon. No doubt America's evolution from an agricultural to an industrial society in the nineteenth century brought excess wealth to the upper class. That, coupled with better art knowledge—largely as a result of art history courses offered at the college level—and the increasing number of high-profile professionals in the field, had made the generous spending on art possible and pleasurable.

No one knew better than American art dealers about the influx of private collectors. At Sotheby's, two-thirds of the one-month lot in the fall of 1980 went to private collectors who were notably more sophisticated than those of earlier decades. Similarly, the Marlborough Gallery

in New York City reported in 1984 that 70 percent of its clients were individuals, 9 percent were museums, 7 percent were corporations, and the rest were art consultants.[20] "All of a sudden, a whole new group of collectors is emerging," said New York dealer Clyde Newhouse.[21]

Inflation also played an important role in frantic art purchases. While inflation rates fluctuated, art prices continued to rise. The late New York dealer Sam Salz reportedly commented, "It's not the pictures that aren't worth the money. It's the money that isn't worth the money anymore."[22] Thus it is arguable that wise investors disposed of their extra money at auction galleries.

In spite of the fact that the phenomenal growth of the contemporary art market is new, the concept of art as an investment is not. During the eighteenth century, art collecting was an investment practice of French bankers who followed the example of their Florentine mentors. Well aware of the uncertainty of the value of the livre, they often acquired works of art to use as a hedge against possible inflation. It was not by coincidence that the mistress of King Louis XIV of France, Madame de Pompadour, whose putative father was a financier, grew up to become one of the most influential eighteenth-century patrons of the arts.[23] Since art is regarded as inflation-proof, it has been used as collateral for loans in some countries.

Investment, however, requires substantial knowledge of art and its market; naïve art buyers often fall prey to unscrupulous predators. Looking for a hedge against inflation and pushed by both profit and pleasure principles, such buyers selected—without due insight or foresight—peddlers' works of art. One such buyer's misfortune was captured by a November 14, 1989 report of an incident to the New York City Police Department. It was here that a popular artist complained to Detective Thomas Moscardini of the Art and Antique Unit that an associate had copied a number of the artist's drawings and sold them for $14,000. The copies were so poorly executed as to mystify even the average consumer as to how the buyer could not recognize them as fakes.

In addition to the profit-making incentive, buying art for ego grati-fication was not uncommon, for art acquisition brought certain social status to the owner[24] and had become fashionable among the affluent classes all over the world. As the twenty-first century opened, appre-ciation and acquisition of works of art is a privilege increasingly shared by most members of all strata of the American society.

Certainly, it is the element of commercialism that has made it so. The contemporary art market did not confine itself to trading merely in expensive items like paintings; it dealt in prints, posters, ceramics, Oriental art, primitive art, and photography—all at a price comfortable for everyone's pocketbook. Clever art dealers were astute to develop trends of art appreciation that stimulated new areas of collectors' interests, such as American Indian art, by attracting press coverage of their new exhibi-tions and creating curiosity among art buyers.[25] For contemporary art-ists in whose products they invested, some dealers produced television documentary films about the artists and their work. Advertisement is the hallmark of commercialism, and the returns are tremendous.

Other factors, including the enormous increase in the number of American museums and the phenomenal growth of corporations, had added impact for the art market in the 1980s. No doubt purchases made in the years between the two world wars attested to the formidable buying power of American museums.[26] Dealer Newhouse exclaimed, "There's nothing in the world comparable to the number of museums in this country, and not just big museums but college and university galleries."[27] In those days, that number was 8,200 and increasing every year. Because treasures attract the curiosity of visitors, museum cura-tors had acquired some of the most expensive works of art. In 1985, a period in which few paintings realized million-dollar sales, the J. Paul Getty museum paid $7 million for Dieric Bouts's *Annunciation*, one of those rare paintings by old masters with rather too high a price for most individual collectors.[28]

In addition to being purchased by museums, art was acquired by corporations. Although corporate patronage of art has its historical

precedent in the Renaissance, when the Medicis were commissioning most of the art in Florence, it had not been widely practiced in later periods of history. Furthermore, art purchases by corporations were often looked upon as unsophisticated.[29] This trend drastically changed in the 1980s with the increasing acquisition of valuable artwork. In 1984, the Equitable Life Assurance Society of the United States bought Thomas Benton's mural *America Today* for $3.1 million to install it in the lobby of its headquarters in New York City.30 Corporations often purchased American contemporary art because they believed the patronage of local artists reflected corporate social responsibility.[31]

The United States government—another patron of the arts—introduced new tax laws to encourage art donations. Americans, for example, could donate an artifact and received a 30 percent tax deduction on the gift.[32] In fact, until 1965, the law allowed a donor to receive a tax break on an art bequest to a museum even while the donation remained in the donor's home until his or her death.[33] In the 1980s, a survey conducted under the aegis of the American Association of Museums, found that at least 85 percent of the museums' acquisitions were donated.[34] The result of government patronage was the obvious: incentives increased donations.

Until recently donors had been known to abuse the tax law for their benefit by presenting fraudulent appraisals of their gifts to charitable organizations.[35] The problem had been largely ignored until 1984, when the Tax Reform Act imposed tighter regulations on appraisals, new penalties for overevaluations of donated artifacts, and the involvement of receiving institutions in the appraising of the gifts.[36] As a result, the number of museum donations noticeably decreased.[37]

The Temptation

"The cheapest thing you could buy in the 1950s was art," recalled a New York art dealer.[38] However, in November 1961, a blockbuster sale

took place at the Parke-Bernet auction gallery, an event few members of the art market could forget: the Metropolitan Museum paid $2.3 million for Rembrandt's *Aristotle Contemplating the Bust of Homer* when Louis Marion, the gallery's chief auctioneer, had hoped to raise but $1 million.[39] After that art prices kept rising until the recession in the early 1990s, which put a temporary halt to the art investment fever. Billions of dollars had poured into the art market in which works of both old and modern masters had realized fabulous prices. Over a decade ago, *Art News* reported that the finest works by first-rate artists had brought multimillion-dollar prices. At the same time, prices for the best works by second- and third-class followers had moved into the five- and six-figure range.[40] In 1990, the art market reached its peak with van Gogh's *Portrait of Dr. Gachet* sold by Christie's for $82.5 million and Renoir's *Au Moulin de la Galette* by Sotheby's for $78.1 million.[41] Within three decades, record-breaking sales for paintings by old and modern masters increased from $2.3 million to $82.5 million. In fact, not only did the works of old and modern masters sell remarkably well but also those of certain famous contemporary artists such as David Hockney and Francis Bacon. Their paintings commanded from $2.2 million to $20.7 million even in 1989.[42]

During the boom years of the art market, some art dealers were bewildered at the profits they made, most of which came from their commission fees.[43] When Australian industrialist Alan Bond bought van Gogh's *Irises* in 1987 for $53.9 million, Sotheby's received an undisclosed commission. Normally auction houses got a 10 percent commission. Two and a half years later, acting as an agent for Bond, Sotheby's sold the painting to the J. Paul Getty Museum for $65 million, realizing an $11 million profit for Bond.[44] Since the best-quality art has always been scarce, second-rate works have often come to supply the art market, their value increasing 370 percent between 1971 and 1986.[45] "Our cry," lamented Newhouse, "is, we've got the clients, we need the pictures...If I had ten fine Dutch and Flemish still lifes, I'd have no trouble selling them."[46] During the five-year period between 1984 and 1989, the

value of art in general showed an annual growth of 20.9 percent, while Impressionist and modern works increased at a rate of 32 percent and with less fluctuation than the stock market.[47]

Perhaps the extent of the profits that can be made with art speculation in the contemporary world is most clearly indicated by the investment of the British Rail Pension Fund, which, from 1974 to 1980, accumulated from $74 to $76 million worth of art.[48] In 1987, as the art market approached its peak, British Rail began a series of sales to profit from its vast collection. In the spring of 1989, after a sold-out auction of twenty-five Impressionist and modern pictures and sculptures that realized $65.58 million—double Sotheby's estimate—Maurice Stonefrost, chief executive of the pension fund, proudly commented on the pictures that had been bought between 1975 and 1981 for about $5.7 million: "Impressionist and modern pictures have been the single best investment I have had on my books."[49] Following the example set by British Rail, the Chase Manhattan Corporation planned in 1989 to raise $300 million from large pension funds to purchase artwork ranging in value from $1 to $10 million. It sought to locate clients among companies with pension funds of at least $1 billion in assets.[50] *Fortune* had predicted in 1955 that art could be the most lucrative investment in the world.[51] This financial forecast undoubtedly proved to be accurate.

While the art market rapidly expanded, law-enforcement officials became aware of the increasing rates of art theft, the presence of blue-collar, white-collar, and organized crimes, and the participation of members of all classes. Indeed, today it is not a surprise to hear news about educated and upper-class individuals facing art-theft charges of the blue-collar-crime variety. In 1978, Calgary Police entered a home and found the premises full of stolen artifacts valued at $13 million. University of Calgary psychology professor Raymond Hertzog and high school teacher Ernest McLeod were charged with burglary and possession of stolen property.[52] Journalist Karl Meyer suggested that the increase in art prices has, more than any other single element, caused theft, mutilation, and destruction of art in the world.[53] In spite

of this, an accurate estimate of the monetary loss due to art theft in the United States has not been established, though the cost due to these crimes was estimated in 1989 at $4.5 billion per year worldwide.[54] Not surprisingly, law-enforcement officials believe that the international traffic in stolen art ranks second—only after drug smuggling—as the most costly transnational criminal activity.[55]

To combat this proliferating crime, during the heyday of art theft France had thirty officers assigned to investigate art theft, while Italy had eighty and England eighteen.[56] In the United States, the Los Angeles Police Department employed a full-time detective in the Art Theft Detail. Similarly, one full-time art-theft specialist was assigned between 1971 and 1989 to the New York City Police Department's Art and Antique Investigation Unit. In 1979, the FBI established the National Stolen Art File, a computerized index of stolen and recovered art located at the National Crime Information Center in Washington, DC.[57] The International Foundation for Art Research (IFAR), a non-profit agency created by Bonnie Burnham in New York City in 1976, had also assisted law-enforcement agencies in the recovery of stolen art by receiving art-theft reports from all over the world. It maintained the first computerized index of stolen art and distributed art-theft information through its *IFAR Reports* published ten times per year until 1998. In 1991, it joined Lloyd's of London and a number of major auction houses and insurers in England and Germany to form the International Art and Antique Loss Register (ALR), which stores an image database of stolen artwork globally.[58] Interpol, the international police agency headquartered at Lyons, France, regularly sends out circulars on stolen artwork and wanted suspects.[59]

Art Theft in New York City

The Art and Antique Investigation Unit

The line of visitors moved slowly, forming a soft curve as it wound its way to the receptionist's desk. It was my obsession with understanding art theft and how the thieves were caught that led me to One Police Plaza to meet Detective Thomas Moscardini. After all, he was a critical nerve in the control center of the NYPD Art and Antique Investigation Unit. In fact, it was his legendary role in the unit that I had honed in on, long before I met him, while reading an art-theft article in California. Who can explain the vagaries of chance? It seemed, at the time, such a remote possibility that our paths would cross, and now I found myself in the midst of his operation. I realized that I had been given a researcher's entrance to the most important art-theft investigation unit in the United States. More than that, I would actually meet the

man who headed it—the same Moscardini whose words were scattered under headlines in the news.

It was November 18, 1989, and nearly lunchtime. The edge of a crisp autumn wind released the tail of my coat and its claim on my ears, as I, eager for the warmth inside, whisked myself beyond the turnstile of the revolving door. First I relieved myself of one glove and then another. The numbness of several fingers immediately relented as I presented identification to the receptionist and indicated my appointment with the art-theft specialist, Detective Moscardini. The intercom she spoke into for confirmation echoed against the high ceiling, and a voice on the other end crackled through as she handed me a clearance label on which she had written the detective's room number. Mechanically and by rote, she told me to affix it on my coat and directed me to a bench where I was to wait. As I leaned against the cold brick wall, I searched the faces of the numerous police officers passing the large entrance hall, looking for the man of "medium height, with dark hair and a mustache," as Moscardini had described himself to me during our telephone conversation in the past week. To my dismay, there were so many officers who had dark hair and mustaches that I became confused.

Suddenly, an urbane-looking man in his midforties emerged from the crowd and approached me with a polite and cautious, "Miss Ho?"

"Yes," I responded.

"Tom Moscardini," he warmly assured me and shook my outstretched hand.

I smiled and mused to myself, "So this is Detective Moscardini." The giddiness of anticipation could finally ride its course after three years of hoping, working, and maneuvering for this very meeting.

As my epiphany melted into memory, giddiness transcended into intimidation. I was about to cross over some invisible threshold, leading me from a world of the safe and familiar to the unknown domain of a big-city detective. I was struck by the realization that I would be embarking on an adventure for which I would have to navigate two

worlds: my own—the quiet and communicative world of art and academe, and the other—the unpredictable and secretive world of criminals and detectives. Moscardini would soon unfold before me many of their secrets.

As a matter of fact, the first secret unraveled was Moscardini's own. The detective who would virtually become an art-world icon had found himself in the predicament—thought it was also an envious position—of succeeding another legend, Robert Volpe, the first full-time art-theft detective and groundbreaker of newsworthy recoveries in the early 1970s. Because art theft was becoming serious enough for the NYPD to follow the lead of England's New Scotland Yard, four volunteer detectives under the direction of Captain Thomas Kissane, including Detective Marie Cirile from the Safe, Loft, and Truck Squad, participated in a six-week training course in art identification. The experience, however, soured their interest in art theft. In fact, by the time they completed the course at the Parke-Bernet auction gallery, most preferred to be assigned to anything other than the art team. It was then that Detective Robert Volpe, an amateur painter, was challenged to head the new unit and promised the temporary assistance of Detective Cirile. Together they made up the bare-bones team called the Art Identification Unit, then located at the First Precinct on Old Slip Station.[1] After Volpe's retirement in 1982, Detective Moscardini took over the one-person unit and renamed it the Art and Antique Investigation Unit, which was a part of the Special Frauds Squad of the NYPD.

Once on board, he immersed himself in art-history classes, studied the shadows, shapes, and color punctuating museums and galleries, and kept company with their professional coterie. Functioning as an art-theft expert and a liaison between the NYPD and the art world, Moscardini enjoyed the assignment and the respect he earned.

In 1984 Moscardini began compiling an extensive art-theft file to facilitate his investigations. As a repository file for art-theft incidents occurring throughout New York City, this centrally located record

provided official data about art theft that would have otherwise remained unknown.

Following Moscardini to his eleventh-floor unit, I noticed that the offices were very small, and detectives constantly moved in and out of several very large crowded rooms where their desks were placed side by side. I was also somewhat surprised that a few detectives were rather physically unfit. Expecting the environment of sophistication and machismo I had enjoyed in the movies, I was brought back down to earth and muttered to myself, "So this is what it's really like."

Stopping at a small office off the main room, where a window allowed a trace of the New York sun to skip across the desk, I was introduced to Moscardini's supervisor, the commander of the Special Fraud Squad, Lieutenant John Kelly. Kelly, a congenial man in spite of his tough-looking exterior, showed great interest in the work I proposed to accomplish at the art unit. He graciously introduced me to Captain Noxon, the commander of the Major Case Squad, and Lieutenant Joseph Pollini, the commander of the Safe, Loft, and Truck Squad.

The Special Investigation Division of the NYPD consisted of the Safe, Loft, and Truck Squad, the Missing Persons Squad, the Special Frauds Squad, the Major Case Squad, the Felony Augmentation Section, and the N.Y.C. Joint Bank Robbery Task Force. Though the general policy was that each unit should take care of itself until it needed assistance to help solve a problem, I learned that when a very serious matter occurs—for example, when a person goes missing—all units of the detective bureau must immediately get involved.[2]

Once inside Moscardini's office, I found a very small, windowless room crammed with his desk, two chairs, several file cabinets, and a bookcase. Moscardini began to respond carefully to my questions about his work. He showed great enthusiasm about his job and revealed that it took the department over one year to find a suitable candidate to fill the post he then held and that Volpe left the unit

no information for his successor to use to investigate pending and future cases.

Finding himself operating in a vacuum, Moscardini started to rebuild the unit by compiling art-theft complaint reports from all the precincts and renewing connections with the art community. He also mentioned that I met him at the right time because if it had not been for his last year of service, art-theft information would not have been accessible to a researcher. Realizing the unique opportunity being presented to me, I offered to pay him a consultation fee for assisting me in my data collection; thereby I would be able to ask him any questions relating to art-theft investigation and similar issues. Because he had to spend most of his time on the streets, he informed me that after I submitted a request to collect art-theft data to Commissioner Benjamin Ward and received his approval, I would have to work alone in his office. But he also mentioned that I could use all available documents of the Art and Antique Investigation Unit for my dissertation research project. It was during the course of that first encounter that I noticed, hidden away in this tiny space, several drawers full of art-theft complaint reports and other investigative information no researchers had ever been allowed to examine. Moscardini explained to me that before 1985, the NYPD received very few art-theft complaint reports. However, there was a marked increase in this type of crime report after 1985, and it had kept increasing since then. The Art and Antique Investigation Unit therefore compiled only reports from 1985. I was allowed to collect and conduct a data analysis of all the reports from 1985 to 1988.

The art-theft complaint report is the first formal notification to the police of the occurrence of an art theft. Its importance as a major document providing art-theft information cannot be overemphasized. It is prepared specifically to help detectives in their criminal investigations and to assist in the preparation of crime statistics. More importantly, it is the initial step in the process that may lead to the recovery of the stolen art as well as to the arrest, conviction, and incarceration of the offender.

Moscardini explained that most art-theft complaints were filed shortly after the discovery of the loss of the artwork or immediately after the reporter of the crime had witnessed the theft. Information for these reports was gathered by dispatched officers or by a police officer at the precinct. All reports were filled out voluntarily. Owners of stolen artwork usually tried to be accurate with their information in the hopes that this might facilitate the recovery of their stolen objects. However, because the information on the complaint reports would be used in subsequent stages of the criminal-justice administration, any complainant who wanted to amend the report had to fill out a Modification to Complaint Report form, and this process was time-consuming.

Because art-theft investigation requires some knowledge of art, precinct detectives would often send their complaint reports and their own complaint follow-ups to Moscardini if they could not follow through on their cases. More often than not, Moscardini received reports that had no follow-up documentation.

"Information contained in the complaint reports and the precinct detective's follow-up reports provide the starting point for my investigation," Moscardini pointed out. "After evaluating the completeness of these reports, I interviewed the victim personally or by telephone for additional information and then recorded the findings on my follow-up forms."

As a result, I was able to use these reports to study art-theft incidents without further assistance from owners of the stolen art. The large volume of these reports enabled demographic analyses of crime patterning.[3]

My hope to discover the true extent of art theft in New York City vanished when Moscardini revealed that it was not unusual for some victims not to report the crime and that although all art-theft complaint reports taken at any of the other seventy-four precincts of the New York City Police Department were supposed to be forwarded to him at the Art and Antique Investigation Unit, he estimated that only

80 percent of these reports were actually deposited there. The remainder was not sent to the unit for one of three reasons: First, due to a significant lack of important information, most of these cases were not assigned to precinct detectives, a fact that explained the disappearance of these reports from the start. Second, if it were possible to avoid, precinct detectives refused the NYPD art-theft specialist's assistance in order to keep good arrest and recovery records for themselves. And third, though the Art and Antique Investigation Unit had been established in 1971, some older precinct detectives did not bother to comply with the "new" rule.

Because of the failure to report stolen artwork and the problem of missing reports at the Art and Antique Investigation Unit, the total number of art-theft reports per year was not substantial. Then, adding to my chagrin was the discovery that these complaint reports had flaws with regard to the accuracy of the values of the stolen art. Unless a person was a professional collector or art dealer, he or she often did not know the monetary value of the stolen object and therefore reported only its estimated value or no value at all. The opposite extreme was the tendency toward deliberate reporting of an inflated value for insurance purposes.

Fortunately, Moscardini also gave me access to his eighteen investigative cases conducted between 1985 and 1988. These cases included all information about his investigative work that served to substantiate criminal charges against the accused offenders. In the Art and Antique Investigation Unit, a case was closed with an *A* written on the front side of the folder if a recovery and an arrest had been made.

While examining the contents of these files, I was impressed by the evidence of extensive planning in the investigative process. Moscardini was required to get approvals from his supervisors before taking every crucial step and to keep them informed of the progress of his cases. This requirement, in my opinion, while protecting the suspect from police abuse of power, contributes to the reduction of

the surprise element and to the lengthy investigative process. Though each case was different, the following documents were included in most:

- An index listing all the documents belonging to the case

- A complaint report containing all basic information about the stolen artwork, the owner of the stolen art, the suspect, and general details of the incident

- At least one complaint follow-up report in which further details of the crime were recorded by subsequent investigators

- A photograph of the stolen artwork—essential for the investigation

- Information from the Division of Criminal Justice Services showing the suspect's criminal record

- The FBI Identification Division's brief on the suspect, which provides additional information about the accused offender

- An application for a search warrant filed by the detective in order to legally search the suspect's residence

- Written statements by any witnesses, which are usually used to obtain a search warrant

- A search warrant provided by a justice of the New York City Criminal Court

- A subpoena commanding the subject to surrender information the detective needs for the investigation

- An arrest work sheet including the plan for the arrest of the suspect

- A request for the use of a police car equipped with a flashlight filed by the commander of the Special Fraud Squads

- A request for an art-dealer plate used in undercover operations in which the art-theft detective assumes the role of an art dealer interested in buying stolen artifacts

- A request for duplication of the Nagra tape used to record the conversation between the detective and the criminal during a buy-and-bust operation

- Several photographs and a layout of the location where the detective met with the suspect to negotiate the purchase of the stolen art

- Photographs of the location of the arrest

- Photographs and fingerprints of the suspect taken at the precinct after the arrest

- An inventory and affidavit of property taken under search warrant in which descriptions of the confiscated stolen object were recorded

- A property clerk's invoice voucher and the police department's receipt of the confiscated artwork

- A report on the recovery of the work from the commander of the Special Fraud Squad to the commanding officer of the Special Investigation Division

- A release application for the stolen work to be returned to the owner

- A detective bureau unusual occurrence report written by the detective to report the case to his or her supervisor

- A felony complaint filed by the detective to the New York State Supreme Court

These 229 art-theft complaint reports forwarded to the Art and Antique Investigation Unit by detectives from the other seventy-four precincts during the period from 1985 to 1988 were unique in that they were the first, and perhaps the most complete, collection of police records on art theft in the United States for some time.

Extent of Art Theft in New York City

For the purpose of investigation, the New York City Police Department categorizes artwork as drawings, paintings, sculptures, prints, photographs, antiquities, liturgical objects, icons, manuscripts, rare musical instruments, rare coins, and rare stamps.[4] Complaint reports on the theft of these works come from various locations in the city, including private residences, art galleries, business establishments, and public facilities. Many of these reports suffer from incomplete reporting, and significant discrepancies often exist in the rates of official and unofficial property-crime reports, especially in the case of thefts in which the victim might find it detrimental to report the theft.

Indeed, detectives investigating these crimes acknowledged that far more art thefts occurred than were reported. For example, when I expressed my concern to Detective Joseph Keenan that I might not find enough art-theft incidents for my study, he replied, "You may find half of the dealers on Madison Avenue had thefts." His response gave me much hope for my research plan. Criminologists searching for data on

crime often find that although the estimates made by those who have spent years in the administration of criminal justice—including law-enforcement officials, lawyers, and judges—are not exact, their opinions come from intuition based on accumulated experience and often prove to be reliable.[5] Though well aware that an accurate estimate of the extent of art theft could not be obtained from official records, I proceeded to examine them because they are the most reliable sources of information that can be used to provide a general description of this offense.

The New York City Police Department categorizes art theft as the stealing of artwork by larceny, burglary, robbery, and fraud.[6] It classifies both shoplifting and employee theft as larceny because in most cases the theft of an artifact committed by an employee can only be ascertained at the conclusion of the investigation. Unless the reporter of the crime knows the theft has been committed by an employee, all thefts occurring at galleries during business hours are referred to as shoplifting.

There is, however, a distinct difference between art theft by larceny and art theft by burglary. Whereas burglary is theft preceded by an act of trespassing and must have the element of breaking and entering a premise, larceny is theft that occurs where the offender is lawfully at the premises. During business hours, a shoplifter is permitted to be in an art gallery; likewise, an employee may be present in a gallery at any time as required by the job. In New York City between 1985 and 1988, art theft by larceny was the predominant type of art crime—burglary, robbery, and fraud occurred less frequently.

Data collected from the Art and Antique Investigation Unit shows that of those affected by art theft, over 60 percent were businesses—mostly commercial art galleries reporting some form of art theft during the four-year period of the study. Businesses made up 60.7 percent of the victims; a lesser percentage involved individuals (38.9 percent) and public facilities like libraries, churches, and schools (0.4 percent).

Though it would have been desirable to have an accurate estimate of the total value of losses per year, I was not able to obtain these figures

because ten victims did not report the value of the stolen art. Since the number of the missing values is insignificant—less than 5 percent—I estimated the value of the loss per theft incident after excluding these ten cases. The average value, then, was $20,000 per theft, a very modest sum considering the common perception that art-theft losses usually hit the six-figure range. It is possible that the media prefers to report significant art theft losses because large sums of money make better news.[7] Police information also disclosed that the difference between the minimum and maximum value of the losses was extreme—between one hundred dollars and $6 million. Based on the available data, on average two items were stolen per theft. In most cases, only one object was stolen because the majority of art thefts were shopliftings. But in one incident, five hundred objects were found missing.

I was not surprised to find that art had been stolen most frequently at commercial art galleries and with a lesser frequency from private residences, offices and business establishments, parked cars, storage facilities, churches, and other public facilities. Though only a fraction of these crimes took place at storage facilities and warehouses, it was at these locations that the greatest number of stolen objects per incident occurred. Typically, the owners of the stolen artwork did not know when the property had been taken from storage but discovered the theft when they visited the storage location.

In addition, wealthy immigrants in New York City often bring all their possessions when coming to this country. Very often they will store family heirlooms and artwork in rented storerooms. Oftentimes leaving them for years without conducting periodic inventories, the owner is unable to give police crucial information about the theft once it has been uncovered. This would explain why a report does not have the exact date of a crime, which is the most critical information. This type of theft can create the most devastating loss if the owner is an artist. A 1995 theft is a case in point. At age eighty-two, painter and sculptor Arbit Blatas discovered that his bin—one of three thousand at Manhattan Mini Storage—was empty. This container had held

nearly two hundred paintings, which the artist had created over a long period of time, valued at about $2 million. Included in this collection was *The Three-Penny Opera*, a series of fifty paintings on which he had worked for fifty years after attending the original production of the play in Berlin. This series was to be donated to a museum being built in Dessau, Germany. A thief had cut the lock and absconded with the artist's lifetime of work.[8]

Though museums house the most art per location and Bonnie Burnham's 1978 survey of museum thefts in the United States revealed that each museum in her sample lost an average of 1.48 objects per year, I found only one informal reported art theft from a museum at the Art and Antique Investigation Unit.[9] Instead of filing a complaint report for this incident, one of the museum administrators wrote a confidential letter to the police in which he reported the discovery of a loss that might have taken place sometime during the preceding three-year period. This appeared to confirm my belief that museums often absorb their losses for fear that the negative publicity may result in the unwillingness of donors to entrust their art collections to an unsafe facility and that negotiations for loan exhibitions with other art institutions or collectors may be poorly received.

The problem of missing reports emerged again when I found that the prime location of art theft was commercial art galleries, but an average of only twenty-six complaint reports from these galleries were filed at the Art and Antique Investigation Unit per year. This small number raised a serious question about its representation of the population of victimized galleries. Perhaps Moscardini had the answer when he revealed to me that "record keeping is not a detective's priority."

The Recovery of Stolen Art

During the period from 1985 to 1988, the Art and Antique Investigation Unit recorded eighteen cases that resulted in the recovery of stolen artwork (ten of which were closed with arrests) and a

recovery rate of 8 percent. This, however, was the recovery rate of art thefts reported only in New York City. The total number of recoveries was slightly higher because many art objects stolen in other cities were consigned for sale in New York galleries, and this fact led to their discoveries. Still, it was impossible for me not to question this low recovery rate, and I soon found myself searching for an answer. As I probed deeper into the investigation, a number of explanations surfaced.

At the national as well as international level, art theft is a crime against cultural property.[10] Unfortunately it belongs to the category of property crimes, which are of low priority to the NYPD. While those who value cultural property may contend that the theft of artwork displayed at museums and galleries results in a denial of the public's right to view artifacts and to enjoy a cultural experience, it is not a violent crime and affects only a small percentage of the population. In addition to the fact that art theft is not a "categorized" property crime—like, for example, auto theft—and that valuable artwork is usually insured, the NYPD's limited resources and attention are given to property crimes only after violent crimes have been dealt with. This procedure is reflected in the city's employment of only one full-time art-theft detective to investigate stolen art worth what is estimated to be over $13 million. In England, the art-theft squad suffered the same fate when the New Scotland Yard's Art and Antiques Squad was disbanded in 1984 due to economic hardship. Although it was reinstated in 1989, criticism of its operation was not unheard of because many people believed that police resources should be devoted to fighting street crime rather than spent on the search for the lost treasures of the wealthy.[11]

Other difficulties are inherent in the nature and practice of the art-theft investigation. As a group, artwork is perhaps the only type of valuable property that does not have a system of registration. While a $100,000 apartment requires legal documentation and perhaps days to purchase, the transaction of a painting valued at several million dollars may be accomplished within minutes. Easily portable, unregistered, and without serial numbers, stolen artwork presents a serious problem

of identification in a detective's course of investigation, especially if he or she is not supplied with a photograph of the lost object.[12] Art objects, particularly paintings and prints, are also easy to conceal; they can be wrapped, folded, or painted over with a removable medium.

This technique was used in a 1982 smuggling case. According to an arrest complaint filed in Federal District Court by customs agent Charles Koczka, four men, including Reverend Lorenzo Zorga, smuggled two stolen Italian Renaissance paintings into the United States. A confidential informant had reported to Koczka that one of these accomplices, art restorer Giordano Garuti, had disguised one of the paintings by covering it over with an erasable, newly painted picture.[13] In some cases, thieves altered and thereby damaged delicate paintings and stolen sculptures.[14] In 1992 Mexican dealer Peter Juvelis consigned, for sale by Christie's auction house in New York for a client, a watercolor that resembled a stolen work by Winslow Homer, *Off Gloucester Harbor*, valued at about $125,000. A Homer expert examined it and declared that it was the watercolor stolen from the Jennings's home in Massachusetts more than a quarter century ago. The crude addition of two smaller sailboats on the left and flying seagulls in the sky was obviously intended to disguise the work as a painting other than the one that had been stolen. The damage was irreparable.[15]

Another form of identification is the provenance of the artwork. Though artifacts sold by dealers have statements of origin, these documents can be easily counterfeited,[16] and many art-theft victims do not take photographs of their artwork unless they insure it. Surprisingly, many dealers I subsequently interviewed did not have photographs of their inventory. In fact, almost one in three had less than 76 percent of their art objects photographed. Without a photograph of the stolen art, the case is considered to be closed.

During an investigation, the detective must rely on his command of the art. When Scotland Yard revived the Art and Antiques Squad in 1989, its two new officers spent four days at Christie's, three at Sotheby's, and two at Phillips before going on to receive two weeks

of training from the British Antique Dealers' Association. This special training gave them insight into the problem of stolen art while providing a wide variety of useful contacts for their future investigations.[17] In the United States, property-crime detectives assigned to investigate art-theft cases received no art training, yet from the first step in the recovery process, the precinct officer responding to the complaint must be able to communicate with owners and the art community. His or her knowledge of art is critical in establishing the confidence of the victim in order to gain necessary information. Thus the officer's familiarity with and appreciation of art reassures the victim that the investigator recognizes the loss goes beyond its monetary value. This encourages trust and facilitates cooperation from the victim.[18]

As can be expected, very few precinct officers possessed such knowledge,[19] resulting in an inadequate record of the theft, due to poor communication between the victim and the officer. It was at this point that art-theft expert Moscardini at the Art and Antique Investigation Unit was called in to break the case. Unless the case was very important and demanded immediate attention, it might be quite some time before Moscardini got around to his follow-up investigation. By that time, some victims already became preoccupied with other issues, and their memory of the details of the thefts likely faded, a fact that further impeded the process. Due to limited resources, personnel, and time allotted to each case, NYPD detectives were able to pursue only cases in which the value of the stolen property was at least $10,000. It is no wonder that recovery rates are low.[20]

Another issue that contributes to poor recovery rates is inherent in the New York City Police Department's practice of rewarding its veteran property-crime detectives by assigning them to investigate art-theft cases regardless of their specialization.[21] Though extensive investigative background in burglary and theft is necessary, these detectives found that they were at a disadvantage because they lacked strong contacts throughout the art community, where stolen artwork often surfaces. However, it often takes years to develop such relationships.[22] Serious

problems occurred when experienced art-theft detectives retired; the interruption of their services and their investigation further impeded progress. With no readily available replacement or apprentice to provide a smooth transition, many cases were shelved, causing frustration in the art community. This was evidenced during the chaotic period I experienced after Moscardini's retirement. For reasons unknown, a police officer was assigned to temporarily replace Moscardini. Hoping to speak with Moscardini about their cases, dealers telephoned the New York City Police Department but found themselves talking to a police officer who was unfamiliar with their cases and unable to communicate with them. In vain some tried to reach Moscardini at home.

Dealers' lack of cooperation also hampers recovery. Many dealers who have experienced thefts do not follow up with details of the thefts or provide photographs of the stolen objects. Some refuse to show detectives their records. According to Michael Fischman, an art insurance adjuster I subsequently interviewed, 95 percent of the dealers in New York City have art insurance and usually file complaint reports in order to receive compensation. If they do not expect the police to be able to recover the stolen works, they are unlikely to pursue the case and provide additional information to the detective. In other words, it is more expedient to get the insurance compensation than to have the stolen objects recovered.

Another possible explanation for art owners' lack of cooperation is that their missing artwork may have been a stolen piece to begin with, or it may have been purchased with money they could not account for.[23] In addition, to claim insurance, some unscrupulous dealers may burn[24] or commission thieves to burglarize their galleries. A notorious case occurred in 1986 when Houshang Mahboubian, sixty years old and owner of the Mahboubian Gallery of Ancient Art in London, masterminded the foiled burglary of a customs warehouse in Queens to steal his two containers full of Middle Eastern gold and silver antiquities. Having shipped these from London, he had planned to defraud his insurers, Lloyd's of London, of $18.5 million. At the trial, Assistant

District Attorney Cyrus Vance Jr. contended that Mahboubian organized the burglary after he was unable to sell the artifacts because they were forgeries. He and one of his codefendants, Nedjatollah Sakhai, owner of Ely's Antiques in New York City, were convicted of conspiracy, burglary, and attempted grand larceny in 1987.[25] Because of such discoveries, owners of stolen works often chose not to cooperate and thereby avoid any problems that might arise once the police had conducted their investigation.

The deeper my investigation penetrated these crimes, the more I became aware of their complexity. Though police information was invaluable, I was not satisfied with the scope and magnitude of art theft from the Art and Antique Investigation Unit's data. The total number of art thefts reported per year was too insignificant for me to believe. Though my discussions with Moscardini and other detectives revealed that to catch an art thief, a detective must have knowledge of the thief, his or her motivation, skills, and fencing activity, too little of this information could be found in the police reports. Because the victim, next to the thief, would know more about the theft than anyone else, I was convinced that an interview with New York City art dealers might peel away the veil of secrecy surrounding this crime. With that in mind, after Moscardini's departure from the NYPD, I bid farewell to Lieutenant Kelly and promised to send him a copy of my dissertation in the future. The time I spent there had been productive and revealing. Everyone was gracious and more hospitable than I had expected. Encouraged, I left with my appetite whetted to dig even deeper.

Rogues in the Galleries

The Quest for Art-Theft Information

Rush hour in Manhattan produces rivers of people pouring onto the streets and moving like waves toward the subways that will deliver them to their destinations. The incredible energy surrounding me while awaiting my Lexington Avenue train on this early spring day is what had always made New York City exciting for me; it reminded me of my late art professor and noted portrait painter Alvin Gittins, who said he most enjoyed New York City from the vantage point of a subway station, where he never failed to be fascinated by the variety of faces he saw.

I had set out to discover art thefts at commercial art galleries in New York City at the first sign of springtime in 1990. Spring always replenishes my energy and clears my winter doldrums, like the sun dispersing dark clouds following a storm. Feeling renewed, the thought of spending several months conducting a criminological inquiry for my

doctoral dissertation while visiting numerous art galleries in this great city appealed to my imagination. Simultaneously I was intimidated by feelings of insecurity and frustration. Was I setting a trap for myself? I never considered myself particularly gregarious, but the die, it would appear, had been cast, and the Lexington Avenue train would be the first leg of this incredible adventure.

Prior to contacting my subjects, I had randomly selected a group of art dealers from a population of four hundred commercial art galleries in New York City and telephoned them to ensure that they were still in business, that they were not operating a nonprofit gallery, and if they were listed in the art directory as director of the gallery, that they still functioned in that capacity.[1] It was disheartening to learn that 20 percent of the galleries I contacted were out of business and that most directors of these obsolete galleries were operating solely as private dealers and no longer running galleries. Obviously the art market had been hard hit by the recession of 1990.

I sent letters to those dealers remaining after this first contact, inviting them to participate in my art-theft survey, assuring them that I would not reveal their identities and that I would mail them a copy of the survey findings. These letters were sent in five separate mailings, which would allow me to meet with my subjects within two or three weeks of the mailing. I felt reasonably confident that the short lead time between mailing and conducting the interviews would ensure that the dealers would remember the purpose of the survey, which would enable successful interviews.

A week after the mailing, I called the galleries and solicited a personal interview with the directors. In a few cases where I was unable to speak with the director after three attempts, I requested the receptionist to ask the director whether he or she would be amenable to a personal interview.

Of course, some declined the interviews and bluntly indicated they had "no time" or "didn't want to talk about it." Some said they were "not interested," "didn't know," or "had never had any problems." On two occasions the dealers seemed nervous on learning

the purpose of my inquiry and responded, "Why me?" Both refused to meet with me. Some questioned how I got their names. Another dealer, after meeting with me and seeing who I was, declined the interview. Perhaps he was more interested in seeing who I was than he was in the interview.

The individuals I ultimately interviewed were as diverse as the galleries they directed. Of the twelve women and thirty-three men, five were European and more than one-half were gallery owners; the rest were president-managers, partners, or assistants to the manager. On the average they had been in business for nearly twenty years. Of the forty-five galleries at which the interviews were successfully conducted, twelve belonged to the Art Dealers Association of America, an advocacy and support organization of well-respected dealers. Nonmembership, I should note here, does not imply that a gallery is not qualified to be included in this organization.

At the conclusion of the survey period, I was able to use the information from forty-five dealers. Though I was well prepared with two questionnaires that I had developed and pretested with five dealers in New Jersey, the meetings were full of surprises for both interviewer and interviewee. The first questionnaire related to the dealers' opinions about art theft and the second questionnaire focused on details of incidents of art theft that had occurred at their galleries during the previous twelve-month period.[2]

Most of these dealers were so familiar with the issues raised in the survey that it took them an average of forty-five minutes to answer approximately sixty-six questions if they had not had any thefts and an hour to answer approximately ninety-five questions if they had had thefts. During these periods of time, unless the art dealers had to answer phone calls, we worked intensely. They seemed as interested in what the next questions were going to be as I was thrilled by the unexpected responses.

During the first phase of the survey period, I conducted one interview per trip to New York City. Following a New Jersey dealer's advice during a pretest interview, I began to schedule the interviews after two

o'clock in the afternoon, the time during which most dealers were in their galleries. Because a few dealers were very busy with clients in the afternoons during the second phase of the survey, I scheduled the interviews in the mornings and made it possible to complete each interview within an hour. Subsequently, I planned two interviews for each trip to New York City so that the survey could be concluded before the end of May. Galleries were not very active during the summer as dealers often take time off to travel to other cities or countries to do business.

The Art Dealers

"Beware," one precontemporary art dealer said, his hand slightly touching the sleeve of my dress. "Many art dealers don't know art. They deal in art like salesmen sell clothes."

Regardless of their knowledge of art, dealers in New York City usually belong to one of four categories: those who deal in precontemporary and contemporary art, private art dealers, print dealers, and corporate art consultants.

Precontemporary and contemporary art dealers were most common among the commercial art gallery directors I interviewed. These dealers typically sold artwork consigned to them and organized exhibitions to promote works by the artists they supported. Some galleries also exhibited untraditional forms of art like performance art and showed works in video or film. While these dealers traded a wide variety of art objects, print dealers typically carried only prints and had galleries where they displayed prints for sale and organized print exhibitions.

Unlike these two types of dealers, private dealers function mostly as middlemen. They traditionally do not have storefronts and stock-in-trade and are not obligated to make the required satisfaction guarantees of an art gallery. They buy and sell art objects for collectors who either do not have time to look for the works they wish to own or dislike the atmosphere at well-established galleries. Some private art dealers also operate small galleries and function as precontemporary

or contemporary art dealers in a limited capacity. Who, then, are the private art dealers often suspected of dealing in stolen art? Many private dealers are aristocrats, collectors, and art scholars, whose need to collect artifacts exceeds their means to buy them. These dealers find pleasure in dealing in art without the burden of managing a gallery. Because of their expertise, passion for art, and personal connections in the art world, private art dealers carried out some of the most profitable transactions in the art market. In New York, they were highly successful businesspeople who turned their attention from collecting art to trading in it. Primarily as a source of amusement, these dealers brought their shrewd business practices to the art world.[3]

Since the middle of the twentieth century, the active participation of corporations in the art market has given rise to a new breed of private art dealers—namely, corporate art consultants, who serve corporate clients. Due to the nature of their work, very few private dealers and corporate art consultants met my survey's definition of "art gallery director," a person who directs a commercial art gallery open at least five days per week during business hours. Therefore, my dealers' survey included only precontemporary and contemporary art dealers and print dealers, who are referred to as "dealers."

The Modern Art Market

My interview subjects included galleries in Soho, the East Side of Manhattan, and Fifty-Seventh Street because of their high concentration of art galleries in the 1980s. In fact, all art-dealer thefts reported to the NYPD were found in these three areas. The interviews took me to twenty-one galleries in Soho, eighteen on the East Side, and six on Fifty-Seventh Street. I should note that my research had been conducted before the Chelsea area on West Twenty-Fourth Street became a major art district.

Most of the well-established commercial galleries were located on the East Side of New York City and on Fifty-Seventh Street. With a few

exceptions, galleries on the East Side exhibited European and American precontemporary and traditional fine arts. Galleries here were also the temporary homes of the works of old and modern masters and established contemporary artists as well as the products of obscure deceased artists and some mediocre-quality traditional art objects. While the East Side galleries were for the most part located in small, old buildings, the majority of the art galleries on Fifty-Seventh Street were located in the Art Building, the Fuller Building, and other high-rises. Most of these galleries carried the works of better-established contemporary artists.

Galleries located in the Soho area dealt in all types of contemporary art—including abstract, realistic, and avant-garde art—as well as highly commercial art objects, perhaps due to the daily influx of tourists into the area. Soho had become the center of American contemporary art in the 1970s with the first gallery, Paula Cooper, opening in 1968.[4] The migration of artists seeking a lower cost of living to Soho from Greenwich Village was followed shortly thereafter by the resettlement of galleries promoting contemporary art. There were about one hundred art dealers attracting thousands of art lovers with their continually changing exhibitions.

The New York Art Galleries

Art galleries are customarily classified into two general categories: nonprofit and commercial. Nonprofit galleries exist primarily to serve the public and to help struggling artists. They include art center galleries, university galleries, corporation galleries, artist co-ops, and modest exhibition spaces at libraries, hospitals, and government buildings. Directors of nonprofit galleries are usually paid employees or, in the case of co-op galleries, artists who take turns; they are usually not professional art dealers. Unlike most commercial galleries, these galleries often have—with rare exceptions—small budgets and can afford neither art insurance nor adequate security measures. As such, thieves

rarely, if ever, approach directors to sell stolen art. Hence questions relating to insurance, security measures, and the purchase of stolen art, which are relevant to commercial galleries, are not applicable to nonprofit galleries. As a result, I interviewed only the directors of commercial art galleries.

Incorporated galleries represented the most participating establishments. A smaller number were individually owned, and a few were partnerships. Over one-fourth of my subjects operated more than one gallery, indicating that these dealers were not always present at their galleries. However, it was not unusual to find a gallery directed by a manager hired by an absentee owner.

At these galleries, the most frequent number of full-time employees was one to three people (46.7 percent). A small percentage of galleries did not have a full-time employee (11.1 percent) or employed more than twelve full-time workers (13.3 percent). This corresponds with my observation that small galleries were most common. All galleries, however, hired part-time employees to reduce operating costs. Ninety percent of the participating galleries had one or two part-time employees; many used art students who served as interns to help with the operation of the gallery.

The sizes of the galleries ranged from extra small to extra large. Seven of these galleries were extra small and covered less than five hundred square feet. Small galleries, however, were most common and typically had about five hundred square feet of floor space, whereas medium galleries and large galleries covered from five hundred to two thousand square feet. In small galleries, there was usually only one room for the showroom and the office, while in medium and large galleries, there were an office and one or more showrooms. Extra-large galleries often had more than two thousand square feet and resembled small museums. These galleries dealt in a variety of periods and types of art and were divided into departments within their operations. Such was the gallery of one Fifty-Seventh Street dealer—it was vast and had separate departments for prints, paintings, and sculptures.

To Catch an Art Thief

Gallery Thefts

Among the forty-five dealers interviewed, two-thirds described thefts at their present galleries that ranged from "serious" to "insignificant," while only one-third reported that art theft at their galleries was only a "potential" or "not a problem."

Similar to police information, data from my dealers' survey showed that shoplifting was the most common form of art theft, followed by burglary, employee theft, and "mysterious disappearance." Because it was impossible to accurately characterize the fifty cases of "mysterious disappearances" reported by one Soho dealer, who did not know whether or not all his fifty prints had disappeared at the same time and admitted that they could have been misplaced or stolen by shoplifters or his employees, I decided to list them as one single incident. Therefore I created the category "mysterious disappearance" to suit the ambiguous nature of this type of loss. I did not include it in my quantitative analysis of art theft because the works might have been misplaced and not stolen. As can be expected, the majority of the losses took place at the showroom, and the ratio of employee theft to shoplifting was estimated at around one to three. This signals the seriousness of employee theft.

So how serious was art theft at commercial art galleries? With a theft rate of 67 percent, this crime was a real cause for dealer concern. In addition, one-third of the galleries I visited had been victimized at least once. On the East Side, this figure was almost 40 percent, thus approximating Detective Keenan's earlier estimate of 50 percent.

Of these forty-five dealers, sixteen experienced a total of thirty-five thefts and 128 stolen objects, and each victimized gallery lost an average of eight works. The mean number of thefts per gallery was 2.1

In each incident, there were 3.7 missing objects on the average, but thefts of one single object were found to be most common. This type of theft occurrence may be explained by the fact that the most frequent cause of losses was shoplifting, which is similar to my finding from police reports.

I was also able to determine that the total value of gallery thefts during the year preceding my survey was $1,163,450, and the average loss of each victimized gallery was $72,716. My investigation also revealed that the median value per theft was $34,219, with $20,000 worth of art objects per incident found to be most common, and while the maximum value of loss per theft was $750,000, the minimum was only $400. This finding indicates that the value of loss per theft from my survey was much higher than the value of loss per theft from police information that I had collected, which was $20,000. It is possible that while many private art owners who reported their thefts did not have the most recent appraisals of their stolen works, dealers were aware of the present value of their stock-in-trade, which had likely increased.

During my survey period, friends in the art world often asked me which area among Soho, the East Side, and Fifty-Seventh Street was the prime target of art thieves. Apparently, these crimes occurred most often in Soho, which experienced a theft rate of 90 percent, possibly because of inadequate security measures during business hours in many Soho galleries, as supported by my observation that none of the twenty-one Soho galleries I visited used buzzers—door locks operated by a remote control device.

The significantly higher art-theft rate in Soho—in contrast with the art-theft rate of 77.8 percent in the East Side and 33.3 percent on Fifty-Seventh Street—also suggests that offenders may come back to locations they find vulnerable. But Soho's high art-theft rate compared with the other two areas of the art district does not indicate that this area is the prime target of criminals. The East Side, having the highest percentage of victimized galleries, was indeed the preferred area of art thieves. Although they took fewer items per incident from these galleries than from Soho galleries, they visited more galleries in this area. Also, galleries that deal in mostly realistic art seemed to attract more thefts than those dealing in mostly abstract art. Below is a table that summarizes my survey findings.

Commercial Art Gallery Thefts by Area (n=45)

Category	Soho	East Side	Fifty-Seventh Street	All
Galleries visited	21	18	6	45
Victimized galleries	8	7	1	16
Art-theft incidents	19	14	2	35
Mean incident per victimized gallery	2.4	2.0	2.0	2.1
Percent of victimized Galleries	38.1	38.9	16.7	31.2
Art theft rates (percent)	90.0	77.8	33.3	67.0

The Dark Figures of Crime

Of the thirty-five gallery thefts I recorded, fifteen had not been reported to the police. Likewise, none of the fifty prints recorded as "mysterious disappearances" were reported. The ratio of unreported thefts to reported thefts was one to 1.3. Results of my inquiry offered some explanations as to why the dealers did not report thefts at their galleries in more than one-third of the cases.

The majority of those interviewed feared that reporting art theft at their galleries may have led to an increase in insurance premiums or the cancellation of their insurance. To confirm their apprehension, I interviewed art insurance adjuster Michael Fischman, who agreed that the dealers' fears were not unfounded. He said, "If I know a dealer has many unreported thefts, I would not like to do insurance business with him." His reply hinted that inadequate security contributed to losses in these galleries.

The dealers were also critical of the police. Most agreed that the police could not do anything about this crime. One dealer who had experienced five thefts worried that he might lose consignments as a

result of the losses but did not report the thefts because he felt that the police would not be able to do anything about them. The dealers' negative opinions about the police, however, were not unfounded; the recovery rate had been quite low. Therefore I was not surprised to find that in all cases of nonreported thefts, the losses were under $10,000. This coincides with the NYPD's practice of ignoring property cases that had a value of less than $10,000.

Lack of proof was another reason for not reporting this crime. Victims often did not have sufficient evidence to help detectives in their investigations. One reason for this was that since stolen objects had usually been taken away without the owner's knowledge, he or she did not know when the theft had taken place and could not offer any information as to possible perpetrators. This was validated by police information that indicated suspects were known in only 15.7 percent of the cases.

Furthermore, the dealers often did not know if the loss was the result of an employee theft or a misplacement of the object—evidence of poor record keeping. They worried that wrongfully reporting an incident of employee theft may have resulted in a lawsuit being brought against them by the employee.

Others preferred not to report the theft in order to avoid confrontation with the guilty employee if they still had to depend on his or her service.

The perception that uninsured artwork does not need to be reported also surfaced during these interviews. To many dealers, a stolen work that had a value less than the amount of his or her insurance deductible was an object uncovered by insurance. Because reporting theft was time-consuming for them, most dealers saw no benefit in spending uncompensated time reporting losses not covered by insurance.

During the course of my research, I was curious about the value of the average insurance deductible that seems to affect many dealers' decisions to report art-theft incidents to the police. Unfortunately, 33 percent of the dealers failed to answer the survey question, "What is your insurance deductible?" According to Fischman, the average theft insurance deductible of art galleries in New York City was from

$1,000 to $2,500. Of those who did respond to the question, the average deductible was $2,500.

Still, a few dealers preferred a higher deductible; in this way they purchased the less expensive catastrophic insurance, for which the amount of the deductible was at least $10,000 per incident. Among the thirty-one dealers who responded to my art insurance inquiry, seven had catastrophic insurance. The insurance deductibles of those interviewed, then, ranged from $250 to $50,000.

Besides the insurance, the lack of proof, and police ineffectiveness, there was concern regarding a decrease in consignments as a result of publicity about the theft. Consignment is often a dealer's primary source of income, and news of art theft might make collectors and artists reconsider placing their artwork on consignment. That, together with the observation that art theft is relatively infrequent, caused some dealers to absorb the losses rather than report them to the police unless the value of the work was substantial.

Finally, coupled with the dealers' fear that publicity might adversely affect business, there was the possibility that publicity of thefts from victims' galleries might serve as model for other offenders who would not have otherwise committed art theft and would let other art thieves know that these galleries had "treasures" and that they were vulnerable. Publicity, then, would likely attract more thefts. At all costs dealers wanted to minimize the allure of this crime. Their precaution was justified by the fact that precinct detectives receiving instruction on art-theft investigations were advised not to disclose the identification of victims and the exact locations of losses. Though the NYPD permitted the release of such information, detectives still tried to avoid further losses.[5]

Problem or Plague?

Although the small number of victimized galleries represents only 11.25 percent of all the commercial art galleries in New York City, several generalizations can be made about the extent of art theft in those

days. However, they may only be used as a suggestion of the extent of art theft at these galleries because a sample of sixteen cases is too small to yield a good validity.

I surmise that among the existing four hundred art galleries, as many as 180 galleries experienced thefts during the one-year period of the survey, which is in stark contrast to the twenty-six galleries reported as victimized in the police information. During that period, 394 art-theft incidents also might have occurred—a number fifteen times greater than that reported in official records of dealer thefts in 1988, the year preceding the survey. If my findings were generalized to the population of art dealers (n=400), 1,440 works of art valued at $13,088,812 could have been stolen in a year, and as many as 563 objects could have disappeared or been misplaced:

Number of victimized galleries	180
Art-theft incidents	394
Quantity of stolen artwork	1,440
Value of stolen artwork	$13,088,812
Percent of unreported art thefts	42.9

Within the group *dealers*, the difference between the total number of art thefts from the survey and from the official records was 368 incidents. This large discrepancy clearly identifies that the magnitude of art theft in New York City was far underestimated, and this intensified my concerns about the loss of cultural property worldwide unless better security measures were to be taken.

A New Breed of Criminals

Art Lovers or Thieves?

*B*ack in my room in New Jersey after an exhausting day of wandering in the art districts and catching subway trains, I was ready to forget all about the interviews. While I browsed my old newspaper clippings, my eyes caught the banner headline of the *Sacramento Bee* that had appeared on Christmas morning in 1985: "Huge Heist at Mexico Museum."

I remember vividly that clear winter California morning when I read the news of this Christmas Eve theft. Within minutes my telephone rang. A friend had called to ask whether or not I had read the news of the biggest heist of pre-Columbian artifacts. The theft of this artwork, valued at millions of dollars, sent shock waves throughout the art world.

The thieves had pried off the wooden moldings at the bottom of several glass display cases in three exhibition halls, removed the panes

of glass, and stolen almost all of the museum's collection of artifacts from two major Mayan finds. These stolen objects, made by Indian cultures that had existed in Mexico from the sixth century AD until the Spanish conquest in the 1500s, were very small—even the largest items measured only ten inches in diameter. Museum officials suspected that the thieves were professionals who had connections with international traffic in stolen cultural objects and planned to try to sell the artifacts abroad. The thieves appeared to have known exactly what they were after because they had left dozens of display cases untouched and cleaned out the ones containing objects most valuable and easiest to transport. The eight police guards and the one officer assigned to the twelve-hour shift on Christmas Eve were supposed to visit each room in the museum at least once every hour. Curiously, the theft was not discovered until the day shift of guards arrived at the museum at eight o'clock on Christmas Day.[1]

Newspapers often suggested art thieves had knowledge of art and were very skillful; they belonged to a special breed of criminals who used their prowess to create sensational news and pique the imagination. Art-theft investigator Robert Volpe commented that at the hearing of an art-fraud case, the self-confidence of both the victim and the thief so impressed everyone in the courtroom that they were treated with the same respect.[2] Though this image of an art thief creating mystery satisfied the press's penchant for sensationalism, in reality, the typical art thief does not exist. There are four categories of art thieves: common thieves, professional thieves, professional art thieves, and amateur thieves.

Common thieves—opportunists who are unsophisticated in disposing of stolen objects—consist of two types. The first type is the small-time criminal who does not engage in stealing on a full-time basis. He or she makes use of, rather than creates, an opportunity to steal artwork. In fact, the majority of the shoplifters who victimize galleries can be presumed to have no knowledge of art because they seem to take the stolen objects at random. One Madison Avenue dealer

who was the victim of several shopliftings explained, "Shoplifters steal anything that the opportunity offers and then try to turn it into cash later. Furthermore, they don't need to have art knowledge to know the value of the artwork in this gallery. Everybody knows that anything displayed in Madison Avenue stores must have some value."

Besides the price stickers and price lists available at galleries, which the common thief could use as a guide to the value of art objects, shoplifters have another way to appraise the artwork: by noticing the presence of red dot stickers. During the three incidents of shoplifting at the galleries of one dealer in Soho and of another on the East Side, the thieves took only the paintings that had red dots affixed on the wall next to them. Attached to the back of sold paintings was a card with the title of the painting, the artist's name, the name and address of the buyer, and the price. For the thief, any art object that had been sold confirmed its value and made its resale more certain.

Nevertheless, the chance that an offender could shoplift a very valuable piece was unlikely. Galleries that housed "treasures" were very security conscious because the cost of a loss would be too great. One Fifty-Seventh Street dealer remarked, "In our gallery, we wire our valuable paintings to the wall or display them in a safe place where they can be guarded by employees." The kinds of artwork stolen by shoplifters who did not use a modus operandi were most likely not valuable. That the average value per incident of shoplifted items was found to be merely $9,500 supported my contention.

Like dealers who state that common thieves are responsible for the majority of the losses at galleries (31.1%), art-theft detectives also observed that art is often stolen by people who have little understanding of its value.[3] This does not necessarily imply, however, that as individuals, common thieves target only works of art, because the resale of stolen art objects, to the inexperienced, could be very difficult. Since offenders usually do not continue to steal hard-to-sell objects, after a few unsuccessful attempts to dispose of the stolen art, a common thief is likely to desist from stealing this type of property.

To Catch an Art Thief

Law-enforcement officials believe art theft is primarily a common street crime committed by shoplifters or burglars.[4] Evidence of blue-collar theft was undeniable in a 1982 case of a stolen truck carrying eighty-nine paintings and sculptures in New York. Upon their apprehension, the uninformed thieves were shocked and fearful when Detective Volpe informed them that a painting they had sold for a few hundred dollars was worth $80,000. Volpe admitted that the theft was "an exercise in innocence."[5]

Time and again the *New York Times* recounted stories of valuable stolen paintings found by the police at church garage sales or flea markets because the thieves could not dispose of them. Many art thieves are ignorant about art and, unless instructed, would steal unsalable works. Sometimes, not knowing what to do with the stolen objects and preferring to avoid trouble with the law, they send them back to their rightful owners. This occurred in 1988 when the Manet painting, *Bouquet of Peonies*, painted in the later years of his career and valued at more than $1 million, was stolen from the Heckscher Museum in Long Island while visitors at the museum were paying attention to a video program on a television monitor. The press immediately announced the theft. Four days later a man telephoned the Suffolk County Police twice to report the location of a laundry room in a Queens apartment where the Manet was hidden and to confess with some nervousness that his theft was impulsive. Apparently, he was convinced that he would not be able to dispose of the painting because the disappearance of the Manet was widely publicized.[6]

In the case of the Mexican National Museum of Anthropology theft, Mexican law enforcement admitted three years later that the thieves were neither professional nor knowledgeable of art. In fact, reliance on presumptions to the contrary had impeded the investigation. What investigators eventually learned was that the celebrated theft was the job of two Mexican college dropouts, Carlos Trevino and Ramon Garcia. The two young criminals had visited the museum more than fifty times in the six months prior to the theft and learned,

among other things, that there was no alarm system and that display cases were not locked. Knowing the precise location of the eight police guards and one officer assigned to patrol the three floors of the museum at least once every hour, they chose Christmas Eve to jump over the fence and entered the museum through an air-conditioning duct. Once inside the museum, they found the security guards drunk and sleeping, perhaps from an earlier Christmas Eve celebration.[7] They accomplished the heist without difficulty and hid their stolen antiquities in the home of Trevino's parents in Mexico City for more than one year. After the well-known artifacts had been transported to Acapulco, where a few pieces were given to a drug dealer in exchange for an amount of cocaine, Mexican investigators located the stolen antiquities and determined that the unlucky thieves were unable to fence their booty.[8]

The second type of common thieves of art and antiquities is an employee who has art knowledge though often not knowledge of sophisticated methods for stealing and disposing of stolen artwork. Detective Moscardini revealed in his 1988 case that Suzan Dorais, a former employee of the Ryan Gallery, tried to dispose of five stolen Sybil Andrews prints valued in excess of $3,000 by placing an advertisement to sell five Sybil Andrews prints in the *New York Times*. The advertisement caught Moscardini's attention because dealer Mary Ryan had reported to the police the disappearance of forty-one block prints by Sybil Andrews, altogether valued at $81,400. Acting as a collector and equipped with a recording device, he made arrangements to meet the seller in New York City to inspect the prints. When the disguised detective asked for proof of ownership, Dorais told him that she did not have a provenance for any of the prints. She had owned some of them for many years, and one of the prints was on consignment. Recognizing the prints as those previously identified as missing by the dealer, he placed the woman under arrest and informed her of her rights. Subsequently, the search of her New Jersey apartment by FBI agents uncovered Mary Ryan's missing artwork.[9]

To Catch an Art Thief

Art theft also attracts a more sophisticated category of blue-collar criminals who find stealing artifacts to order to be a lucrative business. They are willing to use violent means to accomplish the offense. On the morning of August 19, 1989, two men posing as police officers appeared at the front door of the third-floor apartment of art restorer Vlaicu Ionescu in Jackson Heights, Queens, and requested him to identify a painting inside a package. While Ionescu was concentrating on opening the wrapping, the men pushed him back into his apartment, sending him to the floor. With pistols, they whipped, handcuffed, and covered the sixty-seven-year-old man with a piece of cloth. When Ionescu heard the robbers say they had been paid $50,000 to steal his artwork, he made them a counteroffer if they would leave the paintings. But the robbers refused, saying that their families would be in danger if they did not execute the contract. With the assistance of at least two other accomplices, they carried off forty paintings estimated at $4 million down the stairs and loaded them into a waiting van. They also took the authentication documents of the most valuable painting, a sixteenth-century work by Andrea del Sarto, *Marbadori Holy Family with Saint John, Saint Elizabeth, and Saint Joseph*.[10]

Professional thieves, however, are skilled burglars or shoplifters who create opportunities to steal art to order or commit the offense if they believed it will be profitable. They also plan what to steal both from where and to whom to sell the item without getting caught. Making a career of art thievery, they enjoy the status their peers and the police give them.[11] Similar to common thieves, this type of offender does not necessarily specialize in stealing artwork. Art objects are just one of the many types of items professional thieves might steal if they think they are resalable. Unlike common thieves, however, professional thieves have connections with professional receivers of stolen goods.[12] An art thief whom criminologist John Barelli called "Randolph" said, "I don't know the difference between art and antiques, and I'm not an art expert. What I do know is that I can make money by selling paintings,

silver objects, jewelry and furniture that I steal. I also make money by selling clothes and stereo equipment that I steal."[13]

Difficulties with disposing of well-known works due to lack of art knowledge were exemplified in the famous Colnaghi Gallery theft on the East Side in New York City. Because galleries are closed on Sunday and Monday, in 1988, burglars entered this fourth-floor gallery on Monday between half past six in the morning and half past ten in the evening, when the thieves accidentally set off an alarm. They had gained entry by breaking through an unalarmed, two-by-four-foot, reinforced glass skylight. When the police arrived, they found the floors scattered with empty frames, dustcovers, and wrapping paper. The thieves had fled through a rooftop hatch. They took eighteen paintings and ten drawings, mostly small works by old Dutch and Italian masters worth from $6 to $8 million. The most valuable losses were two paintings by Fra Angelico, a fifteenth-century Italian Renaissance master. The news of the theft was televised nationwide, and the FBI immediately placed the thieves on its most-wanted list.

Detective Moscardini, who investigated this case, believed that the offenders were professional. They appeared to know the size of the area in which the artwork was kept, how much they could take, how much time they had to complete the job, and their means of escaping from the fourth-floor gallery. But the burglars could not dispose of the paintings because the works were too well-known, and they instead had to pawn some of them for $50,000.

While trying to crack the case, the police received information from the underworld that revealed the thieves had been shocked to learn from the press the morning following their burglary that the stolen paintings were worth $6 to $8 million. Fearful for their arrests, they immediately fled the country.[14]

In another case, a thief drew attention to himself when he asked far too high a price for his booty. He was ignorant of the value of the object and perhaps misled by the high prices of artwork often reported in the news media. In August 1990, a nineteenth-century pre-Columbian

Mayan cylinder vase from Tikal, Guatemala, a were-jaguar ax from Veracruz, Gulf Coast (ca. 1100–800 BC), and a jaguar pelt were stolen from the Mingei International Museum of World Folk Art in La Jolla, California. The Mayan cylinder belonged to the Museo Nacional de Arqueología, Guatemala, and had been lent to the Albuquerque Museum in 1985 as part of the "Maya, Treasures of an Ancient Civilization" exhibition. A flyer containing the theft information was circulated to Pre-Columbian dealers and collectors in time for their meeting at the November Tribal Art Show in Santa Monica. A dealer noticed that a man who had approached him there and asked for his business card showed up at his gallery in San Diego two months later. "I have two antique vases for sale," he told the dealer while opening a box.

The dealer looked at the wares. They were the cylinder vase and the were-jaguar ax he had seen in the museum's flyer. "How much do you want for the cylinder vase?" the dealer asked.

"One million dollars," said the seller.

Knowing the value of the vase was $35,000, the dealer became suspicious and attempted to ensure the return of the stolen item. "I am not interested myself," he said, "but I think I know a collector who may be interested in buying these vases. If you want, I can set up a meeting for you."

A few days later, the sting was set up at an airport hotel. While the thief tried to sell his wares to an FBI agent posing as a collector, FBI Special Agent Virginia Malloy, three California law-enforcement officers, and Martha Longenecker, director of La Jolla Museum, listened to their transaction in an adjacent room. The seller, Dale Cletcher, was arrested and charged with receiving stolen property worth in excess of $100,000. Police information revealed that Cletcher was a professional thief with two aliases and a record of theft convictions.[15]

Oftentimes professional thieves are highly motivated and known for their professional ingenuity and tenacity. No doubt examples of this type of thief often make headlines in the news. William Porter, who burglarized artist Andrew Wyeth's well-protected office in 1983

and absconded with paintings valued at $750,000, was the owner of a burglar-alarm business in Jonesboro, Tennessee.[16] Similarly, in one complaint report filed with the Art and Antique Investigation Unit in 1986, a number of works of art were stolen at a private residence in New York City and replaced with fakes. The owner, an elderly man with poor eyesight and declining health, cared for by a valet and a housekeeper, was unaware of the art theft until his son came to visit him. Similarly, in 1991, after the death of the former wife of New York City art dealer George Staempfli, the heirs of the invalid woman reported to the police that a Picasso and a Magritte were missing and had been replaced with fakes. The original Picasso had been painted on brown paper, but the replacement was an oil-on-canvas copy; the faked Magritte picture, though cleverly imitated, could not pass for the original.[17]

During my quest for art-theft information, I discovered that burglars who had knowledge of art could cause substantial losses to galleries because of the wider range of opportunities they had upon gaining entry. As a New Jersey dealer put it, "He can steal from the storeroom." Once in there, he might make off with only salable works.

Fortunately this type of art burglar was not common. Of the seven incidents of burglaries that had occurred at the galleries I visited, only one incident seemed to indicate that the thief had knowledge of art. The victimized dealer, who specialized in precontemporary art, said the offender selected seventy-five small prints and drawings and a small bronze sculpture, all by known artists and valued at $750,000. The stolen works could easily reenter the market because their loss was not significant enough to draw attention. They were, however, valuable enough to attract collectors.

On the other hand, professional art thieves are those who specialize in stealing artifacts, though they might occasionally take a nonart object. They possess art knowledge, are skillful shoplifters or burglars, and knew fences who will dispose of the stolen objects. Making a career of art thievery, they develop connections with certain dealers

who buy stolen art objects or commission the thefts and choose to steal only marketable works.[18]

Police suspected that professional art thieves steal artwork more often than other types of offenders because they have knowledge of art and sophisticated methods of disposing of the stolen objects. The art dealers I interviewed also believed that professional art thieves were responsible for the highest percentage of losses at their galleries (38.2 percent). The profile of an art thief at the Art and Antique Investigation Unit described the typical professional art thief as a male Caucasian approximately forty to forty-five years old, possibly multilingual, and financially secure. He had the expertise to choose and be selective about what he stole and was able to reintroduce the stolen art objects into the market without causing any noticeable disturbance.[19] Incidentally, a dealer specializing in realistic art described one such thief as a man of forty-five who had exquisite taste in art and stayed at a first-class hotel in town.

Another Barelli's interviewee whom he referred to as "Adam" seems to fit the police profile of a professional art thief very well. A gentleman in his midforties, he belonged to an upper-class English family, was educated at the finest schools in England, and spoke three foreign languages. Adam used the books read by art connoisseurs, such as *The Economics of Tastes* and *Country Life*, to research and obtain prices and locations of art objects to steal. Not interested in museums, as he reasoned that the artwork was well documented and thus difficult to sell, he chose instead country houses both in England and France as his targets. He believed that thefts at these places would go undetected.[20]

Once in a while, certain thieves might steal art objects simply because they like art. They are museum or gallery visitors who happen to be "possessed" by certain pieces and steal them impulsively. These individuals, it seems, generally keep the stolen items for their own enjoyment or give them to their acquaintances. In some cases the guilty party might even return the item to the gallery. Such was the

story of an art student who went to an exhibition of Homer's works and profoundly admired a watercolor. He could not resist taking it off the wall, concealed it under his coat, and carried it away. Ten years later he became a distinguished member of the community, had his works exhibited, and grew very uncomfortable with the presence of stolen artwork in his home. Fearing he might be questioned by the police, he arranged to return the painting to the museum through a friend[21]

The Hard-Core Criminal

The notion that art theft was an unsophisticated crime was no longer maintained. A Scotland Yard official maintained that the police were fighting a new phenomenon—the cultivated art thief and a highly organized group of criminals with art knowledge.[22] As early as in the 1980s, officials of the International Police Organization (Interpol) declared that there was evidence of many small networks and gangs of professionals using stolen art as collateral or a bankroll for the drug market.[23] Confirming Interpol's statement, New York City detectives Alex Sabo and Joseph Keenan remarked that major narcotic dealers bought art for their personal pleasure and to launder their dirty money.[24] In "The Case of the Missing Rembrandt," the precious eight-by-nine-inch painting *The Rabbi* is in the possession of a French narcotics trafficker, Jacques Faidit, who keeps it underground in an airtight Tupperware container in the hope of using it as collateral to acquire a considerable amount of narcotics. During its eight-year odyssey with underworld figures in Paris, it had seen Amsterdam, Frankfurt, Vancouver, Buffalo, Washington, DC, and the involvement of the police forces of several nations.[25]

Organized crime had also left its marks in the international traffic of stolen paintings. In 1988, Lorenzo Zorza, an Italian priest suspected by those who knew him to be highly connected with an Italian-American criminal organization, was arrested for his alleged involvement in the Mafia's plan to launder drug money through a Titian masterpiece, *The Martyrdom of Saint Peter*, reportedly destroyed by a fire in 1867. He was

arrested near Bologna at the home of Adria Santunione, an Italian art restorer whom he and his associates had sought out for advice on the authenticity and state of preservation of the Titian. Law-enforcement officials were able to identify some of the men involved as Mafia figures wanted by the Italian police and the FBI. Reportedly, the Titian was in the hands of the Mafia in Zurich.[26] The involvement of the Mafia became undeniable when Felice Maniero, a Mafia boss from northern Italy, confessed to the police that he had participated in the thefts of *Madonna and Child*, a fifteenth-century painting adorning the Ducal Palace in Venice, and several paintings from the Galleria Estense in Modena with the purpose of using the artwork to blackmail police and judges. The safe return of the reliquary of Saint Anthony, taken from the Cathedral of Padua during a notorious 1991 armed robbery that he had masterminded, was also used in his bargain for a reduced sentence.[27]

Since its disappearance from the Church of San Loranzo in Palermo in 1969, Caravaggio's masterpiece *Nativity with Saint Francis and Saint Lawrence* has been the most-wanted stolen artwork in Italy. The painting was created before the artist's death in 1610. Its value was $40 million. In 1974 a mysterious telephone caller unsuccessfully demanded ransom money for its return. The painting was believed to be stored in a vault in the well-guarded home of a Mafia boss.[28]

The Criminal Elite

Outside the realm of petty theft and organized crime existed evidence that art theft was a white-collar crime. Several cases involving scholars who used their professional knowledge and status to gain privileged access to museums and libraries to steal artifacts were reported to the police. In 1995, an Ohio dealer in medieval manuscripts, Bruce Ferrini, asked US Customs to seize two stolen leaves of a manuscript that belonged to the Vatican Library. From the Vatican came the identification of the would-be seller, Professor Anthony Melnikas, one of the scholars who had examined the manuscript. Melnikas was a specialist

in medieval manuscripts, and his three illustrated volumes on the subject of the compendium of canon law were published by the Vatican in 1975. He had conducted research in the Vatican Library for decades, and as a trusted colleague, he was given privileged access that most researchers did not have. Customs agents subsequently questioned Melnikas and recovered a third leaf from him. Interviewed by the *New York Times*, Melnikas said there was an explanation for his actions but did not expand on this. However, Special Agent Mark Beauchamp discovered that the Vatican manuscript pages were not the only items Melnikas illegally possessed. A search of his home uncovered a number of manuscript pages taken in 1965 from cathedral libraries in the Spanish cities of Toledo and Tortosa. In August 1996, he pleaded guilty in federal court in Ohio to all charges brought against him.[29]

Another case in point reveals a grim picture of some members of the clergy. In 1996, Michael Dongarra, a former Anglican priest in Arizona, renounced the ministry of the Anglican Church after being notified by the Federation of Anglican Churches that he would be restrained from the ministry of his church due to his part in an alleged fraud scheme in art and real estate.

After reporting a burglary to the Oro Valley Police Department in September 1994, Dongarra reported a similar incident on Christmas Day, 1995, at his new residence located within the town limits of Oro Valley, a fact that he might not have known. In a town of 20,000 residents with a burglary rate of one per month, Dongarra's two theft reports within a fifteen-month period naturally led to police suspicion. Detective Buddy Novak, who was assigned to the case, contacted insurance agencies. Officials from State Farm Fire and Casualty Insurance Company confirmed that they had paid both claims, and the Church's Mutual Insurance Company also admitted that it was the insurer of the missing early Renaissance panels, *Saint John the Baptist and Saint Anthony Abbot*, that once belonged to the famous Contini Bonacossi collection in Florence. The paintings were given to Saint Philip's in the Hills as part of the Kress gift collection. In February 1994, they were

discovered missing. Detective Novak was not able to determine the true owner of the two panels until he received a telephone call from Jean Cox, director of the Fine Arts Center of the church. Ms. Cox had learned from a television newscast that an Oro Valley man had been arrested for stealing religious artifacts from California. Suspecting that Dongarra might have had something to do with the missing panels, she went with the police to Dongarra's rented house, where they found not only the stolen panels but also a number of religious paintings, textiles, and candlesticks. Among the catches in Dongarra's home was a nineteenth-century Gothic Revival German altar stolen four years before from the Sisters of Mercy Convent in Burlingame, California, possibly during the time Dongarra was living near San Francisco. Religious objects from Saint Elizabeth's Church in San Jose and Saint Patrick's Seminary in Menlo Park were also found. In April 1996, a Pima County grand jury indicted Dongarra on two counts of fraud and three counts of theft by control, which received the same penalties as theft.[30]

Oftentimes the real smugglers—those who carried the artifacts across borders—included white-collar criminals, diplomats, and journalists as well as art lovers.[31] Substantial losses of paintings by old masters and antiquities through diplomatic pouches and official channels generally immune from customs searches frequently occurred. In Manhattan, on March 1, 1982, the police served arrest warrants to four upper-class men for their illegal transportation of stolen paintings. The four individuals were Reverend Lorenzo Zorza, a forty-two-year-old Roman Catholic priest who was a member of the staff of the Permanent Observer of the Holy See to the United Nations; Giodano Garuti, an art restorer from Cremona, Italy; and Achilles Renzullo and Vincent Del Peschio, the latter an Italian instructor at Baruch College and business partner with Renzullo at Ital Craft Inc., a furniture-importing company. One of these paintings was an Italian Renaissance work, *Saint John the Baptist as a Young Man,* by the school of Andrea del Sarto, valued at $80,000. A confidential informant reported that Renzullo had offered to sell him two stolen Italian Renaissance paintings for $66,000 and that

A New Breed of Criminals

Father Zorza had smuggled the paintings into the United States. Zorza was quoted by the informant as having said he had used his official status as a member of the staff of the Permanent Vatican's Observer of the Holy See to the United Nations to smuggle stolen goods into the United States in the past. His fee was $8,000 to bring the painting into this country. The charge of illegally transporting stolen property carried a maximum sentence of ten years in prison.[32]

Law-enforcement officials also accused certain members of the art market of being fences for stolen artwork. They suspected that thefts were facilitated by unscrupulous appraisers, auctioneers, and dealers who knew the art market very well.[33] Joining this group were official valuers, art and antique dealers, some archaeologists, and museum curators who had been suspected of or found acting as receivers of stolen artwork.[34] In 1981, Sherman Lee, the well-known art historian and former director of the Cleveland Museum, knowingly purchased Poussin's *Holy Family on the Step*, which was illegally exported from France. A French judge issued an international warrant for his arrest. Though an international arrest warrant issued in France had no legal status in the United States, Lee might run the risk of arrest if he traveled abroad.[35] Likewise, in *King of the Confessors*, Thomas Hoving, former director of the Metropolitan Museum, recounted his thrilling experience of smuggling a stolen ivory cross for the museum in the 1960s while he was an assistant curator at the Cloisters, a branch of the Metropolitan Museum of Art for medieval art located on a hilltop in New York City overlooking the Hudson River.[36] Yet this practice was not out of the ordinary among American museums until modern times. Museum administrators, fearing a loss of donations, a decline in museum visitors, and a consequent reduction in federal and state funding, would rather avoid negative publicity than damage the reputation of the institution.

Art theft as an occupational crime was also reflected in the trade in smuggled antiquities worth $3 billion a year facilitated by corrupt customs officials and in the number of people involved in this crime,

particularly in Central America. In Colombia, an estimated sixty thousand grave robbers earned illegal income by digging up antiquities and selling them to dealers and collectors who smuggled them out of the country, mostly to the United States. In Italy, especially Sicily and Emilia-Romagna, the activities of the clandestini who looted tombs have been known, not so much as crimes but as a local industry or way of life. In the 1960s, between eighty thousand and one hundred thousand Italian tombs were destroyed at one antiquity site alone. In Sicily, pilfering priceless relics so threatened the preservation of artistic patrimony that the superintendent of antiquities in the Selinunte area, hoping to stop illegal digs, offered tomb robbers regular employment as excavators on official excavations.[37]

The most serious of thefts in the United States, however, appeared to be those committed by museum employees. According to a security director of a large eastern museum, employee thefts, which were responsible for most of the losses and disappearances from storage areas, particularly in print departments, were not unheard of in museums in New York, Washington, DC, and Baltimore, to name a few places.[38] Like art gallery employees, museum employees were familiar with the record-keeping practices of their museums and were more likely to know members of the art market to dispose of the stolen artifacts. In 1989, the new director of the Museum of Cartoon Art in Rye Brook, New York, discovered that twenty-nine of the museum's best Dick Tracy comic strips drawn by Chester Gould and valued at $250,000 had been removed from a room inaccessible to the public. During the course of a police investigation, the curator, Sherman Krisher, appeared to be very nervous and confessed that he had committed the crime over a one-year period.[39]

But the most serious case of white-collar crime was discovered in the illicit activities committed by the former art acquisitions director of Brigham Young University Wesley Burnside. His dubious conduct had gone unnoticed over a fifteen-year period until it was unveiled in 1987, when the Utah County Attorney's Office filed charges against him.

A New Breed of Criminals

The university had an extensive collection of American artists as well as the Art Acquisitions and Display Committee to authorize acquisitions and disposing of artwork. From 1960 to 1985, the committee assigned Burnside the responsibility for in-house appraisals of the collection and often relied on him for assessment of the historical and aesthetic value of potential acquisitions and to make decisions to dispose of undesirable pieces.

Toward the end of 1985, the university placed the administration of the art collection under the dean of the college, James A. Mason. An inventory of the collection was undertaken after the new collection manager received inquiries from a number of people about works they had previously donated to the university but which could not be located. The inventory identified 250 missing works of art and many objects that were not acquired by the committee.

Police investigation revealed that Burnside used his position, professional knowledge, and connections in the art world to commit the crimes. He often entered into deals using the university's art collection without knowledge or approval of the committee. He also frequently set the values on pieces slated for donation, trade, or sale by outside agents far below market values. He then obtained or provided appraisals that greatly exceeded actual market value even though some of the works were known by Burnside and the outside agents to be unauthenticated ones. He was accused of receiving commissions or other benefits for his role in the sale of artwork to prospective university donors and outside agents.

Museum searches found many of the collection records were missing, and Burnside was further found to be involved in questionable dealings. For instance, during the inventory period, a California dentist requested the return of a donated artwork he claimed on loan. When confronted with the record of the artwork donation, the dentist and Burnside demanded a compensation for a Bierstadt painting they said the university had lost. The local police department was requested to investigate the case and found that Burnside had consigned an

art gallery in New York to sell the Bierstadt and that the dentist had received payment from the sale.[40]

Employee theft was also a problem at the galleries I visited. Although numerous measures were taken to curb pilfering, "the problem [was] the president stealing from the corporation," the president of a large gallery pointed out to me. In a rare 1986 employee theft case, the chairman of Con-Ker Fine Art, Dr. Ron Parker, informed Detective Moscardini that twenty-two works of art, including a bronze sculpture by Renoir, all valued at $120,000, were identified as missing and presumably stolen from the gallery. On the following day, Jill Greenberg, the office manager of the gallery, visited the apartment of the president of the gallery, Trisha Conroy, and saw some of the missing pieces there. She informed Detective Moscardini, who immediately obtained a search warrant from the New York State Criminal Court. Armed with the warrant, he went to Conroy's apartment, where he identified the stolen artifacts and placed her under arrest.[41]

To obtain data on this type of white-collar offender, I examined all art-theft cases from IFAR reports between 1987 and 1993 and found that there were twenty-three cases involving twenty-five members of the art market. My research disclosed that 56 percent of these cases involved thefts. Twenty percent fell within the category of the purchase of stolen artwork, another 20 percent involved possession of stolen artwork, and 4 percent belonged to the category of breach of fiduciary duty. In almost one-third of the cases, the crimes lasted over a long period of time—from six to twenty-five years. These facts suggest that detecting occupational crime is difficult.

The majority of these white-collar offenders were art dealers. In order of frequency, they were museum directors or curators; professional people in the security business—including one museum security director, one security personnel, and one alarm salesman; and other individuals associated with works of art. These included one secondhand dealer, one diamond appraiser, one art historian, one church organist, and one librarian. These offenders' places of business varied

from art galleries and museums to similar facilities—namely one auction gallery, one secondhand outlet, one security firm, one university, and one church.

Antiques were the favorable targets of white-collar crime perhaps because it was easier to sell antiques than fine arts. Usually antiques were usable pieces like jewelries and household items, whereas fine arts consisted mostly of paintings, drawings, prints, and sculptures. Of the twenty-three cases, 60 percent involved the loss of antiques and 40 percent fine arts.

In addition, the number of art objects stolen ranged from a single piece to a collection, totaling 595 pieces and three collections. The largest number of pieces stolen by one single offender was 127. The value per incident was from $25,000 to $18 million, totaling $39,575,000, excluding five cases without reported values. In most cases the losses at the museums were discovered following the appointment of a new director who subsequently made an inventory of the museum's holdings.[42]

Portrait of an Art Thief

The Mysterious Criminal

"*I* was knowledgeable in the area of art and saw where I could make a profitable living at it," art thief "Adam" told Criminologist John Barelli. "On an average I would say over the last twenty years, I have averaged approximately £50,000."[1]

Adam's explanation of his criminal activities reinforced the assumption that avarice and the notion that large sums of money could be made from the sale of valued art outranked most other possible reasons for thefts. I found this in the case of Dr. Xavier Richier, who, during the early 1960s, organized many burglaries to steal antiques and ecclesiastical objects from country homes and churches in France. Though he had a fascination with art objects and kept the most valuable pieces for himself, his selling off 70 percent of his booty suggested the strongest motive for the greater number of thieves—sheer unadulterated greed.[2]

To Catch an Art Thief

Assuming that the increase in art prices might affect the rate of art theft, 68 percent of interviewed dealers feared that the publicity of record-breaking art prices would result in increased crime. Furthermore, it was easy to learn about art prices: a naïve art thief needed to only visit the Soho or East Side areas to know the value of artwork. In New York City, dealers were required by law to place either a price list at the front counter or a price sticker next to each work. Although the majority of the dealers still used price lists, an increasing number preferred the efficiency of pricing each item with a sticker because they did not have the time to answer customers' queries about the prices of individual art objects.

Not surprisingly, the majority of dealers believed that price stickers had facilitated the commission of theft at these galleries to a certain extent. The assumption was that price stickers might have suggested the idea of stealing because they confirmed the value of the objects. In addition, thieves could look at the price stickers to decide what to steal if they did not know the value of certain artwork. A Soho dealer said to me, "I knew you were not a thief because I had observed from my second-floor monitor that you did not pay any attention to our price stickers although no employee was present in the gallery."

Several interviewed dealers, who used price lists, admitted that they did not keep the lists in an accessible place because they feared that a price list might inform the ignorant thief of the monetary value of the works and thereby encourage a theft. This view, however, was not accepted by all interviewees. One Madison Avenue dealer firmly declared, "No, shoplifters will steal anything! They don't have the time to make selections because opportunity dictates when and what to steal." In addition, there were connoisseur thieves who were knowledgeable of the value of the pieces prior to the thefts and those who chose items to steal on the basis of personal taste rather than price.[3]

Therefore, money was not always the motive to steal artwork; there were thieves who stole them simply because they loved art. What had happened in Soho in 1984 clearly supported my view. Ten paintings

and sculptures, all valued at about $200,000, disappeared during business hours from nine galleries within two months. Who did it? Responding to their complaints, Detective Moscardini took surveillance of their galleries. He solved the case one month later when, dressed in civilian clothes, he grabbed a man walking out of the Paula Cooper Gallery with a $30,000 Joel Shapiro sculpture under his arm. The thief, thirty-one-year-old Louis Hillen, was a commercial artist and painter from New Jersey. Without the slightest resistance, he turned over the sculpture to Moscardini and took the police to his studio apartment where stolen artwork valued at about $200,000 were found mounted on pedestals or hung from the ceiling as if placed in an art show.[4] Interviewed by the *New York Times*, Hillen explained that he stole the works because he enjoyed being surrounded by artifacts in his home.[5]

In fact, dealers who dealt in abstract art tended to believe strongly that the motivation to steal artwork came from the love of art. As one abstract art dealer explained, "Since we have a hard time selling artwork, I don't know how anyone can steal them for a living."

What made art theft so unique, however, was that some thieves seemed to have a psychological need to collect artwork. A very unusual case of rare book theft was unveiled in 1990 in Ottumwa, Iowa, when Stephen Blumberg was charged with receiving and transporting stolen property across state lines. For years he was able to avoid police investigation of his removal of numerous rare books from libraries throughout the country.

The son of a well-to-do family in Saint Paul, Minnesota, this forty-one-year-old man had a history of mental illness and was first arrested in 1967 for breaking and entering and carrying a concealed weapon. But his reputation as a book thief started in 1974 when he was convicted of possessing fifty-two library books stolen from several midwestern universities. In the 1980s, he traveled on the West Coast with an identification card of a University of Minnesota psychology professor, Dr. Matt McGue, whose identity he assumed. With a driver's license in McGue's

name, he was able to gain access to many West Coast libraries and was suspected of stealing rare books from many collections.

In 1988, school officials at the libraries at Washington State University at Pullman and Claremont College in California discovered heavy losses of rare books. Though Blumberg was subsequently arrested in April 1988 because he had been found illegally entering a restricted archive of the University of California at Riverside Library and in possession of evidence linking him with the two earlier thefts at the library, he was released for lack of evidence. The police, however, did not give up.

In March 1990, with damaging evidence provided by a confidential informant, the FBI was able to obtain a search warrant for Blumberg's home in Ottumwa. There the agents discovered shelves lining the walls of the entire house holding around twenty-one thousand rare books and ten thousand valuable documents. They also found stained glass windows, paintings, prints, and antique furniture, all suspected to be stolen items. Among the loot was an eighth-century book of music, a Bible published in 1480, and three shelves of priceless incunabula from 1450 to 1500. Some single volumes were estimated at $70,000 to $90,000. It took two trucks to transport the confiscated stolen property—valued at $40 million and weighing nineteen tons—to a storage area. Subsequent seizures of stolen property from his residences in Minneapolis included over three hundred stained glass windows, two hundred pieces of silverware, gold bars and foreign gold coins, fireplace mantels, clocks, watches, and other antiques.

However, Blumberg's motive puzzled the detective investigating this case because he also owned an antique shop in Amarillo, Texas. They discovered that he had hired thieves to steal some of the art and antique objects found in his residences. But his method of removing books from the libraries remained a mystery. Following the seizure of the books, a group of forty volunteer librarians and four staff members of the Online Computer Library Center came to assist the police in the process of returning the stolen books to their rightful libraries. They

found these books had been taken from over 140 libraries throughout the United States and parts of Europe.[6]

In probably one of the most interesting cases of the psychological need to collect, Professor John Feller, a fifty-one-year-old historian and expert in Chinese export porcelain, pleaded guilty in 1991 to having stolen eight objects valued at $133,000. During the investigation that led to his convictions, the police revealed that since 1972, he had removed more than eighty pieces of porcelain artifacts, concentrating on Chinese export porcelain collected by US presidents, from at least eight northeastern museums, including the Philadelphia Museum of Art, the Wadsworth Athenaeum, and Boston's Museum of Fine Arts. He had gained access to the artifacts while conducting research at these institutions. Police had not investigated his criminal activities until he reported to the registrar at the Winterthur Museum, in January 1991, the loss of a Chinese serving platter valued at $25,000 and once belonging to George Washington and then to Robert E. Lee. He had removed this platter, which measured seven and a half by ten inches, to study and hidden it beneath a manila folder placed on a table where he was working. Before leaving the museum, he slipped the carefully wrapped porcelain into the back drawer of a sideboard in the adjacent room, the DuPont Dining Room. Two days later he reported to the registrar that when he went to the display case where the platter was kept, it was missing. Subsequent searches located the platter. Detective Sergeant Anthony Davolos, a Delaware State police officer assigned to investigate the case, explained, "Because Feller was the last to sign out the platter and had reported it missing, we focused on him in our investigation. It is our contention that Feller was the one who hid the platter in order to retrieve it."[7]

At first Feller denied trying to steal the platter. Then he gave up and confessed his crime. A subsequent search of his Pennsylvania apartment by FBI agents uncovered over one hundred museum pieces stolen over eighteen years from the storage rooms, basements, and study rooms of eight museums in the United States and England. Particularly

of interest to officials of the Winterthur Museum was the discovery of two Chinese export porcelain dinner plates from President James Monroe's collection valued at $11,000 each that had been reported missing. Feller allegedly smuggled them out of the museum among papers in his briefcase. He was also in possession of rare founders' records from the Dorflinger Glass Company, holdings of the Corning Museum of Glass.

This art-theft investigation that would have otherwise been routine—though significant—stunned the art community as well as the police. They were amazed to discover that the well-known art connoisseur and professor in the History and Political Science Department at Scranton University frequently donated his stolen porcelains to the Peabody Museum where he was an honorary curator. While conducting his ceramic research, often in the basements or storage rooms of his host museums, he had built a study collection of late eighteenth- and nineteenth-century Chinese export porcelains, which he gradually transferred to the Peabody as his circumstances permitted. For example, after discovering a cache of thirty thousand pieces of antique porcelain covered with dust in the basement of the Wadsworth Athenaeum in Connecticut, he selected eighteen pieces, hid some in his camera bag and others under his shirt, and walked out of the museum undetected. The loot was subsequently given to the Peabody Museum, which specializes in objects from the China trade. His generosity seemed to pay off. He was appointed to the Peabody's board of trustees in 1990. It was obvious that he was gratified by his elite membership in the museum world. In addition, he was very proud of his "collection" and often invited noted members of the art community to view it in his modest apartment in Scranton, where he would boast of his publications and his important positions. During his years of pilfering, Feller made a profit only once. He sold a Chinese export saucer that bears the Great Seal of the United States to the State Department for $4,500. He had stolen this piece from the Rhode Island School of Design Museum.

Portrait of an Art Thief

In an article published in the *International Foundation for Art Research Journal,* Feller was dubbed the Robin Hood of the arts because he stole from one museum where the pieces were neglected and lent and donated them to another that appreciated having them. Strange as it may seem, some members of the art community supported this. For example, an eighteenth-century porcelain plate illustrated with a scene of Christ's baptism that Feller had donated to the Peabody Museum was found to have identical descriptions as a plate that had been reported missing from the Philadelphia Museum of Art in the late 1970s. Kathryn Hiesinger, then curator of decorative arts after 1700 at the Philadelphia Museum, commented, "He might have wanted the plate to be on public view at a museum where there was no other comparable work. Ours was in storage."[8]

James L. West, the United States attorney for the Middle District of Pennsylvania, argued that Feller stole and gave artwork to "advance his career and standing in the academic and art community." However, Dr. Pereira-Organ, a professor of psychiatry at Thomas Jefferson University Medical College in Philadelphia, diagnosed him as someone who suffered from a serious lack of interpersonal relationships and had stolen "the surrogated objects to love, to admire, and take care of."[9]

Was Feller a true Robin Hood? He confessed in his article "Confessions of a Porcelain Bandit" that once or twice he got greedy and stole objects that had nothing to do with his research, such as a pair of green chandeliers with hanging prisms that he found particularly attractive, and kept them in his apartment. Because the statute of limitations had expired for most of his thefts, Feller was sentenced to only eighteen months in prison. He had hoped to receive twelve months due to his cooperation with the FBI to identify the stolen objects and return them to their rightful owners.[10]

Motivation for art theft ranges from greed at one extreme to altruism at the other. In 1982, Mexican lawyer-journalist Jose Castaneda stole a seventeenth-century Aztec manuscript from the Bibliothèque Nationale in Paris. Two months later, when arrested by Mexican

authorities in Cancun, he explained that he was simply reclaiming a vital piece of his country's heritage and was acclaimed by the Mexican press as a national hero.[11]

In another unusual case in 1971, a Vermeer was stolen from Brussels's Palais des Beaux-Arts, and the thief demanded $4 million ransom payable to a relief organization for East Pakistan refugees.[12] Yet another thief in Tokyo stole a Renoir from a private collector's home and left instructions ordering the owner to donate the painting to a museum as condition for its return.[13]

Stealing artwork for political gain was also the motive in several cases reported in Europe. In France, a political group, the Direct Action, held stolen art to bargain for either money or the freedom of terrorists.[14]

But the most intriguing personality in the history of art theft was Dr. Rose Dugdale, heiress of British insurance tycoon James Dugdale. After earning a doctorate degree in economics, the Oxford-educated heiress worked tirelessly as a social worker and spent more than $40,000 from her own trust and stocks to help the poor of northeast London's Tottenham district. She once said that for years her family had been taking money from the poor; in helping them now, she was trying to restore the balance.

During that period of association with the working class, Dugdale became involved with the Irish terrorists' cause. In 1973, she was convicted of stealing $200,000 worth of paintings and silverware from the country home of her parents to raise funds for the IRA and was given a two-year suspended sentence, while her IRA sympathizer and accomplice, Walter Heaton, received a four-year prison term. At her trial, she publicly told her father that she loved him but hated everything he stood for.

Barely a year later, Dugdale led three gunmen to the Dublin mansion of Sir Alfred Beit, a diamond millionaire and former Tory member of Parliament. They found him and his wife in the library listening to records and tied them up along with their servants. The robbers slit from their frames a Vermeer, *Woman Writing a Letter*; a Frans Hals,

Portrait of an Art Thief

Portrait of a Cavalier; a Goya, *Woman in a Mantilla*; and sixteen other valuable paintings, all valued at $20 million. The raid took only seven minutes, and the gang drove off into the night after also taking checkbooks and papers, including certificates for the paintings. It was the biggest art robbery at the time. Within twenty minutes a national manhunt had begun for the robbers.

A week after the heist, the director of the National Gallery of Ireland received a ransom letter the police believed Dugdale had helped write. The letter offered the paintings to the British authorities in exchange for $1,250,000 and the transfer of four IRA prisoners to Northern Ireland. Her scheme failed, and she was again convicted and sentenced to nine years in prison.[15]

My research led me to believe that thieves' motivation to steal artwork was strengthened by the weakness of the criminal-justice system. In addition to the low clearance rate, art-theft sentences tended to be light.[16] The courts had displayed considerable leniency in art-theft cases, with few art thieves ever convicted of grand larceny because plea bargaining was widely used in exchange for the thief's cooperation in the retrieval of the stolen artifacts. This practice was clearly demonstrated in the 1989 case of Curator Sherman Krisher, who stole the Dick Tracy comic strips from the Museum of Cartoon Art in Rye Brook, New York. Though his theft could have resulted in his serving seven years in prison and paying the museum up to $200,000, he was ordered to complete five hundred hours of community service and pay $45,000 restitution. His cooperation with the police in a sting operation to recover forty-four comic strips offered for sale clandestinely by a Cincinnati art dealer was an important factor offsetting the seriousness of his crime.[17]

In Moscardini's twelve completed investigative cases leading to arrests and recoveries, the offenders were convicted only of possession of stolen property, a relatively minor crime. Unlike common thieves, who, for lack of money, typically use the services of public defenders often overloaded with criminal cases, "many art theft offenders," said Moscardini, "hire defense lawyers," thereby making convictions less certain. As a result, in

cases where the theft involves an important collection and many pieces are no longer in the possession of the thief, the art-theft detective sometimes finds it better to persuade the hard-to-convict suspect to retrieve the stolen art in exchange for a prosecution deal.

Coupled with the uncertainty of incarcerating an art thief was the detective's concern that most artwork was easily damaged and that the longer it was in the hands of the criminal, the less likely it would be recovered in the original condition. Five years after the 1985 Marmottan Museum robbery, French police found Monet's *Field of Tulips* partially ripped and Berthe Morisot's *Young Girl at the Ball* with two holes in it.[18] But the thief's destruction of two Grandma Moses paintings, stolen from the Bennington Museum in Vermont in 1996, epitomized the detective's worst fear. Barely two weeks after the heist, the FBI found the stolen paintings *December* and *Brown Church* crumbled to pieces inside a plastic bag. It was obvious that the thief, James Campanella, had tried to destroy the evidence.[19]

The seriousness of art-theft sentences often depends on each defendant's previous criminal record and the nature of other crimes that accompanied the theft. As a case in point, Israel Glassman was sentenced in 1983 to twelve years in prison for his part in an unsuccessful attempt to steal ten Impressionist paintings valued at $25 million from a Connecticut museum and held them for a $2.5 million ransom. Apparently the hapless thief had recruited an undercover FBI agent posing as a professional art thief to participate in the conspiracy.[20] A year later, Antonio Anfossi received a prison term of ten to twenty years for his robbery in which artwork valued at $3.7 million was taken.[21]

By contrast, leniency seems to be bestowed on nonviolent offenders. In the Brigham Young University theft, though the losses were significant, the Utah County Attorney's Office filed a misdemeanor charge of unlawful dealing with property by a fiduciary against Burnside and required his cooperation with the police in the recovery of the missing artwork.[22] Similarly, in a notorious 1993 case involving the former director of the Southwest Museum in Los Angeles, Patrick Houlihan

was found guilty of five counts of embezzlement and two counts of grand theft from the museum's collection of American Indian art and artifacts. During his six-year employment at the museum, he stole at least 127 art objects valued at $3.5 million and used some of the money from the sales of the stolen artwork to help purchase a house. Although he faced a maximum of seven years in prison, a Los Angeles Superior Court judge sentenced him to only 120 days in the Los Angeles county jail, five years of probation, and one thousand hours of community service related to art, anthropology, or Southwest cultures and ordered him to pay $70,000 restitution to the museum and assist in the efforts to locate 127 still-missing items.[23] This sentencing pattern mirrors that of white-collar criminals who are usually first-time offenders. In most cases, when a crime is committed by a white-collar offender, he or she is more likely to be able to hire a good defense lawyer and obtain a less serious sentence.

My research of art theft as a white-collar crime revealed that of the eight cases in which sentences were reported, one offender was ordered to pay the museum $45,000 and complete five hundred hours of community service, two received probation terms of three years and five years respectively, and five were given incarceration sentences ranging from five days in jail to eighteen months in prison.[24]

Methods of Stealing Artwork

Notwithstanding the various motivational factors, the theft of artwork may occur frequently if it is not a difficult task. Shoplifting appears to be easy to accomplish because it does not require as many skills as does burglary. A longtime print gallery owner noted, "Burglary is too much trouble. Shoplifting is a lot easier." This observation might be realistic, especially since galleries rarely have guards. Another dealer, an owner of a small ground-floor gallery in Greenwich, was victimized four times during a one-year period. His account demonstrated that shoplifting of artwork at some galleries could be very simple and

required only a great deal of audacity rather than sophisticated techniques: "I was in the gallery. The man took the framed photograph from the wall, in my and other customers' presence. A woman said, 'You shouldn't do that,' but the thief took it and ran out of the front door. Once they [the thieves] are on the street, there's nothing we can do about it."

The typical shoplifting does, however, require some techniques, no matter how unsophisticated. Obviously the degree of skill necessary increased as shoplifters became more professional. There were shoplifters who would snatch artwork in the presence of dealers and visitors and run out of the gallery, but there were also thieves who displayed a competence that alarmed gallery and museum administrators. In 1993, the alarm of the Birmingham Museum and Art Gallery in England went off during visiting hours, informing security guards that one of the museum's prized possessions, *Christ as the Man of Sorrows* by Christus, the Flemish master and student of Jan van Eyck, had been ripped from its security mounting. Within two minutes, the museum was sealed, but the thieves were able to escape with the tiny fifteenth-century oil panel valued at $450,000.[25] Similarly, two dealers, whom I interviewed, were in their galleries when thefts took place without their knowledge. They were amazed at the speed with which the thieves took possession of the objects and disappeared. Dealers who experienced shopliftings commented that the thief was so fast that they just turned around and saw that he or she had disappeared with the artwork.

Certainly, it is possible that shoplifting is a spontaneous, spur-of-the-moment act. However, there was an element of planning in the shoplifting of artwork because oftentimes dealers who experienced thefts had previously seen the suspects in their galleries. The thieves probably had visited the galleries to see whether the opportunity to steal existed and to look at the types of artwork on display. Therefore shoplifting consists of some planning and waiting for the opportunity to present itself and then taking advantage of it as quickly as possible.

Portrait of an Art Thief

Various shoplifting methods were used in the incidents of gallery thefts that dealers recounted during my interviews. Sometimes two or three thieves might enter a gallery in a group, wearing coats or carrying large shopping bags. One person would keep the gallery employee occupied with questions, while an accomplice stole the artwork and put it under his or her coat. A dealer on the East Side described an incident in her gallery: "They came in as a group, one woman and two men. The woman was well dressed, and all were wearing coats. They claimed that they didn't know English well, and we had to help them. They created the confusion by asking us many questions and by asking us to take pictures of several objects. Apparently, one stood in front of the other to shield the theft. After they left, we noticed that two bronze sculptures had disappeared."

Of the ninety-one IFAR Reports cases I studied, one-fourth indicated that the offender had at least one accomplice, who was sometimes a child. An owner of a Soho gallery said that when she was running a gallery in Washington, DC, she often noticed that around Christmastime, an old lady carrying a large bag and accompanied by a little boy occasionally visited her gallery. Sadly, the little boy was being used as a lookout for the woman while she stole artwork.

My interviewees also reported that female shoplifters were usually well dressed, making it more difficult for them to display discourtesy even though the women might be suspected of stealing their artwork. A Madison Avenue dealer said, "The lady was in her late thirties, well dressed. I knew she had stolen the sculpture, and it was inside the large shopping bag she was carrying. But I hesitated to stop her to check it out." In addition, art objects from galleries located on the ground level could be subject to the "grab-and-run" method described by one East Side dealer: "The thief ran into my gallery, snatched a Bonnard drawing that had a red dot sticker, and ran out to a waiting car. He knew that the red dot means the work was sold. It cost $75,000. He came back the next day and did the same thing. Both incidents happened in the presence of me and my wife. After that, I used the buzzer."

To Catch an Art Thief

Unlike the majority of shopliftings, burglary requires sophisticated skills, especially where buildings are well guarded. A 1969 burglary is a notorious case in point. In July, while the pope was at his summer residence, four cat burglars visited several apartments in the Holy See, including Pope Paul VI's private chambers. Familiar with Vatican buildings because they were telephone workers, they entered the pope's quarters at the top of the Apostolic Palace. They looted his rooms, unlocked his private elevator with a stolen key, ascended to a terrace, and escaped over the rooftops. Because of the Vatican's tight security measures, the burglars went to great trouble to gain access, including sliding through sewers and leaping over roofs and cornices. They disappeared with $10,000 in art objects. In a state where there is one peace officer for every 4.7 residents, the theft had to involve a remarkable degree of planning and ingenuity.[26]

According to the Art and Antique Investigation Unit's information, burglars' skills vary from such basic techniques as being able to open doors or windows without disturbing the neighbors to bypassing alarm systems or otherwise completing a job in a highly efficient manner in order to escape before police arrival should the alarm go off. Because NYPD officers usually arrived at the crime scene approximately twenty minutes after an alarm was set off, burglars often had enough time to escape with a few stolen objects.

A notorious case causing those of Cincinnati's upper-class society to raise their eyebrows occurred in 1989. Jacob Schott, the son of a former Cincinnati police chief, was arrested on art-theft charges and convicted of interstate transportation of stolen goods. Schott had worked briefly as a clerk for the FBI, a claims adjuster for an insurance company for several years, and a security-alarm salesman for a Honeywell Inc. branch in Cincinnati since the early 1980s. Because Schott sold security systems to homeowners, he knew the workings of his clients' burglar alarms. For example, if the system was digital, he knew the digital code employed to bypass the alarm. In some cases he obtained keys to the houses, although his security company claimed that it did not keep

keys or records of digital codes. In addition, Schott often knew when his clients planned to go away because of routine customer-service calls. For five years this information helped him and his accomplices enter boldly into the homes of Cincinnati's wealthy families to steal art and antiques valued at $2 million.[27]

Other techniques are also used to burglarize premises. Burglars most often try to enter a gallery by breaking or forcing the door open. A Soho dealer specializing in realistic art recalled a burglary incident: "They broke the lower part of the front glass door to get into my gallery, selected the artwork, then crawled out of the gallery without setting off the alarm. They left the large sculpture at the entrance and created such a mess of broken glass."

Data from my interviews with the dealers also showed that burglars entered, in order of frequency, through windows, walls, and roofs of buildings.

For some, breaking through a window was an easy task. In the early morning of February 12, 1994, while the world's attention was focusing on the opening ceremonies of the Winter Olympics in Lillehammer, the surveillance camera of the National Gallery in Oslo routinely captured all activities at the gallery. It showed two men leaning a tall ladder against the museum wall where a window was located. One man held the ladder while the other broke the glass window and landed inside. The intruder went straight to his target: Edvard Munch's masterpiece, *The Scream*. With little effort, he cut the wire holding the painting to the wall, exited with the painting through the same window, and fled with his accomplice in a waiting car. Security guards found the wire cutters, the ladder, and a note saying, "Thanks for the poor security."[28]

Breaking through a wall, however, was a noisy and time-consuming job that required planning in order to avoid detection. Barely five weeks after the death of artist Raphael Soyer in November 1987, Mary Soyer reported to the police that thieves had plundered her father's studio. Burglars tore off the medicine chest in an empty adjoining apartment, broke through another medicine chest in Soyer's studio, and

escaped with five hundred etchings and lithographs, all valued close to $200,000. Curiously, they emptied only the storage cabinets containing the prints, though paintings and drawings were also in the studio.[29] The theft was suspected to be commissioned as Soyer was a very well-known artist and his works would be much sought after following his death. During my visit at an East Side gallery almost three years after the artist's death, a dealer showed me a Soyer drawing and said he would sell it for $27,000. In 1993, burglars also successfully breached sophisticated security systems at Stockholm's Museum of Modern Art by entering the building through the roof. The thieves stole five paintings, one sculpture by Picasso, and two paintings by Braque, all valued at $52 million.[30]

Another technique burglars employ to break in is very intriguing: Daniel Cardebat, a police informant, recounted his part in an art theft at Morgan Manhattan Storage Company during his testimony in a New York State Supreme Court. To accomplish the burglary, he hid in a wooden crate that was carried into the warehouse to be stored. During the following night, he broke out of the crate, stole valuable carpets from a dealer's storage area, and packed them into the crate. Before daybreak, he climbed back into the container and waited for his coconspirator to return and carry the crate out of the warehouse.[31]

At times, impatient to gain entrance, burglars took bold measures. In 1990, thieves drove a van through the storefront of the Dyansen Gallery at half past four in the morning. Having accomplished the crime in clear view of people shopping in a twenty-four-hour produce store across the street, the criminals waved guns to ward off onlookers and then loaded into their van works by Erté and Leroy Neiman valued at $700,000. Helping the police to identify the car of one of the thieves, the witnesses gave them part of a license plate number. Fearlessly the gang soon returned to Soho at five o'clock in the morning, threw a brick through the window of the Nahan Gallery to gain entrance, and cleaned out five display cases containing Roman and Etruscan antiquities.[32] This type of modern-art thief totally ruined the image of the savvy rogue.

Portrait of an Art Thief

Regardless of how daring these incidents were, the robbery of a number of museums and galleries in the United States epitomized the ruthless techniques of hard-core criminals. A case in point occurred in 1988. Before closing time at the Rodin Museum of the Philadelphia Museum of Art, three guards noticed a visitor walking in and out of the museum, asking for the time and saying that he was waiting for his girlfriend. A Caucasian in his midtwenties, of medium height and with brown hair, he spoke with a slight accent and appeared to be calm. At 4:55 p.m., the visitor approached *Mask of the Man with the Broken Nose* by Auguste Rodin, attempted to detach it from the base, and thereby prompted the guards to intervene. Because he said that he merely wanted to look at the back of the piece, the unsuspicious guards turned away to replace the Rodin. Suddenly he pulled out a pistol, waved it at them, and fired off a round into the museum wall while ordering the guards to the floor. After handcuffing them together, he escaped with the $75,000 Rodin mask. Clearly the security at this museum was vulnerable to armed robbery.[33]

A year later, another armed robbery occurred in a Houston art gallery. This time a man with a Middle Eastern accent, who had visited the gallery the previous day with another man, entered the gallery around four o'clock in the afternoon on a Saturday. He browsed around for a while and then told Lowell Collins, the dealer, that he was interested in purchasing a valuable African sculpture. The dealer engaged in what he believed to be a usual business exchange when the customer pulled out a pistol and ordered Collins to lie down. After binding, gagging, and pushing the victim on the floor, he ran to the upstairs gallery, walked directly toward a bookcase, and turned it around. It was the secret door leading to Collins's apartment, where he kept Russian icons from between the sixteenth and nineteenth centuries. It took the thief forty-five minutes to carry approximately sixty-five icons to the gallery door. Outside, two men, including the man who had accompanied the robber on the previous day, were waiting in a getaway car. The Russian icons together with the African sculptures

and pre-Columbian gold jewelry that they stole were estimated to be worth $500,000.[34]

However, it was the violence of the robbery at the Marmottan Museum in Paris in 1985 that shocked the world. At ten o'clock in the morning on a quiet October Sunday, the small museum located on rue Louis Boilly near the Bois de Boulogne in Paris's elegant Sixteenth District was already crowded with visitors. The museum was renowned for its collection of Impressionist paintings, eighty-seven of which are Monets. Its alarm system was unplugged each morning at half past eight and carefully reconnected at six o'clock in the evening. No one paid attention to five men of European origin between the ages of thirty and forty who quietly bought tickets and entered the museum. One of these men suddenly approached the chief guard, grabbed him, pointed a high-caliber revolver to his temple, and ordered him, other guards, and some forty visitors to lie on the floor. Three of the men, all armed, immediately disappeared into the Monet room in the basement, and one went to other rooms. While everyone was on the floor trembling, the bandits broke a glass case to snatch two portraits of Monet—one by Renoir and the other by Naruse—and proceeded to lift other paintings, including a Berthe Morisot, a Renoir, and five works by Monet. One of these was *Impression, Sunrise*, the painting that gave the Impressionist school its name after it had been exhibited in 1874. Within five minutes, the bandits had loaded the paintings in the trunk of their limousine that was double-parked outside and drove away with their $20 million worth of stolen artifacts. The museum administrator immediately called the police, but it was too late. That was the first time museum artwork in France was stolen at gunpoint.[35]

The Trojan Horse

Connoisseurs or Con Artists?

*D*uring one of our frequent discussions about art theft, Moscardini asked me with certain amusement, "Are you familiar with Dr. Waxman's case?"

"Yes, I am. Isn't that an unusual story?" I responded with obvious amusement, which put a smile on his emotionally controlled face.

A member of the executive committee of the Friends of the Philadelphia Museum of Art and a former art student who had chosen to pursue a career in medicine, Dr. Frank Waxman grew up in a prominent family in west Philadelphia. Waxman had a collection of 172 works valued at more than $2 million, which he proudly showed to the Philadelphia museum circle at social gatherings in his home. He reportedly told his guests that he had purchased the artifacts with money inherited from his grandfather. One of his guests later commented that his collection contained only small pieces of artwork. No one knew that, for two years, Waxman had been suspected to be an art thief who terrorized galleries in New York, Philadelphia, Florida,

and Los Angeles over a ten-year period. Because of his social status, the police had delayed their investigation until mounting reports from art-gallery owners suspecting him of shoplifting at their galleries convinced them of a probable cause for action. Following police searches of his apartment in 1982 and their identification of sixty works stolen from galleries in Los Angeles, Waxman was arrested on charges of theft and possession of stolen property.

After his arrest, a dealer commented that his greatest skill was recognizing when the gallery was in a state of confusion and taking that opportunity to abscond with artwork.

One Sunday in 1974, Waxman called Dorothy Blau, an art dealer from whom his friend Leslie Gordon had purchased a painting, and said that he was a friend of Gordon. He wanted to buy a painting for an aunt and asked if she would mind opening the gallery. Blau agreed. Appearing at the gallery with his young son, he asked her to play with the boy while he went through the paintings placed on the rack in the back. Not seeing him return after half an hour, the dealer went to the rack but did not find him there. She immediately stepped out the rear door and saw Waxman close the trunk of his car. After telling her he had been looking for his wallet and had not found any paintings he liked, he placed his son in the car and drove away. When the dealer returned to the gallery on Tuesday, she went back to the rack to find a painting for a client and discovered that eleven works had disappeared.

On another occasion, Waxman went into the Herbert Palmer Gallery in West Hollywood with a shopping bag. It was Christmas Eve, 1981, so the gallery closed early. Everyone hurried to leave for home, but Waxman insisted on seeing a Sam Francis painting that was stored in the back. When the sales clerk brought out the small painting, Waxman suddenly said he had to fetch his wife who was shopping across the street and quickly left. Moments later, the clerk noticed that a Picasso sculpture, *Woman with Large Breasts*, had vanished from its display case.[1]

"Opportunity is the most important factor in stealing," a Soho dealer said to me. "You know, thieves spend a great deal of time wandering around window-shopping for an opportunity to steal. Occasionally, they will step inside a gallery, check the exit door and the security system, note where the office is located, and find the most accessible objects that they may return later to steal."

Of the three New York art districts I visited, Soho and Fifty-Seventh Street suffered from shoplifting more than from burglary, while the opposite was apparent on the East Side. Though the dealers I interviewed attempted to remain one step ahead of thieves, the very nature of their business and the characteristics of their locations often provided unwitting opportunities for thefts.

In New York City, art galleries might deal mostly in one of three specialties: precontemporary art, contemporary art, and prints. Precontemporary art dealers more often than not maintained a limited inventory frequently supplemented by exhibitions of the works consigned to the gallery by their clients. Due to the scarcity of older works and the high prices they command, these galleries are usually very small and are run by the dealers and their spouses or partners with the help of one or two part-time employees. As art insurance agent Michael Fischman pointed out, "It's a mom-and-pop operation." Some larger galleries, however, often have a sizable stock-in-trade and many employees. Because of the large number of employees—giving rise to the opportunity for employee theft—and the high prices of art, the business-minded directors of these galleries often let their employees know that they are being watched.

In contrast to the small number of employees in the typical precontemporary outlets, galleries dealing in contemporary art often have many employees, enabling them to promote the artists they support by organizing frequent exhibitions. These galleries select the works to be exhibited and make all preparations for shows, such as installing the artwork, placing advertisements in art magazines, sending invitations

to an artist's opening reception, and preparing a catalogue raisonné of the artist's body of work.

Not surprisingly, artists from all over the country came to New York City in the hope that, someday, some of the city's hundreds of contemporary art galleries will offer them the chance to gain recognition in the unpredictable art world. Attesting to this was one prominent Soho dealer who spent most of his time during our interview fielding continuous phone inquiries. "Nearly eighty percent of my phone calls," he said, "come from artists." Receptionists, too, are often occupied on the telephone, giving thieves near impunity to steal and quickly exit these galleries with artifacts hidden under their coats or inside large carrying cases.

Employee theft at contemporary art galleries, however, was generally rare. Although these galleries frequently exhibit the works of aspiring artists, unsold pieces are generally returned after the exhibition unless the dealer controls the artists' works. By supporting an artist, a dealer typically provides a stipend to ensure the continuous production of works for the gallery. Few galleries are able to support artists, though, and most do not carry much stock-in-trade. This feature negatively affects the temptation of employee theft.

On the other hand, galleries that deal in prints, particularly those that publish contemporary prints, appeared to suffer most from employee theft. Unlike paintings, prints come in limited editions, making stealing them possible without the threat of immediate discovery. Furthermore, in storage, paintings still come with canvas stretchers, whereas prints are usually kept unframed and are easily rolled into small tubes, thereby making ready targets for employee thieves.

Soho

Before the art industry came to Soho, the area had been a factory district. Attracted by inexpensive rent, artists began moving to the area from Greenwich Village in the 1960s, and many old Soho factory

buildings were converted into art galleries housing the works of con-
temporary artists. Small galleries typically consisted of one single
room for both office and showroom. In many instances, the office area,
where the receptionist's desk was located, occupied the far end of the
showroom. Such an arrangement resulted in the loss of control over
visitor entrances and exits. An obviously awkward structural barrier
to security, such as elevators opening directly into the showrooms,
also offered thieves a convenient means of escape. As a contemporary-
art dealer remarked, "These premises were not designed to be used
as art galleries." The spatial arrangement of one large Soho gallery
I visited especially supported this observation. This gallery was an
old factory that had been converted into four large showrooms, two
small offices, and a storeroom. The first three rooms were located in
the front of the gallery, close to the entrance, with the receptionist's
counter at the end of a long hallway in the fourth showroom, close
to the offices and the storeroom. This arrangement could adequately
suffice in a factory where one does not need to monitor customers'
entrances and exits, but for a gallery, this use of space is likely to facili-
tate shoplifting as thieves can easily exit with stolen objects even as
the crime is being monitored.

Besides the spatial arrangements of the galleries, the environment
of Soho also contributes to the problem of theft. As a tourist area, Soho
includes in its attractions a bevy of haunts for avid shoppers and diners.
Specialty gift shops, restaurants, and clothing boutiques share in the
thriving tourist business. The social ambience of Soho is casual com-
pared to that of the Fifty-Seventh Street and East Side areas and reflects
the international mix of art lovers who come to Soho to view the works
of contemporary artists from the United States and abroad. Seduced
by the American dream, European dealers opened galleries in New
York City. As a young French dealer in contemporary art explained, the
opportunity to succeed in the art world was greater there than in their
homelands. One Canadian dealer, also driven by the twain of ambition
and possibility, managed a gallery on Fifty-Seventh Street because he

could get better prices for the same paintings in New York than in his Montreal gallery.

In this eclectic environment, detecting a thief was difficult. Gallery employees, accustomed to the typical appearance of gallery clients in other more exclusive areas, were often confused by the diversity of Soho gallery visitors. One owner of a sculpture gallery explained to me, "My gallery is vulnerable to shoplifting because of the great number of tourists entering it every day. I often instruct my employees to pay close attention to visitors who don't look like the typical gallery visitors... But my employees are so used to the look of the tourists that they have trouble detecting the atypical visitor."

At these galleries, if a thief did not appear to be a typical visitor, he or she was placed under surveillance. A receptionist at one Soho gallery recounted an incident that she remembered vividly: "When I saw him enter, I thought he didn't look like a gallery visitor. He wore white coveralls, a white baseball cap, and a dark coat. Moments later, while I turned around to pick up the telephone to answer a call, he quickly passed through the front door. I looked at the place where the small painting was hung. It was empty."

Causing loss and consternation to the owner of the sculpture gallery, this heterogeneous environment obviously gave protection to art thieves. From that point on, whenever the dealer noticed the presence of suspicious-looking visitors, he asked them to leave.

"But when does a visitor arouse your suspicion?" I asked the dealer.

"When a visitor is poorly dressed, asks strange questions, or looks at the price stickers more than at the artwork, my suspicion will be aroused." Noting the furrow in my brow, he continued with a very telling anecdote. "I once noticed a man who I was sure was a thief. I came to him, put my hand on his arm and said, 'You are not welcome here. I want you to leave.' The man looked at me and said, 'Tell me what you want, and I will get it for you. Anything.'"

The Soho area was noted for its multicultural atmosphere. Small groups of American and foreign tourists visiting the galleries mingle

with college students, artists, art collectors, and shoppers. My interviews revealed that the average age of gallery visitors was over thirty years. Results from my analysis of police reports also indicated that the mean age of suspects in art-theft cases was thirty-three, with thirty as the most frequent age. In addition, the youngest suspect was twenty-five and the oldest was fifty. Therefore the environment of art galleries appears to provide better opportunities to older shoplifters.

Because of the diversity of gallery visitors, no specific race stood out and attracted gallery employees' attention. As a dealer observed, "In this area, thieves belong to all races." A close look at data from the reports on shoplifting shows that 50 percent of the shoplifters in all three areas combined were Caucasians. African Americans and Hispanics were next in order of frequency. There were seven male suspects for every one female suspect.

Fifty-Seventh Street

Fifty-Seventh Street is the main avenue of one of the most prosperous business areas in New York City. Galleries located on this street are well established, dealing mostly in works of better-known contemporary artists. Generally, the price of an artwork corresponds with the degree of the artist's recognition or the period in which the work was produced.

Except for a few street-level galleries, I noticed that the majority of these galleries were housed on the upper floors of old business buildings and modern high-rises. Unlike the galleries of Soho, the layout of these premises was designed to suit the function of galleries. In most cases, I found the receptionist's counter of a gallery located near the entrance. With easy access to the front door and separate offices, which do not require employees' attention, the arrangement encouraged more contact with visitors in the gallery.

All six Fifty-Seventh Street galleries I visited were located in the Art Building, the Fuller Building, and a modern high-rise. Providing

exclusive housing for about sixty art galleries, the Fuller Building and the Art Building had tight security protecting both entrances and exits. All the galleries were situated on the upper floors, with the ground floors used primarily for security, including a twenty-four-hour guard station located between the front door and the elevator. This use of space limited a thief's opportunity to escape to the street from the front door. In one street-level gallery, visitors were asked to leave their large handbags with the receptionist. This practice made me feel uncomfortable, as I was not accustomed to an art gallery treating visitors as shoppers.

Though most of these galleries had buzzers, not all of them use this device during peak hours due to certain disadvantages. For one thing, in order for a buzzer to be effective, the gallery using it must be locked at all times, forcing visitors to buzz at the door to gain entrance. This may give the gallery an unfriendly image, discouraging potential customers—certainly not a wise business approach unless the gallery is very well established. One director of a Madison Avenue gallery did not use the buzzer most of the time, explaining to me that he preferred "to let people know that anyone can come in." Several months after the interview, the dealer reported to the police two shoplifting incidents in which the thieves used the grab-and-run technique. These incidents could have been avoided had he used the buzzer during business hours.

Another disadvantage to the use of buzzers is that someone must operate the remote control device that closes and opens the door for visitors. This task puts an additional demand on sales clerks, who must concentrate on selling, unless the gallery has a receptionist. And ultimately, if a thief is clever, the buzzer will not have any effect at all because he or she may still be able to escape the scrutiny of the employee and leave the gallery with the stolen artwork. This factor may have contributed to the finding that 68.1 percent of shoplifting incidents did not have identifiable suspects. For the above reasons, many galleries did not have buzzers. If they did, they used them only occasionally, mostly on occasions where the dealer was alone in the gallery.

The Trojan Horse

Even at galleries where buzzers were used at all times, shoplifting still occurred. Every one of the ten galleries insured by Fischman and housed in the exclusive Fuller Building, home of some of the most well-established art galleries in New York City, had been affected by this crime. For a variety of reasons, the dealers chose not to install buzzers at the exit doors leading to the staircase. And there may be the possibility that shoplifting at these galleries did not happen often enough to warrant the use of a second buzzer.

At one very large gallery occupying the entire fifth floor of a modern building, the dealer plainly let visitors know that his gallery had tight security control by displaying three TV monitors at the front desk located at the entrance. A sign posted at the entrance also requested that visitors leave any large handbags with the receptionist. Although this dealer's gallery was vast, he had experienced no thefts during the entire year preceding the interview. When I asked him if he thought security could control art theft, he said, "By implementing better security technologies, the theft problem in New York may decrease but not be entirely eliminated."

The majority of Fifty-Seventh Street galleries located in a high-rise were doubly guarded: the gallery entrances had buzzers or movement-sensor devices, and the entire building was monitored by twenty-four-hour guards. Yet at one gallery, various security measures had not been enough to foil shoplifters. In this case, the gallery was situated on the tenth floor and at the end of a long and narrow hallway; its massive wooden front door was kept locked at all times. Because the name of the gallery was not posted outside, I passed by it several times until I learned from the receptionist of a gallery on the same floor that the nameless gallery was my destination. My interview took place during the gallery's special exhibition of German Expressionist prints. The minimum price for a lesser-known print measuring about eight by twelve inches was $6,000. However, art viewers could not see what was displayed inside the gallery and had to use the buzzer to gain entrance. Inside the gallery, the receptionist's counter was next to the

front entrance, and one of the receptionist's duties was to monitor the remote control device. Yet according to police information, this gallery had been the target of two shopliftings. A thief must be very clever at stealing to go undetected in this type of gallery.

While the atmosphere in Soho was casual, that of Fifty-Seventh Street—the business area—was formal. The appearance of inaccessibility and formality of these galleries could intimidate tourists and others who were not familiar with New York galleries. Unlike the Soho galleries, the Fifty-Seventh Street art galleries seemed to attract a homogeneous group of clients. The majority of galleries in this area represented well-established contemporary artists and tended to attract primarily American collectors because, as one dealer explained, "contemporary art has a national market. In this area, thieves are white because if they are not white, they will stick out like nails, and we will watch them."

The Galleries

The galleries in the three areas I visited were housed in some type of multilevel building—either converted storefronts, remodeled factories, or modern buildings constructed for the purpose of housing art. Though they might be situated on any level, from the basement to the tenth floor, the majority of these galleries were located on the ground level.

Depending on how reputable a gallery was, locating it away from street level did not necessarily result in a loss of business. A contemporary art dealer who directed a well-established gallery located on the fourth floor of a building in the Soho district explained, "I wouldn't want to be on the ground level. There is too much traffic. Furthermore, visitors don't come to my gallery because of its location."

Less well-established galleries, however, found that the ground floor gave more exposure to prospective clients. Easy access to the gallery seemed to invite shoppers to enter the gallery, which was advantageous during the off-season of the summer months. One dealer on Madison

Avenue said, "We opened the door during the summer months, and a lot more people came into our gallery."

The disadvantage of the open-door policy, of course, is that it may also increase the theft rate. An owner of a Soho gallery commented, "Being on the ground level, we get a lot of tourists. There are hundreds of tourists passing through this gallery per month. But only a few visitors are patrons. I'd rather have only a few serious customers per month and not have to worry about shoplifting."

Over one-half of shoplifting incidents took place in ground-level galleries with street-level locations that provided an easy escape. And as a dealer emphasized, "once the thief is out on the street, he or she is free." This is exemplified in a theft at an East Side gallery where the dealer tried unsuccessfully to catch a thief during a grab-and-run incident but lost him when the thief disappeared into a waiting taxi.

Still, moving away from the ground floor did not guarantee total protection from this crime as nearly half of the shoplifting incidents that had occurred during the previous twelve-month period of the survey took place on the upper floors. Thieves generally entered and left each gallery by the same front entrance but occasionally used an exit leading to a staircase if the gallery was housed on an upper floor. An exit door was more convenient to thieves because they did not have to pass by the watchful eyes of gallery employees. However, many galleries did not have exit doors located near the showrooms. As a result, the front entrance was usually the escape route.

While shoplifters were responsible for the majority of the losses in the showroom, thefts from storage areas were likely the work of employees because of their exclusive accessibility. The dealers usually discovered storeroom thefts when they were unable to locate the object when they needed it. The small number of disappearances from gallery storerooms, thefts detected through inventory and reported employee thefts, in contrast to the large number of showroom losses revealed that employee thievery was rare because most art businesses were small operations. Employees were discouraged by loyalty and fear of

discovery. Still, losses from storage areas often dealt a heavy blow to the gallery because employee thieves were knowledgeable, having the added opportunity to discriminate in their choice of valuable and salable works. In a 1991 case, over forty old master paintings were discovered missing from one of New York's best-known galleries after a gallery employee spotted photographs of five paintings belonging to the gallery in a Christie's East catalog. Subsequent police investigation revealed that David Christie, who had no relation to Christie's and was a former art handler of the victimized gallery, had stolen fifteen paintings valued at $650,000.[2]

My interviewees also disclosed that shopliftings occurred most often on Tuesday and Wednesday afternoons. These patterns of temporal opportunity for shoplifting might come from the fact that since most galleries were closed on Mondays, dealers were occupied with telephone business and meeting with clients on Tuesdays and Wednesdays. Many galleries opened at eleven o'clock in the morning; therefore, most customers were likely to be in the showrooms in the afternoons.

Though there was evidence of selected days for theft, no indication of a specific target month was found from my information. As the overwhelming majority of my interviewees observed, "Thieves steal all year round."

A Dealer's Dilemma

Because front doors appeared to be the thieves' chosen exit, a number of dealers tried to control their entrances by installing buzzers. This security device was most effective in preventing grab-and-run crimes because it provided a means of control to a dealer who wished to permit or deny customers entry and exit. Though many interviewees believed that guards were the most effective means of controlling shoplifting, among the forty-five visited galleries, only one had a full-time guard. In addition, only eight galleries used buzzers on a regular basis.

In large galleries with many showrooms, closed-circuit TV was often used. Still, these devices did not always prevent thefts because, as a Fifty-Seventh Street dealer said, "Human error is the problem in high-technology security." An employee simply could not look at the monitor for long periods of time without losing his or her concentration.

At several galleries where theft had become a concern to the dealers, they used many other security devices—some high-tech, some low-tech, and none completely foolproof. One Fifty-Seventh Street dealer installed an infrared light beam at the entrance, where the door of the building's elevator was also the door to the gallery. This gallery had previously been a victim of two thefts within a one-year period. When I left the elevator, I immediately crossed the light beam, setting off a buzzer alerting the gallery receptionist to my arrival.

One Soho dealer installed an electronic checkpoint at the entrance that sounds an alarm when a client walks out without paying for an art object. Although the device helped reduce shoplifting incidents, it, too, was proven to be flawed. The most recent losses at the gallery were those of two paintings that were cut brazenly from their canvas stretchers. The thieves were able to exit through the electronic checkpoint entrance without being detected because the security devices were attached to the stretchers.

Other methods of preventing shopliftings included placing a bell mat at the front entrance to alert employees to visitors as well as marbles on the canvas stretchers, which would fall on the floor and make noise as a thief tried to lift a picture. If a painting is large or very valuable, it could be tied securely to a hook on the wall. But a dealer who used this method acknowledged that this was very inconvenient every time he had to remove the painting to show it to an interested client.

At a Madison Avenue gallery, one dealer avoided displaying the prices of his artwork by using a coding system to represent prices. For example, the code "120" translated to $1,200. As in retail stores, mirrors were used to extend their visual control of gallery visitors; small items were placed in display cases. Dealers glued sculptures to their

pedestals if they were placed near the entrance. Because thefts did not occur often enough at their galleries, it was more important for these dealers to display objects at aesthetically proper places in order to increase the value of the show than to worry about an unlikely loss.

One dealer who worked in a large New York City print gallery for many years before becoming the director of a New Jersey gallery told me that many print galleries in New York City could not keep track of the number of prints that disappeared because they did not have adequate inventory systems. Many art dealers resisted using techniques of inventory control necessary for a successful business enterprise either because of the rules of "tradition" in running a small business or because they lacked a strong business-management background. While the knowledge of art is essential in art dealing, it does not provide the necessary qualifications to run a successful business in today's world in which stiff competition demands not only art knowledge but also business skills.[3]

These skills were becoming increasingly complex as the business of dealing in contemporary art requires capability in both promoting promising artists and convincing the art world of the value of their works. One dealer I interviewed turned his hobby of collecting glass sculptures into a successful gallery career after spending many years as a salesman of women's ready-to-wear. Nevertheless, perhaps due to a lack of interest in the nonart aspects of the business, some dealers seemed to be very tolerant of the inefficiency of their galleries. For example, a prominent dealer who owned a large gallery specializing in old master drawings and prints employed seven full-time people but did not use a computer for his record keeping. In fact, he never took inventory of his stock. Although the dealer suspected that a certain number of prints or drawings had disappeared due to employee theft, strangely enough, he never reported these incidents to the police for fear of possible lawsuits being brought against him by the suspected employees.

The dealers I interviewed were aware that some employees might have knowledge of the gallery's insurance deductible and the

theft-reporting practices of their managers. If an employee stole art-work with a value below the gallery's insurance deductible, he or she knew it was unlikely that the employer would report the incident to the police. Thus, while art insurance protected the dealers from substantial financial losses due to thefts, it also kept many art-theft incidents from being reported. At print galleries, employees might feel less guilty about stealing prints because the stolen works were only copies. But by "being employees in print galleries," the same New Jersey print dealer commented, "they know which are the marketable works and have access to customers who will be interested in buying them." They could, therefore, dispose of these prints more easily. Yet employees often played an important role with respect to the safety of an art dealer's stock-in-trade—both as perpetrators of theft and protectors of their employer's inventory.

Faced with a dilemma for which there were probably no easy answers, dealers tended to hire artists and individuals with previous gallery experience who could communicate with dealers and clients and assist in the selection of works to be exhibited and in the presentation of a show. One Soho dealer confided in me, "To prevent employee theft, I hire artists to work for me because artists don't steal other artists' work." While employing artists may reduce the amount of employee thefts, artists are not necessarily security conscious, especially when it comes to gallery visitors. "Most of them are naïve about gallery visitors and don't expect shoplifting," remarked the same dealer. His opinion was shared with another dealer, who said, "They don't watch visitors."

Nonetheless, the reliance of dealers on artist employees to assist in creating an aesthetically pleasing atmosphere for displaying art-work was invaluable. As one Soho dealer noted, however, pleasing surroundings also interfered with security. "So comfortable is the interior of most galleries," the dealer commented, "that a seductive ambience could reduce employee alertness." But this same dealer enhanced the beauty of his art objects with ceiling light sources shining directly

upon them. As a result, the showroom was protected by a minimum of light, creating an atmosphere both comfortable to employees and convenient for thieves. To counter the liability of the display while protecting the aesthetic value of the show, he used closed-circuit TV and closely watched visitors from his second-floor office, where a monitor was placed. Though aware of the problem inherent in his display, he was willing to take the risk because, after all, he was in the business of selling art.

Poor visual security was also the primary reason for the losses. This problem may be caused by an inadequate number of employees, complacency due to the casual and comfortable atmosphere of the gallery, artist employees being out of touch with security issues, or employees being simply unaware of criminal activities taking place while attending to customers. The problems of visual security are complex, with dealers torn between enhancing security and showing courtesy toward gallery visitors.

With electronic monitoring and the use of door buzzers considered tedious, time-consuming, and costly to employers, the use of guards could take the burden of security away from the employees. In fact, the dealers cited the lack of guards as the second most common reason for shopliftings after poor visual security. Furthermore, only guards could prevent thefts committed by grab-and-run thieves. In 1990, when the associate director of the Weintraub Gallery chased such a thief, overtook him, and wrestled him to the ground, the offender was still able to break free and disappear into Central Park.[4]

The East Side

In the soft light of her spacious Fifth Avenue gallery, she stood gracefully among the paintings looking like a Sargent's patron posing for an oil portrait. With a smile, she led me to the area of the gallery near the window where we could see each other better, and we began to speak of her experiences on the East Side. When I asked her what

type of art theft caused the most damage to the gallery, she replied without hesitation, "Burglary."

"There are a lot of burglaries on the East Side," I noted.

"That's why we moved from the East Side to this area," she murmured. "It's much safer here."

Some of the most spectacular art thefts in the world have been accomplished by professional burglars with daring plans to both abscond with priceless masterpieces and remain outside the grasp of the law. The largest single art theft ever reported in New York City occurred at the Colnaghi Gallery.[5] Though the majority of the artwork taken from the theft was recovered three years after the heist, the police were unable to arrest any of the offenders on art-theft charges.

Located in one of the oldest and most well-established areas of New York City, the East Side galleries assume a tastefully old-fashioned ambience. Many of these galleries are within walking distance of the Metropolitan Museum of Art and are housed in some of the choicest residential areas, lending a quaint atmosphere to the mostly precontemporary galleries. Indeed, dealers of precontemporary art bristled at the commercial look of many contemporary-art galleries, choosing instead the elegance of the East Side. The eighteen galleries I visited were clustered along Madison Avenue and the East Side streets.

With the exception of the galleries on Madison Avenue, the East Side galleries were located on relatively quiet streets, many offering art connoisseurs both old and modern art. Dealers there generally carried the most expensive artwork in New York City and were very conscious of the value of their stock-in-trade.

On the occasion of my interview with one of the East Side dealers, I found my way to a gallery located in a four-story town house on a quiet, tree-lined street. With no marquee to identify the gallery and only the street number of the building in hand, I rang the buzzer and waited as a male voice from within requested my identity. Shortly the massive double doors were slowly opened, and an employee appeared at the entrance, inviting me in and relieving me of my coat, which

would be kept in a front closet during my visit. He then led me through the first floor—a large empty hall decorated with several unusually large old master prints—to the elevator and gave me a tour of the gallery. While stopping briefly on the second and third floors, which were filled with classic drawings and prints, we exchanged comments on the artwork. At the same time, I could not help but notice from the amount of furniture in the gallery that the surroundings felt more like a home than a place of business. As time seemed to stop in this quiet gallery, a Lamartine's verse suddenly emerged from a distant past:

Objets inanimés, avez-vous donc une âme?

Qui s'attache à notre âme et la force d'aimer?[1]

Later another employee, who escorted me from the third floor where the interview with the dealer had taken place, informed me that the dealer actually lived on the fourth floor—the top floor of the building. This living arrangement, I found, was a common practice of directors of large galleries, particularly those who carried old artwork. Indeed, I noted during my visits that the directors of the two galleries carrying very valuable works took domicile on the top floor of the galleries and thereby reduced their chance of being victimized by burglars.

Security consciousness during business hours was apparent, though modest, on the East Side. Curiously, only six out of eighteen galleries used buzzers during business hours, with one very well-established gallery employing a full-time guard. These galleries catered to a select, discriminating clientele, which enabled dealers to easily recognize visitors who did not appear to belong in the setting of their galleries. At one Madison Avenue gallery, I noticed a receptionist refusing to open the door to a man waiting to enter the gallery.

Attracting a less homogeneous clientele than galleries on Fifty-Seventh Street, the precontemporary art dealers on the East Side enjoyed an international market of foreign collectors. As a result, visitors unfamiliar with precontemporary art usually felt out of place.

[1] Inanimate objects, do you have a soul?
That attaches itself to our soul and forces us to love?

The Trojan Horse

Consider the case of one East Side gallery owner who specialized in Futurism. Unlike Impressionism, the art of this school was less popular among the general public and was known among fine arts students as "intellectual" art. A visitor to the gallery looked at a painting and commented that he had never heard the artist's name. The dealer, an older European immigrant, said to him, "Let me give you some advice: One buys art because of his eyes, not his ears."

This unkind reaction came from the frustration of dealers doing business in a country rich in many ways but poor in the art tradition. The American public is largely unfamiliar with precontemporary art because the majority of artists are European. As dealers in precontemporary art savor foreign visitors and enjoy sharing their love of art with their clients, a thief of any nationality, in order to be successful, must seem sophisticated enough to go undetected in this type of environment.

Nocturnal Visitors

Galleries on Madison Avenue are typically converted, ground-level storefronts, though some upper-floor galleries can also be found, especially on the side streets and in remodeled apartment buildings. Most of the buildings are older and built with little attention to security; in particular, they have many windows, a coveted feature for burglars. In these galleries, the receptionist's counter is typically in the back of the showroom. However, since most East Side galleries are small, employees can easily observe the comings and goings of visitors and use a remote control device to open and close the front door.

Though limited opportunities for shoplifting in this area explained the infrequency of shopliftings, a determined thief could still enter these old buildings after business hours. If it was not possible to gain entrance through the doors, a burglar might enter through windows or from the roofs of the buildings. Adjoining rooftops made it possible for burglars to break in to upper-floor galleries, protected by the canopy of foliage on the tree-lined streets.

To Catch an Art Thief

I subsequently obtained an analysis of burglary patterns in the Nineteenth Precinct that showed that during a six-month period in 1989, there were thirty-one burglaries at East Side galleries, all occurring on Madison Avenue. The most common method of entering the premises was to break a window, although in other areas, particularly in Soho, forcing the door open was more common. This was perhaps due to more frequent police patrol on the East Side than in Soho. Assuming the skill of cat burglars, thieves also entered galleries through skylights, ventilation ducts, and boiler rooms. One East Side dealer who operated a fifth-floor gallery dealing in old master prints and drawings recalled a burglary incident happening on a Sunday: "Evidently they broke the window in the back of the building and got into the hallway. They tried to open the door but couldn't make it. So they opened up a three-by-three-foot hole in the wall, next to the door. They must have stayed in the gallery for a while because they selected seventy-five prints and drawings and a small bronze sculpture. I remembered turning on the alarm before leaving, but apparently it did not work. Someone came to work the next morning and saw the hole in the wall."

When I attempted to analyze temporal opportunities, though no definite patterns with regard to months were discernible, an obvious pattern emerged from my data as to the day and time of week that burglaries occurred. Because most art galleries were closed on Sundays and Mondays and the chance of a dealer returning to his or her gallery on Sunday was unlikely, the majority of burglaries took place on Sunday nights.

An Evening on Fifty-Seventh Street

Between 1985 and 1990, there were only six reported incidents of burglary at Fifty-Seventh Street galleries, while shoplifting occurred almost six times more often, owing perhaps to the limited access to the galleries after business hours. Since burglary took place most often at night when buildings were closed and heavily guarded, the only way a

burglar could get inside the showrooms was through a window or the roof. This was not easily accomplished because all the galleries I visited were located on the upper floors of modern buildings.

In addition, the area surrounding the Fifty-Seventh Street galleries was a center of cultural activities and nightlife. Carnegie Hall, the Russian Tea Room, restaurants serving corporate clients, hotels for businesspeople, and the Broadway Theater District were located there. Discouraging even the most daring burglars, police cars could be seen patrolling day and night.

What Price Security?

The dealers took burglary very seriously. Almost all the forty-five galleries I visited had necessary security measures to meet the standards of art insurance companies. Thirty-six of these galleries had burglar alarms connected to the alarm company. This does not lead to the implication that the remaining eight galleries did not meet security requirements, as insurance brokers determine the level of those requirements based on the types of art and a risk assessment of each individual gallery.

In one instance, a modest Soho photography gallery—housed in a single, windowless room sandwiched between a storefront art gallery and a rental room—met the requirements of the insurance carrier by installing only locks on the front and back doors, the only points of entry into the gallery. The security of two other Soho galleries that did not carry insurance, however, was in question. In these cases, the gallery directors reasoned that insurance would have been more expensive than the cost of having their art objects stolen because they either dealt in less expensive types of artwork or let the artists know that their galleries were not covered by insurance. They chose instead to protect their galleries by installing security devices that they could afford. One dealer used locks, motion detectors, and closed-circuit TV; the other used only locks.

To Catch an Art Thief

Alarm systems served as the favorite protective mechanism to guard against burglary. Unfortunately, false alarms were often set off by motion-detector devices. In old buildings in the Soho and Madison Avenue areas, mice wandering at night could cause these devices to set off an alarm. Every time a gallery had a false alarm, the police would give the dealer a warning. When the gallery had passed the limit of false alarms per month—more than four times—the police would issue a summons.

Though motion detectors were essential, they did not always prevent burglars from entering a gallery. During the burglary at a Soho dealer's gallery, the burglars cut the lower part of the front glass door and crawled into the gallery, avoiding the motion detector. When they left by the same path, they again did not set off the alarm.

Alarms were provided by alarm companies, and their clients paid a monthly fee. Insurance Agent Fischman told me that art-gallery alarm systems were connected to around fifty central stations located throughout the city. When an alarm went off, the alarm company would notify the police and send a security officer to the victimized gallery. Unfortunately, the alarm of one East Side dealer did not operate when his gallery was burglarized. The alarm company claimed that he did not turn it on before leaving the gallery and advised him of a 50 percent increase in his monthly art insurance premium.

Galleries that did not have central alarm systems used alarms, both outside and inside, that would ring loudly if thieves broke into the gallery. At many galleries, reinforcing devices were installed at windows and doors, and additional lights were added to dark areas. A number of galleries used the service of twenty-four-hour lobby guards employed by the owner of the building where the gallery was located.

Then why did security fail to protect these galleries? Even with the most sophisticated of security devices, galleries remained vulnerable to burglary because alarm systems did not always operate reliably.

Although the majority of the dealers made efforts to improve their security over the years, only 20 percent of them believed that adequate

security could deter art theft. It was indeed impossible to prevent all art thefts because professional thieves were clever and could bypass most alarm systems. This was supported by the fact that the Art and Antique Investigation Unit did not have one single case in which the accused seemed to possess the technical sophistication of professional art thieves who, it appeared, had been able to avoid detection.

In spite of the problems inherent in security techniques, most of the dealers interviewed still had faith in modern technology because adequate security could deter art theft substantially if not absolutely. While half of them spent a great deal of money on security because it was a good business practice, an almost equal number did not. These dealers would not spend money on security greater than the cost of potential losses. They argued, of course, that it was impossible to control all thefts. Others found that at their galleries thefts did not happen often enough to worry about and chose instead to hire guards when they had important exhibitions.

In addition, different methods to deal with consignors of works stolen were used. One Soho dealer confided to me that because many works consigned to his gallery were not covered by insurance, when a work in question was stolen, he telephoned the artist and explained what had happened. His artists often accepted the loss as an accident and asked nothing of him. At one modest gallery, the uninsured dealer of photographic art would offer to pay the artist the cost of materials in the event of a loss. Though this arrangement was obviously unfair, many struggling artists were delighted to have the opportunity to display their works at any New York gallery and were willing to accept the risk of a loss at uninsured or underinsured outlets.

The Missing Artifacts
The Treasure Trove

*D*own the long and dark hall of the university's computer lab facility, I found the office of David Orwin.[1] Orwin was a friendly computer-program consultant who often provided an ear while I analyzed the art-theft data in the computer lab. With his hair covering his shoulders and very casual clothes, he was in distinct contrast to my conservative colleagues at the university. He was very oblivious, or at least indifferent, that his nonconformity set him apart from others. He seemed to say, "This is me; you don't have to look at me if you don't like my appearance." He had become very interested in the subject of my research and rarely saw me without asking about it.

"What brought you here?" Orwin asked with a smile.

Showing him the eight-page flyer containing pictures of the latest missing artwork, I asked, "Have you read the reward on the art-theft alert from the International Foundation for Art Research?"

"Let me see it!" he said, snatching the flyer from my hand and glancing at the advertisement for a $100,000 reward offered by Maxson

Young Insurance Company for information leading to the safe recovery of sixty stolen art objects.

Pushing his chair away from the computer table, he looked at me and asked, "What's the story?"

"About a week ago," I said, "a private collector residing in the Upper East Side of Manhattan lost a collection of sixty pieces of art, including twentieth-century art, tribal art, and antiquities, mostly small pieces. It must be very valuable because the insurance company requested IFAR to publicize the reward. IFAR mailed this art-theft alert to 10,500 collectors and other people. This is the largest collector's loss known in the United States."

"Do you have details of the theft?"

"Yes. Thieves leaped from the fire escape of an adjacent building to the collector's apartment and broke in through a window in the evening. They set off the alarm but had enough time to empty a wine carton and drawers and fill them with small sculptures and paintings."[1]

"When did the police arrive?"

"Over one hour later.[2] It must be a very busy day for the officers, I guess, because they usually arrived within twenty or thirty minutes."

News of missing collections of artwork from private collectors in the United States was not rare. Sometimes the most avaricious thief was a person who shared with a collector a fascination for art collecting. A case in point began in 1978, when Dr. Jane Werner, the founder and then director of the Tibetan Society, met and befriended Craig Warner, who introduced himself as a collector of Tibetan and Nepalese artifacts. She invited him to see her large collection in her apartment on the East Side of Manhattan, and Warner soon became her frequent visitor.

On Christmas Day, 1978, Dr. Werner's home was burglarized while she was away. Fifty-eight Tibetan and Nepalese works were taken. The police were suspicious of Warner and subsequently questioned him. After refusing to take a polygraph test, he vanished from the New York area. Ten years later, a friend of Dr. Werner noticed

that Warner's name had appeared on a communication from a Los Angeles organization involved with Tibetan culture. She wrote a letter informing the Los Angeles Police Department of Dr. Werner's theft and suggested that Warner was living in the Los Angeles area. Detective Martin from the Art Theft Detail was assigned to the case. He telephoned Dr. Werner, and she followed up this conversation with photographic evidence of her losses. Finding that Warner had three minor traffic arrest warrants, Detective Martin and his partner visited his home and requested permission to search the house. Noticing a bronze statue similar to the one Dr. Werner had reported missing, the detectives started to question Warner, who subsequently showed them the rest of Dr. Werner's stolen artifacts that he still possessed. The stolen works were hidden in the drawers of the living room furniture and in two footlockers in the trunk of Warner's car. For ten years, the thief had kept the stolen collection almost intact while he was living off his landlady.[3] No one knew whether he was trying to hold on to his loot until it was safe to sell it or if he was a thief possessed by the need to live with the artwork he could not legitimately own.

However large lost collections were, they constituted only a small number in the fast-expanding list of stolen art objects recorded by the International Foundation for Art Research since 1974. The Art Loss Register in New York contained an image database of some sixty thousand stolen works of art worldwide and was adding about two thousand new cases per month.[4] Many of these works were published in IFAR reports, listed under a variety of categories: fine arts, decorative arts, antiquities, ethnographic objects, Asian art, Islamic art, and miscellaneous objects. Each of these categories was, in turn, subdivided by object, type, and school. Thefts from private homes and churches were often reported in European countries where many country homes contained antiques and artwork, while in the United States, art galleries took the heaviest toll. While conducting my research in New York City, I was eager to probe into the

stock-in-trade of the New York art galleries, the question of whether or not thieves made choices when stealing, and the types and values of stolen artwork.

Since the rise of American Abstract Expressionism in the mid-1940s, New York City became not only the capital of contemporary art but also one of the major centers of the world's art trade. Sotheby's and Christie's, the two largest European auction houses, located their branches in New York City.

The principal feature that distinguished one gallery from another was the predominant style of the artwork, be it two-dimensional or three-dimensional. Whether the work was abstract or realistic was an additional stylistic marker. While abstraction is a trademark of contemporary art and work produced since the early twentieth century, realism dominates precontemporary art. Within precontemporary art, there are two periods: old and modern. Dealers generally use the term *old art* to refer to art created from ancient times to the age of Impressionism in the middle of the nineteenth century and the term *modern art* to refer to works made around the first half of the twentieth century. This term was also used to refer to the succession of avant-garde styles in art that had dominated Western culture almost throughout the entirety of the twentieth century.[5]

In the examination of thirty-four galleries specializing in realistic art, I discovered that sixteen mainly carried precontemporary art and eighteen mostly dealt in contemporary art. There was, then, almost as much precontemporary as contemporary realistic art on the market. Moreover, three-quarters of these galleries frequently carried realistic or semirealistic art, and only one fourth dealt primarily in abstract art. Most of the stock-in-trade was paintings. Also found, in order of frequency, were sculptures, prints, drawings, photographs, collectibles, ceramics, antiques, and other unspecified art objects.

At the surveyed galleries, the most common subjects were landscapes, followed by human subjects, still lifes, and abstractions. The majority of the traditional art was of medium size, around twenty

by twenty-four inches. Few paintings were very small because, as explained by one East Side dealer, "A painting must have enough space for a subject to be developed in sufficient detail."

The average number of art objects in a gallery was around seven hundred. Because a sheet of print took far less space than a framed print or a painting, a small gallery did not necessarily maintain less stock than did a large gallery.

Most galleries carried both two-dimensional and three-dimensional art objects. Two-dimensional works are primarily paintings and prints; three-dimensional works are sculptures, ceramics, and avant-garde art objects. Only one of the forty-five surveyed galleries dealt specifically in avant-garde art, I noted with some surprise.

In general, the value of art depends on the name of the artist, the quality of the piece, and the period in which the work was produced. The older a work is, the higher its monetary value. The majority of precontemporary artwork is realistic. Though an inexperienced viewer would not be able to tell the difference between precontemporary art and contemporary nonabstract art, there is a significant difference in terms of price, with precontemporary art most often more expensive than contemporary works. Being a contemporary product, the monetary value of abstract art is generally less significant than that of precontemporary art. Moreover, while realistic art is easily understood by the general public, abstract art is meant to go beyond realism and challenge viewers' ability to comprehend and communicate with the piece. As a result, abstract art was often more difficult to sell at the surveyed galleries.

Prices of objects for sale in these galleries ranged from fifty dollars for a contemporary print to several million dollars for an old master painting. The prices most often quoted were $1,000, $500, and $200, respectively, making it affordable for everyone. The wide range of the prices for art objects at these galleries was a testimony to the commercialization of art in the modern world.

To Catch an Art Thief

The Question of Selection

Many people believe that every conscious act has a purpose, and this assumption may lead dealers to think that a thief who enters an art gallery intends to steal art objects. Nevertheless, this may not always be the case. Given the chance, shoplifters will steal anything. Many dealers contend that if thieves steal art objects rather than the office equipment of the gallery, it is only because the opportunity to steal artwork is more obvious.

In galleries, items of value that are not art objects are generally placed in a designated office area if the gallery does not have a separate office. Stealing anything from this area is difficult because a receptionist, the dealer, or some person of authority is always around. A potential shoplifter could easily perceive that his or her chances of stealing an art object would be far better than making off with an expensive piece of office equipment. Data on larceny from my survey and police complaint reports further supported the incongruity between opportunity and choice. As indicated previously, a single object stolen per theft was the average and the most common, perhaps due to the fact that the offenses were largely committed in the presence of other people. In all twenty-seven shopliftings reported during my interviews, either the dealers themselves or their employees were in the showroom—circumstances making it difficult for thieves to take more than one item at a time.

Although my previous research and detectives' testimonies of their experiences revealed that burglars would steal anything upon entering a premise, I thought it was possible that art burglars were different from other types of burglars and might steal only artwork even though they had the opportunity to take nonart objects.[6] To test this hypothesis, I selected thefts of artwork from the incident reports of the survey and categorized them as "art only" and "mixed objects." A Soho dealer's recollection of two consecutive theft incidents that occurred at her gallery provides an example of the difference between the categories of "mixed objects" and "art only": "In the first incident, the burglars took

off with office equipment and three paintings. They seemed to like the pictures, so three nights later, they came back to get some more." (She did not explain why she believed they were the same burglars.) "This time they took only artwork, including two paintings and a large sculpture. It must have taken two persons to carry that sculpture to the front door. But I guess the alarm was set off, so they left it there." Thus, when a burglar took multiple art objects, it is possible that he or she chose art objects to steal.

My data on burglary showed that "art only" burglary incidents occurred over four times more often than "mixed objects" burglary incidents. This finding suggests that burglars broke into commercial art galleries to steal artwork, although they appeared to be interested in other objects every once in a while. An owner of a Soho gallery told me of an incident in which the thieves entered his gallery in order to gain access to the jewelry store next door. Although they had ample opportunity to steal artwork, they did not. Similarly, a dealer specializing in abstract art recounted an incident in which burglars broke a hole in the wall to enter the gallery and left with only office equipment.

A Thief's Choice

Small sculptures—those less than eighteen inches in length—were most often taken because they were easy to conceal and carry. This was evidenced in the case of Dr. Frank Waxman, who was charged with theft and possession of stolen property in 1982. When the police entered his apartment, they found a large collection of pocket-size sculptures.[7] Small objects were also easier to sell due to the greater demand for them. A Soho dealer specialized in glass artifacts explained, "Art buyers preferred small works of art because the majority of New Yorkers don't have large living spaces."

Though my survey revealed that more paintings than sculptures were in the art market, sculptures, particularly bronze ones, were the most common targets of shoplifting. Small sculptures are perhaps

easier to conceal under a coat than are small paintings. Given the same length, a statue would usually have a narrower width than does a painting, thereby making it less bulky. Furthermore, one East Side dealer told me thieves could sell bronze sculptures as valuable metal to be melted down for different uses. Therefore they could easily dispose of stolen sculptures, as an element of taste is not necessarily involved. In a 1992 case, Oather Blocker, a church organist and piano teacher in Manhattan and Long Island, confessed to burglaries at nearly five hundred churches and synagogues in New York, New Jersey, Connecticut, and Massachusetts. He had taken gold and silver ecclesiastical objects valued at $2.5 million over a ten-year period and sold most of them to a secondhand dealer to be melted down and resold.[8]

The second most preferred choice of shoplifters was small paintings—around eighteen inches in length—even though galleries usually did not carry many small paintings. Paintings were the most common type of art in most galleries and were usually more expensive than other two-dimensional works, such as drawings or prints.

In the absence of small paintings, drawings and prints, which often came in smaller sizes than did paintings, were most likely to catch the eye of the would-be thief. Although drawings are different from prints, they look alike to the unknowledgeable art viewer. The most important difference is that with prints, there are a limited number of reproductions signed by the artist, whereas with drawings, like paintings, the works are one of a kind and therefore more valuable. Furthermore, though drawings are mostly monochrome, prints can be multicolored and sometimes resemble watercolor paintings. There are also many varieties of prints due to different techniques of reproduction, including relief, intaglio, silk-screen, and lithograph. The value of a print depends on the name of the artist as well as the number of reproductions available. At the bottom of each print, next to the artist's signature, the number of the print is inscribed. For example, 2/50 means the print is the second one out of fifty published

reproductions. If the edition is very limited—to ten or twenty prints, for example—then the value of each individual print is higher. My discussions with dealers suggested that it was highly probable that dishonest employees most often stole prints because prints came in multiple sheets and it would be less noticeable for one of these rather than a one-of-a-kind artifact to be missing. These employees were probably responsible for a number of "mysterious disappearances" at several galleries. As noted previously, a publisher of contemporary prints reported fifty cases of "mysterious disappearances" over a one-year period. Although he was not sure all were the result of employee theft because it was possible that some of the prints had been misplaced or shoplifted, he planned to hire a full-time guard to watch his employees.

Besides sculptures, paintings, drawings, and prints, thieves appeared to select from a variety of handmade crafted objects, including ceramics, jewelry, and tapestries. Such objects were the third most often stolen by thieves.

I also noted with great interest that when the style of the stolen art object—realistic versus abstract—was taken into consideration, the element of offender choice became more apparent, further supporting my hypothesis that target selection existed in burglaries at art galleries. If thieves steal to supply goods in exchange for money, then buyers of stolen artwork dictate, directly or indirectly, what art should be stolen given the opportunity.

Of the 128 art objects lost to theft over a one-year period at sixteen of the forty-five galleries I visited, a mean of 3.3 works were stolen from the galleries carrying mostly realistic art and 1.6 from the galleries dealing primarily in abstract art. This finding suggests the demand for stolen realistic art was greater than the demand for stolen abstract art in those days. However, it might imply that, with respect to paintings, abstract works were more difficult to steal. I did observe that abstract paintings were usually much larger than realistic ones. In addition, since an art thief could be anyone who liked art, many of those who

stole art objects at these galleries for their personal enjoyment might have chosen realism over abstraction as it was easier to comprehend and appreciate.

Further analysis of the survey data revealed that the choice of art objects to steal in terms of value was less apparent than in terms of style. Although once in a gallery and given the opportunity a thief would take any work of art regardless of its value, a few dealers noticed that offenders tended to steal the most marketable and valuable art objects. This observation suggests that marketability of an object was the main attraction to thieves, if the opportunity to make selections was available.

Because the median value of stolen artwork per shoplifting was $9,500, with a minimum of $400 and a maximum of $275,000, I concluded that the typical loss to shoplifting at galleries was far less than the popular belief (six-figure sums). Loss due to employee theft, however, could be heavy. In the Mary Ryan Gallery case in 1988, Detective Moscardini learned that during the thief's one-and-a-half-year period of employment at the gallery, forty-one prints valued at $81,400 had gone missing.[9]

Certainly, dealers fear burglary most because of its potential to cause the greatest financial losses to their galleries. For one thing, the thief could plan the burglary and abscond with not only many objects per incident but also large objects. And though the artistic value of a work does not depend on the size of the piece, larger objects of the same quality fetch higher prices, particularly bronze sculptures, due to the volume of the material used. One Soho dealer contended that unless the work was very large, size did not hinder the burglar's choice. Although the ratio of art theft by burglary to art theft by larceny at art galleries was one to four, dealers were willing to spend up to an average of $10,000 on security measures, most of which were designed to prevent burglary.

So what type of artwork do burglars prefer? Paintings appear to be their first choice. Given the fact that the highest prices paid for artwork

in New York auction houses were often for paintings, if a professional art thief burglarized a gallery, he or she would most likely make off with paintings.

During the twelve-month period preceding the survey, the median loss per burglary incident was only $25,000, though that was still more than double that of shoplifting. The minimum loss per burglary was $250, while the maximum was $6,000,000. Similar to how it was with shoplifting, the value of stolen art per burglary was much smaller than popularly believed.

I was convinced that the public's knowledge was limited to reports of significant art thefts by the news media, a factor that resulted in misconceptions about the value of the majority of artwork on the market in New York City. The fact was that 75 percent of the forty-five galleries I visited carried mostly contemporary art, and very few contemporary works had reached their market value as determined by dealers. It should be noted that a contemporary art dealer may sometimes accept a consignment to sell a precontemporary picture, and a precontemporary art dealer may sometimes be interested in selling contemporary work for a client.

To Steal a Masterpiece

"Are you immersing yourself in your own world again? Your program is disconnected!" The male voice pierced the silence of my thoughts and startled me into the realization that I was, indeed, alone with the computer and my pile of completed questionnaires.

"Here comes the computer genius," I said half-jokingly and half-sarcastically without turning to the man who stood behind me. It was David Orwin.

"You are in a bad mood, aren't you?" Orwin asked.

"Maybe," I said, "but sit down, David, and let's talk."

"So how was your meeting with the chairman of your dissertation?" he inquired.

"It was OK," I said, remembering Professor Mueller's towering figure and the twinkle of delight in his eyes as he sat quietly in his armchair and listened to his doctoral student's report on her adventure in the art world. Then, becoming the investigator again, I asked, "What would you do if you were an art thief, David?"

"I don't know...I guess I would steal a million-dollar painting, so I wouldn't have to work for the rest of my life!"

"Good luck with that theft, David, because it will attract public attention. No one will want to buy your booty, and the FBI will hunt you down wherever you hide." I stood up and slowly walked toward the window. The twilight of the late spring day streamed through, bringing with it a touch of nature and enlivening the dreadful look of Newark. Leaning against the window, I said, "Last week you asked me if I had a model of decision making with regard to the theft of artwork. I have formed three. They are decision making in shoplifting, in employee theft, and in burglary."

"Great! Tell me then."

"I believe a painting is created when three essential elements come together—an artist having the need to create, a subject matter consciously or unconsciously known to the artist, and the artist's materials to create the illusion of that subject. The theft of artwork may occur when three factors are present—a motivated offender, a suitable target, and an opportunity.[10] Different offenders may be attracted to different types of crime. Therefore, those who are driven by art appreciation or knowledge may prefer to commit art theft as opposed to auto theft. Having chosen the appropriate crime, thieves select areas, galleries, and artwork particularly suited to their skills and purpose in order to execute the theft."[11]

"Interesting! But there are people who steal impulsively, too." Orwin seemed to be occupied with his own thoughts.

"You're right." I paused for a moment before continuing. "While searching for factors contributing to a thief's decision to steal artwork, I discovered that totally impulsive thefts are rare, as some planning is

necessary in most cases. An art thief must therefore consider suitable artwork and opportunities in order to steal successfully and profitably."[11]

"That sounds convincing to me! So what do you think a shoplifter, an employee thief, or a burglar will do?"

Encouraged by David's curiosity, I continued, "I noticed that there seems to be a logical relationship between the type of theft and the artwork stolen as well as the opportunity for theft. Different locations appear to offer or deny facilitators for different types of art theft because they provide specific environmental and situational opportunities. My interviews at Soho, Fifty-Seventh Street, and East Side galleries confirmed this belief by producing evidence of either shoplifting, burglary, or employee theft in varying areas of New York City. Dealers in Soho and on Fifty-Seventh Street commented that shoplifting was the most prevalent crime, whereas those on the East Side were preoccupied with burglary. One East Side gallery dealer reported that his gallery was victimized twice and then added, 'But this is very unusual. In this area, we most often hear about burglary.' His claim is supported by my data analysis of police reports showing that the largest number of complaint reports for burglary comes from the Nineteenth Precinct where the East Side galleries are located, while most of those for larceny were filed at the Eighteenth Precinct and the First Precinct, homes of Fifty-Seventh Street and Soho galleries, respectively. From the evidence I collected, it appears that a determined thief has ample opportunity to steal an art object by shoplifting, employee theft, or burglary in any of the three art districts of New York City."

"Wow! I'm learning something about the criminal mind!" Orwin said with a smile.

"And I'm beginning to wonder why you are so interested in knowing a thief's decision-making process in stealing artwork," I said, glancing at him.

He looked puzzled, and then, shaking his head, he broke out laughing and walked toward the door. His mass of silvery hair bounced like an ocean wave behind him.

Decision Making in Shoplifting

Shoplifters, like other businesspeople, select areas that offer opportunities for success. Just as businesses congregate in high-profile areas, shoplifters also find the busy corporate sections of the city, such as Soho or Fifty-Seventh Street, to be most desirable. To be successful in Soho, the thief must look over thirty years old. If an offender is nonwhite and does not know art, he or she will likely head to Soho.

Once a shoplifter has successfully blended in with his surroundings, he or she must have a variety of other opportunities to make the venture worthwhile. For a novice, galleries that do not have buzzers installed at the front entrance are favorable, as well as those that do not employ electronic check-point entrances, unless the thief intends to cut a canvas from its stretcher. Novice shoplifters also often operate at galleries that don't have a TV-monitoring system with attendants.

Crowded galleries with busy employees and objects with price tags give burglars enhanced opportunities for theft, as do galleries with "blind spots" and those without surveillance cameras. Shoplifters also prefer ground-floor galleries with easy access to the street, though they find that upper-floor galleries, not protected with buzzers, with rear exits close to a staircase or elevator are manageable.

Additionally, shoplifters know that when a gallery's receptionist's desk is located far from the entrance, they can leave the gallery undetected when the receptionist picks up the telephone to answer a call.

Unless the potential gain is worth the risk, the majority of the Madison Avenue galleries are not suitable for shoplifting because the typical gallery is very small, allowing employees to guard visitors easily. To be successful, a thief must plan to use the "grab-and-run" method and disappear into busy Madison Avenue, rather than into quiet East Side streets.

Galleries on East Side streets have fewer visitors than do the Madison Avenue galleries and use buzzers, opening the door only for desirable customers. Some galleries on the East Side have door guards

and cloakrooms for visitors' belongings, thereby denying a thief the opportunity to hide stolen loot.

The most important consideration of a shoplifter is size, even though certain types of art, like sculptures and realistic paintings, are often considered. Both common and professional thieves covet marketable artwork, and both kinds of thieves find galleries that use price stickers or price lists helpful in their quest. A "red-dot" sticker, indicating that an object has been sold, is a plum that any thief will pluck because its value has already been determined by its sale. Conversely, a large object, even if it is sold, is not as desirable, unless it is worth the risk of a "grab and run" and the tricky escape into a waiting car. A professional art thief will never steal a very valuable piece of art, since he or she is always trying to avoid intensive police investigation.

Decision Making in Employee Theft

Employees who steal often choose to operate in large galleries that have many employees, allowing them to avoid detection. They are more likely to work in print galleries, especially those housing many reproductions of contemporary prints. When one of these prints is stolen, immediate detection is unlikely, and delayed detection abets escape. Therefore, with only "cold leads" to follow, it is virtually impossible to track the theft.

These thieves prefer galleries that use manual rather than computerized record keeping, and those that rarely inventory their stock-in-trade. Indeed, in galleries where frequent inventories are conducted by an outside inventory specialist, employee-directors are less likely to use gallery artifacts as their personal property by displaying them in their private residences.

In print galleries, size of artwork is not a problem because prints can be rolled up unless they are excessively large. Popular, contemporary prints are very marketable, as are those of pop artists, such as Andy Warhol, or pictures of entertainment idols, such as Elvis Presley,

James Dean, or Marilyn Monroe. Since the demand for this type of art is high and the cost is very modest, these contemporary prints are easy to sell. As for paintings and sculptures, less valuable pieces that can easily be resold are desired targets for employees who steal.

Decision Making in Burglary

Burglars look for commercial areas that are busy by day but quiet in the evenings, having a minimum of nightlife. Therefore Soho and particularly East Side galleries, with the lack of frequent police patrols, offer attractive advantages to burglars. Burglars tend to avoid the frenzied nightlife of Fifty-Seven Street with its Broadway visitors and heavy law-enforcement presence.

Burglars also prefer galleries that carry realistic art, particularly old artwork. Street-level galleries, due to their ease of entry and escape, as well as storefront galleries and those on the upper floors of old buildings with many windows, are favorite targets. Storefront galleries usually do not have guards unless they are located in high-security business buildings, and many of the older corporate buildings do not employ twenty-four-hour guards. Burglars also target older buildings because they rarely have more than four or five stories, thereby making it possible to get onto the roof and enter through windows or skylight openings. Burglar alarms pose little problems for burglars, as long as criminals act quickly and allow themselves at least twenty minutes to escape before the police arrive.

Street-level galleries, which typically have apartments above them, are inconvenient because the tenants may be disturbed by the noise of a burglary. Modern business buildings, such as those on Fifty-Seven Street, are difficult to break into as well because guards patrol the entire ground, twenty-four hours a day. In addition, it is hard to access the roof of one of these high-rises in order to enter through windows or rooftop exit doors.

What types of artworks do burglars prefer? Commanding higher prices than other objects, paintings will likely attract their attention.

The Missing Artifacts

Unless the canvas is too large to carry, size is not typically a problem for burglars. Common and professional thieves may steal as many paintings as they can because they are often not aware the artwork's value and want to maximize their profit. Professional art thieves, however, generally select specific, marketable paintings and do not steal many objects at once, choosing to avoid media interest that triggers aggressive police investigation.

Partners in Crime
Dealers in Stolen Art

*P*erhaps there is some truth in saying that criminals need a lot of luck to stay in the business, considering the high level of risk inherent in their profession. This explains why most of them eventually end up getting caught, a detective once told me. He recounted a story of an April evening in 1992 when a burglar broke into a home in Los Angeles and stole six works of art, including a still life attributed to Bierstadt, a Picasso etching, and a Hartley self-portrait. On the way out, the thief saw the victim's BMW. He conveniently loaded the catch in it and drove away. Two months later, while the burglary was still under investigation, highway patrol police were notified of a five-car traffic accident in Ventura, California. What seemed like an ordinary event turned out to be the key in unraveling three unsolved art thefts and a hard-to-convict art fence.

At the site of the car accident, the patrol officers found that the negligent driver of a BMW had fled the scene and left his slightly injured female companion behind. While the woman was transported to a

local hospital, Officer Randy Klucker checked on the license plate of the damaged car and discovered that it was the same BMW that had been reported stolen. The police then questioned the female passenger about the driver. The resentful woman agreed to guide them to the Oxnard home of the driver, Michael Bell, who was on parole from Folsom Prison, where he had served time for burglary. However, Bell was not at home; a woman appeared at the door and said that she did not know where Bell was. The officers informed her of Bell's fleeing from the scene of accident and abandoning an injured female companion in the car. The woman was silent. She was his real girlfriend.

But the officers did not give up. They soon returned with a search warrant. Inside Bell's house, they found a Tiffany match holder and a computer, identified as stolen from the previous April residential burglary. Bell's girlfriend was apprehended and taken to the police precinct where she was questioned about the whereabouts of Bell's other stolen artwork. Resenting the fact that Bell had a female companion in his car, she told the police that Bell had taken them to his fence, Farhad Keshmiri Zadh.

Knowing the police were looking for him, Bell went into hiding. Eventually he made the mistake of telephoning his girlfriend to ask her to flee with him to Bolivia. She agreed to accompany him, and they set up a meeting date. When Bell arrived at the location to meet her, he found himself surrounded by detectives dressed in civilian clothes. She had set him up.

The stunned suspect was taken into custody and questioned. Hoping for a plea bargain, Bell identified Zadh, nicknamed "Freddy," as his fence. Armed with a search warrant for Zadh's home and place of business, the officers entered his penthouse in west Los Angeles and discovered a depository of artifacts, including works stolen from two other previous burglaries in Los Angeles. Though Zadh had initially denied any involvement with fencing activities, he subsequently led police to another location where he kept stolen artwork he had bought from Bell. In August 1992, he was convicted on the charge of receiving stolen property.[1]

A fence is a person who engages in the business of dealing in stolen property. Many fences are experts in the type of stolen merchandise they receive and in developing networks of contacts in a particular market.[2] Art fences specialize in dealing in stolen artwork. The scope of their fencing varies depending on the frequency of purchases and the degree of their art specialization.

Unlike unprofessional receivers of stolen artwork, who knowingly buy them for their own possession, art fences purchase them for resale at a profit. If they make a living from fencing activities, they are professional fences.[3] Because they know art prices on the world market, the best stolen art usually finds its way to professional fences.[4] Like other types of criminal receivers, they often run an apparently legitimate merchandise business, such as a pawnshop, a secondhand store, or a small art or antique gallery, where they receive legitimate or illegitimate customers and suppliers and keep a large amount of cash ready to deal with thieves.[5] A case in point surfaced in 1988. A pawnbroker named Robert Singer knowingly bought a stolen Rouault valued at least $250,000 for $60,000. The famous painting, *Christ*, had been stolen from an art gallery in Los Angeles in 1981.

Aware that California law prohibited a person convicted of receiving stolen property from operating a pawnshop, Singer pretended that he had attempted to verify the provenance of *Christ* by hiring a private investigator, William Cage, to determine whether the Rouault he was supposedly interested in buying was stolen. Cage checked the information with the International Foundation for Art Research and confirmed that it was stolen, which he reported to Singer. However, Singer claimed that his Rouault had a profile image of Christ, whereas the stolen painting had a frontal view. In 1987, he consigned it to Christie's, hoping to make a large profit. The auction house contacted Rouault's granddaughter in France to validate the provenance of the painting and learned that the Rouault in question was stolen. After this information was confirmed by the International Foundation for Art Research, Fritz Hatton, a Christie's senior vice president, contacted Detective

Moscardini. Moscardini immediately telephoned Detective Martin of the Art Theft Detail in Los Angeles to obtain a copy of the complaint report of the theft. Following Moscardini's advice, Christie's informed Singer that his painting had been stolen and refused to release the painting to him. Enraged, Singer denied that he had knowingly purchased a stolen object and claimed he had lost Cage's report of his findings. The case was brought to court, but Singer immediately pled guilty to the charges of criminal receiving and waived his right to a trial and a hearing.[6]

Art fences are more often than not members of the art market. They have art knowledge and contacts with dealers and art collectors. Without the formal trappings of a storefront business, such as refunds and satisfaction guarantees, private art dealers are well-suited fences of stolen art and indeed have been accused of operating as fences[7] Because dealers are aware of the possibility that their galleries might inadvertently carry stolen artwork, they often guarantee the return of clients' purchases. In one East Side gallery I visited, paintings sold to clients were accompanied with a certificate stating that the purchaser was entitled to return any painting within one year of the purchase if it was found to be stolen.

Familiar with the art market, art fences know offhand the going prices of artifacts. Inside information enables them to buy stolen artwork from thieves who often do not know the value of their loot. Their storefronts offer thieves a place where they might drop the loot as quickly as possible. They provide not only to sellers a haven where they might avoid the chance of being caught in possession of stolen goods but also to collectors—who cannot take the risk of buying directly from thieves—the opportunity to buy stolen art. Fences, therefore, create demand and supply the market for the thieves.[8]

As patrons of thieves, fences lend them money whenever they need cash and give them tips on locations of artwork to steal. Sometimes they educate good burglars on how to distinguish between valuable artifacts and introduce novice and solitary burglars to established gangs.

In other words, fences provide newcomers the opportunity to develop skills and to score.[9] To make an easy profit on art, they hire thieves to steal, and then they resell their booties.[10] According to the police report of the foiled 1986 theft of antiquities from Regency Warehouse in Queens, the fence, Daniel Kohl, was the leader of a network of burglars made up of at least fourteen thieves. Kohl, who pleaded guilty to robbery in connection with running a theft and fencing ring in 1987, operated internationally and specialized in the theft of and trafficking in artwork and antiques.[11]

Though fences work closely with thieves, they do not bear the risk because their low visibility and discreet contacts are legendary.[12] Their operations are covered by a veil of secrecy so thick that the police rarely can penetrate it. This method of operation makes it difficult for the authorities to obtain evidence of their possession of stolen artifacts that they know are stolen. Even if convicted, fences are most likely to receive probation because they are usually first-time offenders of a less serious crime.[13]

The low arrest rate of fences stems from detectives' practice of using fences for information about thieves and their activities. In return, detectives often give them warnings when they are under investigation. Though thieves are aware of this reciprocal practice and suspect that a fence who has never been arrested is likely to act as a police informant, they still prefer to do business with these patrons because if a fence gets arrested, his thieves will likely get arrested, too.[14]

Another reason for staying in the business of dealing with thieves is that though they might inform their patrons, the risk is not high because thieves do not benefit from destroying their receiving sources.[15] While any person on the street might be willing to purchase a portable radio or a TV set, stolen art purchases are not as easily available because artwork does not have a practical use. Without art fences, the bridge between demand and supply of stolen art would be severely damaged.

To Catch an Art Thief

Secret Transactions

The business of dealing in art has one thing in common with the resale of stolen art: buyers are not always easy to come by. Considering that this business depends on mutual trust between buyer and seller—a relationship that often takes years to groom—the art business is a labor of love for some dealers who said they wouldn't do anything else. Though many dealers shared the same passion as the artists, the business was not always easy because "every year, galleries in New York City sprout up and disappear like mushrooms," as an art dealer commented. This painted a sobering picture of the failure of some dealers to nurture a clientele who would keep their businesses afloat.

Ironically, though the majority of the dealers assumed that the primary motivation for stealing art was monetary gain, more than two-thirds of those interviewed contended that finding art buyers was hard work. One contemporary art dealer confided to me, "I have a hard time selling artwork; I don't know how a thief can easily find buyers." Added to that was the extra effort thieves must undertake to arrange for a fence or collector to dispose of the booty as well as the risk they take when a piece had been photographed.

Stolen art objects, however, might be easily disposed of because they are sold well below market value. Contemporary prints and art objects created by less popular artists command lower prices and thus might become logical choices of some thieves. Easily marketed and difficult to trace, lesser-known works of art could provide modest profits, especially for those who do not have a fence.

The paradox here is that though it is difficult to find buyers for valuable works of art, everything has a price—especially if the seller is willing to sacrifice. And whereas most dealers could not make the sacrifice and remain in business, thieves could and apparently did.

Then how cheaply could one purchase black-market art? A thief could expect to sell a stolen artifact for about 10 percent of its market value.[16] This estimate was further supported by the policy of a number

of insurance companies to offer a reward of 10 percent of the value of each stolen work for information leading to a partial recovery of a stolen collection. For example, in one theft in which a collection of thirty-two small sculptures was stolen, the informer reported the whereabouts of only fifteen pieces. He received a reward of 10 percent of the value of the items he had helped the police recover.

At times, valuable pieces of art were sold for a pittance. In 1992 a consignor took a Dubuffet sculpture to an auction house to sell. Upon researching the sculpture and its provenance, the auction-house staff found that the sculpture had been removed along with a Bottero sculpture from a stolen truck in 1990. Although their combined value was estimated at $500,000, police information revealed that the person who sold the Dubuffet to the consignor had bought both sculptures from a fence in Brooklyn for $250.[17]

One Soho dealer recounted the story of a small painting, valued at $1,800, that had been stolen from her gallery. On the afternoon of the same day, the dealer received a phone call from a man who said his girlfriend had unwittingly bought the painting for seventy-five dollars, or 24 percent of the cost. The caller had noticed a card attached to the back of the painting with the name of the gallery and the price. Realizing that the painting was stolen, he offered to return it to the gallery if the gallery would repay his girlfriend the seventy-five dollars she had paid the thief. Cheerfully, the money was refunded! Since the value of a piece of art does not depend on its size, a small painting is small enough to fit under a thief's coat yet potentially valuable enough to make the profit of 24 percent of the original cost a tidy sum for a thief's morning work.

Still, regardless of the price, selling stolen art is possible only if there are people willing to buy—an act, of course, that is a criminal offense. Because most people will refuse to buy stolen art no matter what the price is, thieves usually depend on art fences even though this may reduce the profit to a minimal amount. Other possible sources are available to thieves who do not have connections with art fences.

These include secondhand dealers, pawnbrokers, amateur collectors, art and antiques dealers, and anyone who likes art. Thirty-seven percent of my interviewees suspected that amateur collectors most often bought stolen art.

Though only one dealer I interviewed suggested dealers might buy stolen art, evidence of dealers' involvement in this crime was not difficult to prove. The International Foundation for Art Research had recorded a number of cases in which dealers were charged and convicted of buying stolen art. In one case, New York City police found that a Tiffany silver pitcher stolen from the Detroit Institute of Arts in 1989 was bought by an antiques dealer at the Place des Antiquaires in the same year.[18] Likewise, Madison Avenue art dealer Michael Weisbrod bought a Ming bowl stolen from the Columbus Art Museum in 1989. He was sentenced to six months in prison and six months of home confinement after entering a guilty plea.[19]

Notwithstanding these incidents, whether or not it was a practice of art and antiques dealers to buy stolen art was a question that puzzled me. The fact that thieves were known to offer stolen art to dealers suggested that besides auction houses, galleries were one of the principal means by which they could dispose of stolen works. In New York City, stolen art often turned up not only at auction houses and art and antiques galleries but also at the flea market on West Twenty-Sixth Street, as well as at numerous pawnshops and outlets of secondhand dealers.

Other buyers, though not as easily accessible as galleries, also provide an alternative to the fence who makes a regular profit from dealing in stolen art. The possibility of selling stolen art might increase, depending on the type of collectors with whom the thief happens to meet. In particular, there is a distinct difference between amateur collectors and private collectors. While amateur collectors buy a number of artwork, primarily to satisfy their interest in art, private collectors take art collecting seriously. Their collections often have certain aesthetic directions—they may be made up of Oriental art or modern art,

for example—and the collectors often get involved in trading as well. As one dealer in precontemporary art remarked, "Except for some rare collectors, like the late Nelson Rockefeller, who held on to his collection, every private collector is a private dealer." In contrast, people who simply like art are not collectors because they might buy only a few art objects in their lifetime and never trade them.

In retrospect, some of the most well-known collectors had admitted to purchasing stolen art. Norton Simon, a major collector in Asian art, knowingly purchased a bronze Shiva that had been stolen from a village temple in southern India. He spent from $15 to $16 million during a two-year period on Asian artifacts, most of which were smuggled.[20]

News of collectors buying stolen art appeared in newspapers every once in a while. In 1996, New York City financier Barry Trupin was found guilty of buying a stolen Marc Chagall, *Le Petit Concert*, completed in 1968, near the end of the artist's career.

Trupin, a fifty-nine-year-old, self-made millionaire from Brooklyn, was known for his extravagant lifestyle during his successful business years in the 1980s. But his luck seemed to cease when his dubious dealing in art caught police attention. Raul Zuniga, a sculptor who had done commissioned works for him, testified in court that he had bought, in 1979, a stolen Chagall for $100,000 in addition to a Picasso for Trupin from Angelo Jack Inglese. The seller was suspected of having connections with the burglars who stole these paintings and other valuable paintings of lesser-known artists from the home of a Baltimore car dealer in 1970. According to Zuniga, the purchase had been conducted in a car on a highway near Kennedy Airport. Both paintings had been carelessly wrapped in brown paper, and neither bill of sale nor provenance was given to Trupin. Later, the Chagall was kept in his yacht behind heavy doors that Zuniga had carved. Curiously, the financier neither insured nor appraised this painting, and for ten years it remained there if not in his mansion in South Hampton. In the late 1980s, Trupin's business, Rothchild International, came under the Internal Revenue Service's scrutiny, and his wealth

began to disappear. Faced with financial ruin, the financier tried to sell the Chagall, then worth more than $1 million on the black market in 1990 through his two associates, James Ewell and Irving Ayash, a real estate broker. When these men attempted to sell it in Manhattan for $300,000, an interested purchaser contacted the police. The FBI got involved in the case and set up a bust-and-buy operation where the paintings were seized and the sellers arrested. Ayash later agreed to cooperate with FBI agents and made tape recordings of telephone conversations with Trupin in which the latter, after learning that the FBI was pursuing the case, begged Ayash to save him. He said, "You've got to protect me. You've got to keep me as safe as you can." At his trial, his attorney, David Spears, argued that his client did not know the Chagall was stolen. In addition Zuniga was considered an unreliable witness for telling federal agents several different stories about how he obtained the stolen paintings before arriving at the version he told on the witness stand. Ultimately the prosecutor said because Trupin had insured all his valuable possessions but the Chagall and did not put this painting on auction clearly suggested that he knew the painting had been stolen.[21]

Although none of the dealers I interviewed had ever purchased stolen art, almost half found that a primary attraction to buying from the black market was the business profit of untraceable goods. Once a dealer had found a buyer, his or her risk of being arrested for fencing was remote. In addition, if the dealer had purchased the artwork abroad and still possessed it, his greatest risk would be an order from the court to return the stolen work to its rightful owner. This was exemplified in the case of dealer Peg L. Goldberg, owner of Goldberg and Feldman Fine Arts Gallery in Indianapolis, Indiana. In 1988, Golberg traveled to Amsterdam to meet Michel van Rijn, a Dutch dealer who had been convicted of forgery in France. He showed her the photographs of four Byzantine mosaic fragments, one of which was very rare because it depicted Christ as an adolescent. It was through Robert Fitzgerald, an Indianapolis art dealer and a friend of the Dutch dealer,

that Goldberg learned that the mosaics were for sale. Van Rijn also told her that the mosaics belonged to Aydin Dikmen, a Turkish dealer, who claimed he was the official archaeologist for the region of Cyprus and that he had found the mosaics in the rubble of a Cyprus church and legally exported them to Turkey. This man, too, had previously been indicted but not convicted for smuggling antiquities. These mosaics, considered to be among the three oldest sets of Byzantine mosaics in the world, had been stolen from a fifth-century church, the Church of the Kanakaria, and taken out of the country by the Turkish army that invaded the northern half of Cyrus in 1974.

In Geneva, Goldberg entered the transaction with Dikmen after obtaining a loan of $1.2 million from an Indiana bank. She paid $350,000 to the seller and $650,000 to Fitzgerald and kept $120,000 for herself. Upon returning to the United States, she contacted Getty Museum officials and offered the mosaics for $20 million. Suspicious that the antiquities were stolen, Getty officials suggested that she contact Cypriot authorities. While Goldberg was trying to find buyers for her new acquisitions, a Cypriot clergyman representing the Greek Orthodox Church of Cyprus and the Cypriot government filed a lawsuit against her alleging that she did not attempt to learn whether the antiquities were stolen and requested their return to the Church of Cyprus.

At a court hearing in 1989, Goldberg's attorney claimed that she was a naïve and careless purchaser of the stolen antiquities. But the federal judge decided that she had not exercised due diligence in trying to learn whether the mosaics had been stolen or smuggled from Cyprus. In addition, she had knowledge of van Rijn and Fitzgerald's questionable deals in the past but did not make every effort to clarify the origin of the mosaics, including making contact with the International Foundation for Art Research and officials of the Church of Cyprus. Therefore, she was not considered a good-faith purchaser. The judge ordered her to return the mosaics to the Greek Church without any other penalties.[22]

To Catch an Art Thief

For shady dealers, buying stolen art was just a part of doing business, and considering the profits to be made, I was not surprised to find that some art dealers fall prey to the allure of easy money. In one notable case, Chris Lewis, son of comedian Jerry Lewis, went well beyond buying stolen art when, in 1990, he burglarized a storage facility owned by American Design Limited and stole 168 prints to stock his gallery. Two years later, the police identified him as the seller of some of the stolen prints and searched his home and gallery, where they found another 120 stolen prints.[23]

Sometimes, stolen artifacts are bought because art objects on the legitimate market are too expensive or because the desired works are not available for purchase. And though some art dealers are lured into purchasing stolen art in hopes of easy profits, some had to rely upon the purchase of stolen works to bolster their inventory because demand for old artwork far exceeds supply. If the stolen works are very valuable, these unscrupulous dealers would keep them for years before attempting to sell them. Such was the plan of an Italian dealer who tried to sell stolen artwork in the United States, which caused him to cross paths with Detective Moscardini.

One late afternoon in 1988, Moscardini and US Customs Agent Louis Carducci came to a World Trade Center restaurant to meet Caligero Migliore, an Italian diamond appraiser. Through a confidential informant, Carducci had learned that Migliore had sixteen valuable paintings for sale. They were works by Brueghel, Ter Borch, De Pape, Vranckz, and Teniers, all believed to have been stolen in Belgium seventeen years ago.

Migliore told the disguised agents that the collection was worth several million dollars but he would sell it for $1 million because the paintings had been stolen in two separate burglaries, the first in 1970 and the second in 1971. In 1971, he had been able to smuggle the paintings out of Belgium by boat. Two years later, while attempting to follow his looted treasure, he was arrested by Belgian customs agents who found the photographs of the stolen paintings in his possession. Though he denied

140

any knowledge of the whereabouts of the paintings, he served two years out of a three-year term for possession of stolen property. Thirteen years out of prison, he was now trying to make his trouble pay off, hoping time would erase the paintings' questionable past. Moscardini had quietly listened to the diamond appraiser and then calmly told him that he would have to check out the seller's information and would meet with him at a later date. He then contacted the International Foundation for Art Research and Interpol, who radioed Belgian authorities and learned that Migliore's story was true. Moscardini immediately set up a meeting date with Migliore and asked him to bring the Teniers painting to a Soho gallery where they could examine the quality of the work and discuss the purchase of the entire collection.

On the meeting date, Migliore arrived with the Teniers. Hoping to recover as many stolen paintings in Migliore's possession as possible, Moscardini told him that the asking price was too high and requested him to return with more paintings so that his expert in old master painting could appraise them before he paid Migliore. The unsuspicious dealer agreed to return to the gallery later that day. Little did he know a team of police officers posing as gallery employees and hiding throughout the gallery were watching him leave the building and then awaiting his return.

That afternoon, after Moscardini had seen Migliore's four additional paintings, he commented that they looked good and said he would like to telephone his expert to come down to the gallery to appraise them. As soon as the backup police officers saw him leave the room, they moved in and apprehended Migliore.

Still, Moscardini wanted to retrieve the eleven remaining paintings. He worked out a scheme with Paul Gardenerphe, the assistant US attorney, who then offered Migliore a plea bargain in exchange for the return of the remaining stolen paintings. Migliore revealed that they were stored in the parcel post room at 625 Eighth Avenue. Did Migliore lie about the value of the stolen collection? Sotheby's appraised them at $1.75 to $2 million.[24]

To Catch an Art Thief

Valuable artwork attracted fences who, like Migliore, would not hesitate to go to prison in exchange for their possession because the shortage of precontemporary artifacts within the legitimate art market had caused prices to skyrocket. In one gallery, I noticed Matisse and Bonnard drawings commanding $75,000 prices. Lamenting his predicament, a dealer of precontemporary art confided to me that he could "no longer afford to buy old paintings" and had passed up a painting that cost $80,000 the previous year only to find the same painting at an auction later going for $125,000. Sharing the sentiments of this dealer, some adventurous collectors turned to risky contemporary art, which enjoyed a three-year boom before the decline of the art market in 1990 and 1991.[25]

Although the dealers claimed that they never bought stolen artifacts, more than half of them had been asked to buy stolen art in the past. Many dealers, however, did not ask for the provenance of the work. One Soho dealer recounted, "Sixteen years ago, a woman came to my gallery with a Picasso drawing that was rolled up. I noticed that her clothes were taped up in places...When she told me she would like to offer the drawing for sale, I asked her the provenance of the work. But she said she didn't have it because it belonged to her family. I thought the drawing deserved some respect and wrapped it for her. Apparently, the *New York Observer* sent her out to thirty galleries. I was the only dealer who asked for the provenance."

However, a provenance can easily be faked. For a price, an individual would certify that the stolen art was a part of his or her family collection.[26] Also, a thief might place the stolen artifact at an obscure auction house and then buy it to establish a provenance.[27]

The number of offers to buy stolen works had been relatively constant during the five years prior to my survey, suggesting that it was a common practice of thieves to ask dealers to buy stolen art. In the year preceding my visits, one-fourth of the dealers were offered stolen art to buy. Though one dealer had been approached to purchase stolen art as many as fifty times during a one-year period, the average response was

less than two times. This discrepancy suggests that some dealers were more targeted than others.

Art dealers were undoubtedly approached by a large number of patrons, including art lovers, collectors, artists, and other dealers, on a daily basis. Among the legitimate mix of individuals seeking to sell art, thieves must also make initial contacts to show or describe the art they have to sell. In most cases, an individual simply walked into the gallery and approached the dealer. A number of dealers received telephone calls regarding the sale of a questionably obtained artwork. Some experienced both in-person and telephone solicitations. What caused a dealer to become suspicious? One dealer suspected the work that a caller offered for sale had been stolen when the seller told the potential buyer that his cousin had recently given him the $20,000 print. He told me that he did not believe that anyone would give away a $20,000 object in such a casual fashion.

While stolen art was most commonly marketed in person, this was often the riskiest approach for the seller. One reason was that unless the seller was extremely professional, his or her personal appearance and general demeanor could create immediate suspicion. In describing such an encounter, one interviewed dealer related that "the seller just didn't look like someone who would own the artwork," and another, an East Side dealer, remarked, "The artwork just didn't match the seller."

If a dealer's suspicion about the seller's appearance is not enough, the art offered for sale might, in and of itself, confirm that it was stolen. A precontemporary dealer became immediately suspicious when a suspected art thief asked him to buy twenty-one paintings that he recognized as having been stolen from a Zurich gallery. As soon as the seller left the gallery, the dealer telephoned the FBI, who later apprehended the suspect. Nearly one-fourth of the interviewed dealers said they would notify the FBI or the International Foundation for Art Research if confronted with similar situations, and well over half of them said they would report their suspicions to the police. A few dealers said they would decline the offer to buy stolen art and withhold

reporting the incident to the authorities. One print dealer told me he would buy the stolen art and return it to the owner later because that was the fastest way to recover stolen property.

According to the majority of those interviewed, most art stolen in this country was sold in the United States rather than abroad, and over one-fourth suspected that art stolen in New York City was likewise sold in New York City. Theoretically, this should reduce the recovery time of finding missing artwork. For example, in November 1990, a second-century Roman marble sculpture, valued at $90,000, was stolen from the Daedalus Gallery on Fifty-Seventh Street in New York City, and only four months later, the thief consigned the piece for auction at Christie's, located only three blocks away from the victimized gallery. Recognizing the stolen sculpture, Christie's personnel cooperated with the police by convincing the consignor to return to the auction gallery, where he was apprehended.[28]

While precontemporary artwork has an international market, contemporary art is primarily local and thereby very convenient for the thief.[29] Similar to the case of the marble sculpture stolen from the Daedalus Gallery, an Egyptian bronze figure of a god of the under-world, valued at $50,000, was discovered missing from the University of Pennsylvania Museum in 1988. Although the theft was publicized, a museum volunteer spotted the stolen statue three years later while shopping at a South Street antiques gallery in Philadelphia.[30]

The Hunt for Art Vultures

Who Stole the Renoir Portrait?

*H*e was a cop who could not separate his life from his work in spite of the prospect of early burnout from the job. In his off-duty hours, Leon Smith frequented a nondescript bar in New York City where he listened to customers' conversation while drinking beer or playing cards, hoping to catch information from the underworld. It was there that he first met Frank DeMichele, nicknamed "Beef," in 1983.

During the last week of March 1985, Beef approached him in the crowded bar and whispered in his ear that a painting by Rembrandt, worth $500,000, was for sale. Five weeks later, Smith reported the incident to Lieutenant John Kelly, who called Moscardini into his office and passed the information to him. Moscardini immediately checked his files of art-theft complaint reports and called the International Foundation for Art Research. To his disappointment, no missing Rembrandt had been reported.

At a subsequent meeting with Smith, Beef secretly handed him a photograph of the painting. It was *Portrait of Madame Louis Prat*, painted by Renoir in 1913 and reported missing from the Wally Findlay Gallery in February 1985. The painting was twenty-four by twenty-one inches and valued at $275,000. A meeting with Moscardini, who would disguise himself as the interested purchaser of the work, was scheduled. Several days later, however, Smith informed Moscardini that Beef could not meet with him on the date agreed and that they would arrange a new date for the meeting.

Launching his investigation, Moscardini went to Findlay Gallery to interview the complainant and showed photographs of the painting, Beef, and five others. Gallery officials could not recognize any of the men and said the painting had been transported from an exhibition at an Oklahoma City gallery to the Findlay Gallery in November 1984. Because gallery records did not show the receipt of the painting, it was reported missing to the police.

While waiting for a new meeting date to be confirmed, Moscardini was again informed that Beef could not meet with him that week because he had to go to a hospital for a few days and a new date would be arranged again. In the meantime, the detective contacted a West Broadway dealer and requested his cooperation in this case.

On May 29, 1985, surveillance officers observed Smith and Moscardini, disguised as an art dealer and equipped with a recording device, as they met with Beef at a sidewalk cafe on the corner of McDougal Street and West Eighth Street. The seller was a white male with grayish hair wearing glasses, navy pants, brown shoes, and a short-sleeve beige shirt. He was approximately five feet eleven inches tall and weighed about 280 pounds.

Introducing himself as an art dealer, Moscardini said, "Just so there's no mistake, I understand you have a stolen painting by Renoir entitled *Portrait of Madam Louis Prat*."

"Yes, that's the piece I have," Beef responded and agreed to sell the painting for $130,000. To ensure that Beef would walk into his

trap, Moscardini protested that he wanted to authenticate the painting before money changed hands and the transaction was completed. Beef promised to bring it to the same place two days later. The conversation lasted for about ten minutes. Three officers sitting at a nearby table observed Beef leaving the café in a tan Thunderbird parked on McDougal Street. The driver was Thomas Tuzzolo, a white male with dark hair and in his early thirties.

On the designated meeting date, Beef again did not appear. After Moscardini had left, the surveillance team waited for two more hours and then left the location.

Four days had passed before Beef finally appeared at the same sidewalk café to meet with the disguised detective, who then convinced the seller to bring the painting to the buyer's nearby gallery so that he might authenticate it. On June 4, 1985, at approximately two in the afternoon, they met at a gas station at the corner of Broome Street and West Broadway. Beef and Smith followed Moscardini to the gallery of a prominent Soho dealer who had agreed to cooperate with the investigation, while Tuzzolo drove to the gallery.

At the meeting location, Tuzzolo carefully removed an object wrapped in a blanket from the trunk of his car, and Smith quickly took it. Leaving Tuzzolo waiting in the car, the men entered the gallery and walked toward the office located in the rear. They passed the showrooms full of customers and gallery workers who were, in fact, undercover officers waiting to assist Moscardini in the arrest of the suspect. Once in the office, Moscardini proceeded to unwrap the painting Smith had placed against the desk and carefully examined it, while Beef stood waiting nervously. Giving the appearance of being satisfied that the painting was indeed a Renoir, he walked over to the entrance door of the office, opened it, and gave the passwords "come in" to the undercover agents. As the team entered, he quickly secured the painting and placed Beef under arrest. Outside the gallery, Tuzzolo was also arrested by an officer of the surveillance team.[1] The director of this Soho gallery, I should note here, talked about this incident during my interview five years later.

To Catch an Art Thief

A successful art-theft investigator must possess the same skills used in other types of detective work—namely, informant development and maintenance, the use of surveillance, and acting in an undercover role—but must also have knowledge of art and familiarity with the art community.[2] Such were the qualifications of Detective Moscardini, who, besides being the only full-time art-theft specialist at the Art and Antique Investigation Unit, had the unusual role of public relations officer. In fact, he was the all-important link between the art world and the New York City Police Department.

The success of Moscardini's investigations depended significantly on the information network existing within the art community. Since most missing artifacts would eventually turn up at galleries and auction houses for authentication, appraisals, and resales, one of his tasks was to maintain contact with directors of these establishments in order to receive notice should the work under investigation appear. Art and antiques dealers and staff members of other organizations, such as the American Association of Art Dealers, the American Stamp Directors Association, and the American Philatelic Association, often notified him when someone came to their offices for an appraisal of suspected stolen art or to sell stolen artifacts. Looking for stolen artwork and the opportunity to catch thieves and art fences, he also made regular visits to flea markets, pawnshops, and secondhand dealers' outlets.

Moscardini usually selected a case to investigate after evaluating all the information pertaining to that case. If his chance of making an arrest or recovery was substantial, he pursued the investigation. As expected of an art-theft specialist, his prediction of each case's outcome was correct most of the time.

Typically, a complaint report having sufficient information and filed with the Art and Antique Investigation Unit was initially handled with a telephone call from Moscardini to interview the victim for additional information if the value of the loss was substantial. Often following up with a visit to the gallery, he looked for evidence that might lead to the identification of the suspect or individuals involved in the crime.

Combining details of the theft with information about the stolen art, such as the title of the work, the artist's name, the country of origin, the provenance, the name of the art insurance company, the size and subject matter of the piece, and the work's value, Moscardini could then formulate the direction of the investigation and possibly identify a theft pattern.

If evidence indicated that the theft was committed by a professional thief, the detective would seek out all possible leads in hopes of arresting him or her. If, however, the theft appeared to be the job of a gang that left its stamp on the crime scene, he would concentrate on the whereabouts of this gang. Each gang had its own modus operandi, with several affectionately referred to as the "Entry-from-the-Roof Gang," the "Family Gang," and the "Smash-through-the-Window Gang."[3]

After collecting sufficient information to decide whether or not to pursue the case, if the chance of making an arrest or recovery was good, Moscardini would then notify other law-enforcement agencies, appropriate non-law-enforcement groups, the media, and his confidential informants.

Sometimes the resale of stolen art involved an international market. This outcome would prompt Moscardini to send notifications of the theft to US Customs and the North America Interpol office located in Canada. Depending on the urgency of the alert, notifications would be made by telephone, facsimile, or letter. Interpol would translate his report into French and Spanish and assist him as an investigative liaison worldwide. Moscardini would also communicate the alert within his department via department circulars and use his agency's intercity correspondence unit to send nationwide alerts about the lost item.[4]

Throughout his investigations, the detective maintained close contacts with the International Foundation for Art Research, which had the largest and most complete computerized listings of missing artifacts in the world.[5] By assisting dealers in recognizing stolen art objects available in the legitimate market, this nonprofit organization was able to prevent the resale of stolen art and aid in its recovery.

Moscardini also routinely forwarded information about stolen art to the FBI to be entered into their computerized National Stolen Art File. If the stolen art was a collectible stamp, he notified the American Stamp Collectors Association; if it was a coin collection, a notice was sent to the American Philatelic Association.

The detective made every effort to leave no stone unturned. Thus, if the stolen artifact was damaged, specialists in art restoration were contacted in hopes that the thief might attempt to have the object restored. Likewise, if a stolen painting was not framed, framing galleries were alerted. However, due to the heavy caseload, priority in the distribution of notices and personal contacts was given to cases in which the value of the stolen art was substantial.

Although the press was the fastest, most convenient, least expensive, and most thorough means of mass communication available, the New York City Police Department preferred not to use it unless it was a major art-theft case. Historically, it was not unusual for a case to get out of the control of the police and become an agency's nightmare once it received a lot of media attention.[6] Therefore Moscardini preferred the traditional method of using confidential informants. This was a common law-enforcement practice and allowed information to stay within the agency. Being a detective, Moscardini was pressured to produce convictable suspects in courts and therefore forced to develop his private sources in the community to keep him abreast of art theft.

Confidential informants were a crucial link in Moscardini's search for a suspect and in establishing the whereabouts of a piece of stolen art. Informants were often former convicts with whom he had developed a working relationship based on their ability to provide information of interest to him and his power to protect them from the grasp of the criminal-justice system if they committed misdemeanors. With knowledge of their past criminal records and present criminal involvements, he could extract from them information about underworld activities. They were, however, asked not to give information to other detectives. Because he "owned" them, other detectives would not approach them

for information without his consent. Furthermore, a detective's invading another detective's informational domain is considered unethical.[7] Registered with the county district attorney's office with code names, confidential informants sometimes received payment for their information and also enjoyed reciprocal exchanges of favors between them and their detectives.

During the course of an investigation, Moscardini notified his confidential informants of the missing artwork and requested information about the suspect and the whereabouts of the stolen artifacts, which might already be known to them. Similar to how it is in legitimate society, there exists in the underworld a prestige resulting from success—the more successful a thief, the greater the respect bestowed upon him or her by fellow thieves. As a result, many art thieves talked and bragged after successfully pulling off a job and thus spread news of their heists, which eventually reached Moscardini's informants. Such were the circumstances leading to the arrest of the thief of Rodin's *Mask of the Man with Broken Nose* from the Philadelphia Museum of Art recounted in "Portrait of an Art Thief." The robbery was so violent that the FBI and the police immediately embarked on an intensive hunt for the suspect. Perhaps because of the media attention and public awe of the first armed robbery in a major American museum, the criminal, a twenty-four-year-old unemployed truck driver, bragged about the theft to some of his acquaintances. The information soon reached Philadelphia law enforcement authorities, and they placed him under surveillance. After a museum guard had identified him as the robber from a photograph, he was arrested and charged with armed robbery.[8]

Since the recovery process could take months or years, Moscardini had to be patient and keep communications open. In one case he received a phone call from an art dealer who informed him that a person had brought a stolen artwork to the dealer's gallery for authentication and appraisal. Instructing the caller to keep the client in the gallery until he arrived, Moscardini was able to arrest the suspect for possession of stolen property.

In the foiled theft of Middle Eastern antiquities in New York, an informant alerted the police to a planned burglary of Regency Worldwide Packing Inc. in Long Island City. At midnight a team of fifteen police officers staked out the warehouse where the two crates containing Middle Eastern antiquities valued at $18 million were stored. They observed three men arrive at one o'clock in the morning, break a concrete wall with sledgehammers, and crawl inside the warehouse. The burglars soon emerged with two containers marked *HM* for *Houshang Mahboubian*, the owner, and loaded them into their getaway cars. Before they had the chance to drive away, the police moved in and apprehended them. Among the arrestees were Daniel Kohl, Thomas May, and the informant. Another man, antiques dealer Nedjatollah Sakhai, who conspired in the burglary, was also taken to the police station for questioning. The police revealed that the thieves belonged to a ring of burglars who had been under surveillance by police following an informant's tip.[9]

While a case was active, detectives looked for information from all sources. Prisons were one of them. After the theft of *The Birds of America*, an Audubon hand-painted, engraved book that measured thirty-nine by twenty-six inches and valued at $80,000, Vermont police had their ears everywhere, listening to information about the whereabouts of the stolen book. The culprit had pried open the iron bars covering the Norman William Public Library's basement window in 1994, went straight to the glass display case on the main floor, and stole the work.

Woodstock police received what they wanted when a prison guard in New York informed them that he had overheard a discussion about fencing a stolen Audubon between Patrick Terry and Jay Weinberg, two inmates at the Sullivan Correctional Facility in Fallsburg, New York. Terry was serving time for his involvement in a murder case and Weinberg for grand larceny, insurance fraud, and conspiracy. Both men were previously incarcerated in Clinton Prison in Dannemora, New York, where they met another convict, Gary Evans.

Convicted of the sale of items stolen from a Vermont antiques gallery, Evans was sent to the Albany County Jail and released a month before the theft of the Audubon book. Through an informer, the police learned that Evans had contacted Terry, who was still in Sullivan Prison, to approach Weinberg about finding a fence for the stolen *The Bird of America*. Evans had stated that he wanted $60,000 for the book. Upon receiving the tip, Woodstock Police Chief Byron Kelly forwarded the information to the FBI's office in Ruthland, Vermont. FBI agents were sent to Sullivan Prison to persuade Weinberg to cooperate with the authorities. Weinberg agreed. Following the FBI's plan, Weinberg put Evans in touch with an outside contact, an underworld figure who had agreed to assist the authorities. At a subsequent meeting with this individual, Evans gave him several color photographs of the stolen Audubon that were later positively identified by Marjorie Vail, the assistant librarian of the Norman Williams Library.

Arrangements were made for undercover FBI agents to act as interested collectors and meet twice with the seller. But Evans, experienced in selling stolen artifacts, became suspicious and did not carry the book to their meetings. Hoping that some pressures would make Evan give up the Audubon, Chief Kelly issued a press release offering a $4,000 reward for the return of the stolen book. The trick worked, for, afraid that he might be the target of the police, Evan turned himself and the book in to New York State police.[10]

Sometimes Moscardini was prepared to solicit cooperation from a thief to solve a more serious art-theft case. This practice existed at other police departments as well and was exemplified in a 1987 case involving a stolen Potthast. After stealing the Potthast painting, *Seashore with Women and Children at Play*, Jacob Schott transported the stolen work from Cincinnati, Ohio, to Indianapolis, Indiana, and sold it to an art dealer. A gallery owner saw it surface in Santa Fe, New Mexico, and reported it to the International Foundation for Art Research. The Cincinnati police were contacted, and Schott was arrested. However, the police wanted to convict one of his associates in crime, Ted Rudder,

a dealer in Indian art from Columbus, Ohio. Rudder had been the FBI's target of investigation for his involvement in a string of burglaries in which valuable art and antiques were stolen. To apprehend Rudder, the FBI pressured Schott to cooperate with the authorities in gathering evidence against Rudder in return for lesser charges. Schott turned over to the FBI tapes of his telephone conversations with Rudder. Moreover, during a visit at Rudder's home, he wore a radio that transmitted the details of their conspiracy to commit an upcoming burglary to task force agents in a nearby car. As a result, Rudder was arrested in a restaurant parking lot where he was supposed to pick up Schott on their planned burglary trip. A grand jury indicted Rudder on thirteen counts of mail fraud and interstate transportation of stolen property. He was convicted for conspiring to case and burglarize a home in Cynthiana, Kentucky, transporting stolen paintings, and committing arson at the Paisley Palace in Grangeville, Ohio.[11]

Because stolen artwork is often transported to other countries for resale, open communication with foreign law-enforcement authorities is a must. The French police reports of how the nine Impressionist paintings robbed from the Marmottan Museum in 1985 were recovered reveal the international nature of art-theft investigation.

For three years following this notorious armed robbery, a thirty-member special unit devoted to art theft, headed by French Commissioner Mireille Balestrazzo, patiently gathered information on the whereabouts of the stolen Impressionist paintings. To establish some direction for the investigation, the unit kept its information network open with police agencies all over the world. The investigation was progressing slowly because Balestrazzo feared that a wrong move would risk the destruction of the important artwork. But her patience paid off. On the fourth year of the search for the suspects, she received the first crucial tip from Japan, allowing her to orient the investigation to move quickly and accurately. Apparently, a Japanese police officer, in the course of questioning a local organized crime network, learned that the stolen paintings were intended to be sold in Japan. Subsequent

The Hunt for Art Vultures

French police investigation unraveled the mystery that had surrounded the robbers: the robbery was not the job of professional art thieves but of common criminals who had tried their hand at valuable artwork and could not dispose of their loot in Europe because the works were very well-known. They tried to sell the stolen pictures abroad. However, a deal with a Japanese collector had fallen through, and the paintings were left abandoned in Corsica. After five years of police work, Balestrazzi's unit traced the loot to an apartment in the southern town of Porto Vecchio. The paintings were being guarded by a man identified by the police as a reseller. The team moved in, apprehended the man, and seized the paintings.[12]

The Deals

Since Moscardini's retirement and the subsequent disbandment of the Art and Antique Investigation Unit in 1990, the New York City Police Department had not employed an art-theft detective of Moscardini's expertise. None of the detectives called in to handle art-theft cases had sufficient knowledge of art and familiarity with the art community to successfully disguise themselves as art dealers in order to close art-theft cases with recoveries and arrests. Many cases had not been solved, forcing detectives trained in tracking down property criminals but unfamiliar with art-theft investigation to resort more often to the last method of art recovery: buying stolen artwork from a thief with the reward money from the insurance company and the help of a confidential informant.

In 1990, a confidential informant told a Safe, Loft, and Truck Squad detective working on an important art-theft case that he knew someone who was willing to sell a stolen art collection. Since the insurance company's reward for the information leading to recovery and arrest was $24,000, Detective Alex Sabo and his partner, Detective Joe Keenan, agreed to pay $10,000 for the stolen art, with the other $10,000 going to the informant. All parties involved in the case were pleased

except the agonizing detective, who felt humiliated by the deal. The insurance company paid only a fraction of the insurance compensation. The informant and the thief got their money, and the unit gained a needed recovery. In spite of this, art-theft detectives often preferred not to resort to this easy method because criminals, through confidential informants, were able to sell stolen art to insurance companies via the police and thereby proved to art theft detectives that criminals were always a step ahead of law-enforcement officials.

The same method was used to recover most of the artwork taken during what was known as the biggest gallery theft from the Colnaghi Gallery in 1988. Detectives who took part in the recoveries called the informer "the Man," for revealing his name might place his life at risk. He was an important confidential informant on international drug trafficking for the Drug Enforcement Agency (DEA) who, with the consent of the DEA, had agreed to assist the New York City Police Department in these recoveries. The Man was in his late thirties, fluent in English and Spanish, and noted for his cleverness in dealing with his clients, including the thieves, law-enforcement agencies, and major insurance companies. He also made a lot of money from acting as a go-between for the authorities and the thieves. Lloyd's of London, the insurer of the Colnaghi Gallery, through its insurance adjuster, Graham Miller Ltd., paid him about $100,000 in reward money after he had delivered to them, in 1991, eight of the eighteen paintings, valued at $6 million, that had been taken from the Colnaghi Gallery. DEA Special Agent Robert A. Bryden said, "We can beat our chests and say we don't like dealing with informants, but that's not true because you can't catch somebody breaking the law with a choirboy...At the same time, you know you're making a deal with the devil."[13]

Not surprisingly, dealing with the Man proved to be a frustrating process for detectives Sabo and Keenan. The Man had his lawyer to protect his financial interests and his DEA controller to supervise all meetings with the NYPD detectives, who were not allowed to question him about his other activities. The deal proceeded very slowly because

he wanted to exhaust the detectives' patience in order to make them accept his demands. In other words, he knew how to dance with the police. Many meetings were held at various locations, including in cars and at street corners, restaurants, hotels, the NYPD, and even a federal building in midtown. There were extensive negotiations between the Man, his attorney, and the insurance adjusters and their lawyers. He was extremely distrustful and wanted a written agreement. Knowing the current market value of the stolen artifacts, which was higher than their insured value, he wanted a lot of money. Since the reward was 10 percent of the insured value, the detectives could not close the deal. He kept saying he was not involved in the theft but knew the whereabouts of the stolen artwork because of his underworld connections and had to pay them and the thieves. Because of his value to the DEA, the detectives had to treat him with fairness if not undue respect at times, but they also wanted to know the names of the thieves.

For weeks, the negotiations went around in circles. Finally the Man threatened to sell some of the stolen artwork from the Colnaghi theft to his connections in Colombia and Peru if his demands were not met. But Keenan cleverly reminded him that he would be risking his life doing this for a couple hundred thousand dollars, as the drug dealers might take the stolen works and eliminate him. That comment proved to be effective, for the agreement on the amount of the reward was reached in the spring of 1991 between the Man with his attorney and the Graham Miller insurance adjusters with their lawyers. According to this agreement, a down payment and other moneys were placed into an escrow account for the Man. The funds would be released to him if the authenticity and condition of the artwork were acceptable. On June 4, 1991, at a meeting in a hotel room in midtown Manhattan, the Man delivered eight of the Colnaghi paintings. Later that day another meeting was held at the NYPD, where the reward agreement was executed.[14]

At times, information about the whereabouts of stolen art comes from sting operations. These are FBI undercover fencing operations commonly operated in large cities and aimed at arresting thieves and

fences, recovering stolen property, and ultimately diminishing stolen property markets.[15]

To start the "fencing business," informants would be requested to spread the word that a new fence was in town. A storefront staffed with a team of undercover police officers would be set up. These twenty-four-hour outlets were equipped with security devices, videotape recorders, and a generous amount of cash to buy stolen goods. To collect potentially convicting evidence against thieves and fences, the agents must ensure that the sellers acknowledge the stolen nature of the merchandise offered for sale. All transactions were videotaped for prosecution purposes. At these storefronts, extensive physical security was employed to protect agents from criminal elements. A visit to these stores found that a requirement to buzz in and out was posted on the door and a physical barrier was placed between the counterman and the customer. In addition, an armed bodyguard was always present. What a store's clientele did not see was the presence of armed backup personnel who were ready to descend on them at the first sign of alert. Clients were allowed to visit the store without an appointment, although a call to notify their visit prior to their arrival was required. Attention was also paid to the external security of the storefront. An alarm system equipped with an audible panic alarm and a visible lighted alarm box was activated when a wired door or foiled window was opened.[16]

It was with the intention to sell a stolen Rembrandt painting to a fence in 1977 that Gennarino Fasolino, a sometime fixer for local organized-crime figures in Buffalo, told a local art fence, Chuck Carlo, that *The Rabbi*, worth $5 million, had been stolen and was for sale for $200,000. Little did he know that Chuck Carlo was an ex-convict fence who served as a confidential informant for the FBI and was on their payroll. Carlo was operating a sting operation at the House of Tasha Gallery as part of a massive FBI antifencing crusade in 1976.

After his conversation with Fasolio, Carlo passed the information to the FBI, who recognized that the painting was a Rembrandt stolen from the Bonnat Museum in France in 1971. With the assistance

of Special Agent Thomas McShane, who posed as an art expert to appraise the painting, a deal was struck between "the fence" and the seller, John Joseph Gandolfo, a potentially dangerous fugitive sought by the FBI for safecracking, bribery, auto theft, carrying concealed weapons, and possession of a stolen Rembrandt. The painting was finally bought for $22,000. Gandolfo, reaping the profit from selling the purloined Rembrandt that he had stolen from the thief, was placed under surveillance. Both Fasolino and Gandolfo were arrested at later dates and videotaped evidence of the sale at the House of Tasha was used to convict them.[17]

Another undercover operation involving art that was used to launder drug money was Operation Dinero. In 1992, an informant told the undercover agents in the DEA's Atlanta office that the drug traffickers needed to launder the proceeds from their drug trade. The suggestion came at a time when this office was in the middle of an operation in which DEA agents had penetrated the Cali Mafia, who commissioned the agents to arrange money pickups in the United States and Europe. The idea of establishing a bogus bank to catch the drug money was so brilliant that Operation Dinero was set up soon afterward. The DEA, with the cooperation of the Internal Revenue Service and the British government, established a "class B" bank in Anguilla, British West Indies.

After receiving permission and a license from British authorities in 1993 to set up the phony private bank, the DEA, with the cooperation and advice of the Internal Revenue Service, went about putting the plan into practice, which took almost another year. These agencies requested banking associations to join, while they printed forms, stationery, and brochures, paying careful attention to give them a European look, which included using the correct European size of paper. They set up contacts with correspondent banks in other countries and established toll-free numbers in Venezuela, Colombia, and Mexico. Though supposedly located in the Caribbean, the phony American bank was physically located in a high-rise building in Atlanta to do business,

while phone and fax lines were routed to an Atlanta office staffed with Spanish- and French-speaking employees. To scare away legitimate customers, the bank charged excessive fees. The phony bank was run so successfully that it even attracted the attention of an investigator from the Controller of the Currency who suspected it of being shady. But a brief meeting with the bank's officials put an end to his curiosity.

After gaining credibility with members of the drug trade, including the Cali drug cartel, the private bank began to provide money-laundering services to those clients. These services included loans, cashier's checks, peso exchanges, wire transfers, and accounts with holding corporations. The complex operation eventually handled forty-one corporate accounts, ninety-two cash transactions for drug traffickers totaling $8.9 million, and 291 noncash transactions. Another $39.5 million was handled by the DEA agents prior to the bank's establishment. At one point the drug traffickers indicated to the agents that they had $500 million they needed help in laundering.

As a result of the bank's operation, DEA agents obtained information on methods used by drug traffickers to turn their illegal profits into legitimate assets. One way of cleaning the dirty money was to buy valuable works of art, place them on consignment in the United States, and deposit the proceeds from the sales to a secret account with this phony bank.

In November 1994, one of the members of the Cali cartel met with an undercover agent in Colombia. He said he had two paintings supposedly valued at approximately $9 million. He wished to have them delivered to Atlanta for consignment because selling the paintings would help launder money that had been used to buy them. The drug trafficker identified one of the paintings as a Reynolds and the other as a Rubens. He told the agent they were owned by another drug trafficker known as "the Captain." Then, in early December 1994, another target of investigation told an agent in Atlanta that he also had a Picasso watercolor that was to be delivered to undercover agents in Atlanta for the same purpose of laundering the drug money.

Following these two exchanges, Marta Torres, one of the targets of a drug-trafficking investigation, delivered the three paintings to undercover agents in Miami for consignment. However, these paintings were not placed on consignment like the drug dealers had intended because US agents obtained a court order to confiscated them.[18] As a result, the provenance of the paintings and whether or not they had been stolen remained a mystery. Police suspicion that proceeds from drug sales were used to purchase artifacts was common enough for a Belgian law-enforcement authority to speculate that perhaps part of the art market would collapse if drug dealers stopped laundering money by buying artwork.[19]

As exaggerated as this prediction might seem, it was not based on pure speculation. Evidence of major narcotics dealers' acquisitions of artwork for personal pleasure and as a means to launder drug money surfaced during the course of an investigation conducted by journalist William Sherman. His interviews with officials of US Customs, the FBI, the DEA, and other federal agencies, as well as with the NYPD and the Los Angeles Police Department revealed that there were several ongoing investigations into drug-money investments in art.[20]

No one knew how large the value of this investment was and how long drug dealers had been involved in the art market. But this involvement was certain enough for a special unit of the Treasury Department, the Financial Crimes Enforcement Network (FinCEN), which specialized in tracking down money-laundering operations by criminal enterprises, to hold a symposium on drug-money investments in art. These operations struggled to find success because drug kings, such as Colombians Fabio Ochoa and Pablo Escobar of the Mekelin cartel, often used third parties, legitimate investment advisers, and attorneys based in Europe to make such investments. By 1991, the DEA had seized more than $203 million in drug-cartel accounts maintained under assumed names, third-party names, or anonymous account numbers in banks in Luxembourg, Hong Kong, the United Kingdom, and elsewhere. But works of art, as DEA agents had found, were more difficult to track

because there were fewer records remaining that could be used to trace such purchases, unlike the purchases of property and commercial items, and like at the NYPD, art was not part of field agents' training. However, Special Agent Robert A. Bryden, who was in charge of the DEA's New York field division, observed that there was not a lot of laundering going on with art for it to be a main concern of the DEA. The agency had been aware that the upper-level drug dealers were going to Europe and to auctions or contracting people in the United States to buy artwork for them, more often because owning art made them feel they belonged to the prestigious section of the legitimate society.[21]

Epilogue

The rain continued to fall from the gray sky of New York City, while I sat in a Soho restaurant waiting for it to stop. The rhythm of the raindrops somehow drew me to my favorite lines of a popular Verlaine poem:

Il pleure dans mon coeur
Comme il pleut sur la ville
Quelle est cette langueur
Qui penètre mon coeur?[2]

I had returned to New York City on the occasion of my dissertation defense two years after the completion of my research. Following the decline of the art market in 1990 and 1991 after a three-year boom, interest in contemporary artwork dropped significantly. In 1991, nearly 50 percent of the contemporary works offered at Christie's and Sotheby's were left unsold, while others were bought at or below their

[2] Something weeps in my heart
Like the rain falling on the city
What is this melancholy
That penetrates my heart?

estimated value.[1] Although the recession caused this reduction in the demand for contemporary art, the demand for high-quality works was still great enough that art thieves and fences did not desist in their criminal activities. For example, De Kooning's *July* was sold for $8.8 million while Renoir's *La Tasse de Chocolat* fetched $18.15 million in 1991.[2] In 1993, Cézanne's *Nature Morte* was bought for $28.6 million and van Gogh's *Wheat Field with Cypresses* for $57 million.[3] Old master paintings, even unidentified ones, still commanded astounding prices. In the same year, the Kimbell Museum of Art bid $2.42 million for an unidentified old master painting of the late fifteenth century that was estimated to be worth $400,000 to $600,000.[4]

In spite of the continued support of collectors, the art market had turned to caution, and the lively art scene in Soho had, of course, been noticeably affected. Of the forty-five dealers I had interviewed, two went out of business, two left New York City without leaving forwarding addresses, and one moved back to Washington, DC.

One Police Plaza was still there, but many people I knew no longer worked for the police department. I learned that Lieutenant Kelly had retired. Following Moscardini's retirement in 1989 several weeks before my departure from the NYPD, the central art-theft file ceased to exist. The Art and Antique Investigation Unit was temporarily taken over by a patrol officer, and the task of art-theft investigation returned to the Safe, Loft, and Truck Squad, where art-theft complaint reports became a part of the property-crime file. When the Art and Antique Investigation Unit was officially disbanded in the summer of 1990, property detectives Alex Sabo and Joe Keenan of the Safe, Loft, and Truck Squad began to investigate most art-theft cases. Yet since this unit could only investigate commercial thefts exceeding $20,000, art-theft cases that had smaller values or were not commercial were delegated to precinct detectives. As a result, the art-theft complaint reports of this unit represented only a fraction of art thefts in New York City. By the end of 1990, the Safe, Loft, and Truck Squad merged into the Major Case Squad. Since then, art-theft cases had been investigated by detectives of this unit.[5]

Epilogue

With the inability of police to provide round-the-clock protection and the low recovery rate in art-theft cases, dealers' practice of forming alliances to watch out for one another had grown stronger. The Art Dealers Association of America continued to circulate among its membership flyers containing details of thefts committed at member galleries. I recall that during one of my survey interviews, a Soho dealer showed me one such flier that had a description and sketch of a recently stolen object and the suspected thief. Dealers who did not belong to the Art Dealers Association of America increasingly banded together with other neighborhood dealers and shared theft information among themselves. In fact, a prominent Soho dealer whose gallery had been a frequent target of art theft told me that he circulated among his business acquaintances reports of art theft forwarded to him from victimized galleries. These measures were an attempt to prevent not only art theft but also the resale of stolen cultural property.

At the federal level, Congress passed in 1994 a federal crime bill in which theft of cultural objects of value from a museum was made a federal crime punishable by up to ten years in prison. Moreover, the statute of limitations for this offense was set at twenty years, whereas the average state statute of limitations is five years. Following the Isabella Gardner Museum's theft, this provision was introduced by the late senator Edward Kennedy of Massachusetts. According to this new legislation, objects of cultural value are defined as those worth more than $100,000 or more than one hundred years old and worth at least $5,000. Their disappearance from a museum would now be immediately investigated by the FBI, regardless of whether they have crossed state lines.[6]

After the collapse of Communism in 1991, which led to the opening of the borders of eastern Europe, the rise in the thefts of artifacts from the region had been alarming. In 1990 alone, art and antiques valued at $18 million were reported stolen from churches, museums, and public places in eastern Germany.[7] As a result, the major museums of

the world, including the Louvre, fell prey to art thieves. This famous museum was a victim of art theft three times over a period of seven months in 1994. The first incident occurred on the evening of January 11 when a thief cut a nineteenth-century landscape by De Crise valued at $37,000 out of its frame and escaped with it during a break in the guards' rounds. The second incident took place several days later during visiting hours and with security guards nearby, when a battle ax from a seventeenth-century bronze sculpture by Despardins was taken. The ax, three feet long and weighing about thirty-seven pounds, was returned anonymously ten days later and found in the courtyard. In the third incident, a 1660 pastel portrait by de Nanteuil disappeared from the museum in July. The series of thefts prompted officials of the Louvre to request that the French government provide more funds to improve the museum's security.[8]

In the Czech Republic, around twenty thousand artifacts disappeared every year. This prompted the Czech Ministry of Culture and Ministry of the Interior to establish in 1991 a security program that involved the cooperation of the police in guarding cultural institutions and protecting its cultural heritage. The police would monitor thefts by using a two-way network of radio and telephone lines with transmitters placed in castles, churches, and museums. Additionally, the Ministry of Culture installed in twenty-nine cultural institutions and in eight police stations computers storing descriptions and images as well as a thesaurus of objects. The religious and cultural institutions also collected data and made video images and sent this documentation to the police for use in the case of thefts.[9]

I remember during my meeting with Orwin following my successful defense of the dissertation, he joyfully congratulated me, "Mission accomplished!" Then he continued, "I believe art theft is proliferating because I noticed that unlike before, security guards are now present in all the galleries of the museums I visited, and many New York City art galleries have installed electronic security devices. What do you think we can do to stop this crime?"

Epilogue

"I don't think we can ever stop people from committing art theft because like art, crime is a part of human nature," I responded. "Though increased security measures are necessary and should help reduce art theft, it is equally important to publicize thieves' failures to dispose of stolen art. With the exceptions of organized groups of criminals and professional art thieves, who have art knowledge and connections with art fences, all other types of thieves will eventually learn that the resale of stolen art is a complicated, risky business and not worth the investment of their efforts."

Appendix A

Survey of Profit Art Gallery Directors

Part 1: Dealers' Opinion Survey

Respondent #_____

1. _____ East Side Gallery floor #_____
2. _____ West 57th Street
3. _____ Soho

Gallery Characteristics

1. Did you (the owner, partner, or manager) operate this gallery at this location during the last 12-month period?

 1. _____ Yes (Skip to #3)

 2. _____ No

 99. _____ No Answer

2. How many months during the designated period did you operate this gallery?

 ____ month(s)
99. ____ No answer

3. How is this business owned or operated?

 1. ____ Corporation
 2. ____ Individual proprietorship
 3. ____ Partnership
 4. ____ Government
 5. ____ Other
 88. ____ Don't know
 99. ____ No answer

4. Do you operate more than one establishment?

 1. ____ Yes
 2. ____ No
 88. ____ Don't know
 99. ____ No Answer

5. Excluding you, how many full-time employees did this gallery average during the last 12-month period?

 1. ____ None
 2. ____ 1 to 3
 3. ____ 4 to 7
 4. ____ 8 to 11
 5. ____ 12 or more
 88. ____ Don't know
 99. ____ No answer

Appendix A

6. Excluding you, how many part-time employees did this gallery average during the last 12-month period?

 1. _____ None
 2. _____ 1 to 3
 3. _____ 4 to 7
 4. _____ 8 to 11
 5. _____ 12 or more
 88. _____ Don't know
 99. _____ No answer

7. What kind of art work do you <u>mostly</u> deal with?

 1. _____ Paintings
 2. _____ Sculptures
 3. _____ Prints
 4. _____ Drawings
 5. _____ Crafts
 6. _____ Antiquities
 7. _____ Collectibles (figurines, porcelain, scrolls, manuscripts, coins, stamps, jewelry)
 8. _____ Photographs
 9. _____ Other _____
 99. _____ No answer

8. What is the size of your gallery inventory?

 1. _____ Less than 100 objects
 2. _____ 100 to 499 objects
 3. _____ 500 to 999 objects
 4. _____ 1000 objects and over
 99. _____ No answer

9. What is the most common size of your art work?

 1. ____ Small
 2. ____ Medium
 3. ____ Large
 88. ____ Don't know
 99. ____ No answer

10. What is the predominant style of art work that you carry?

 10a. Modern art:
 1. ____ Realism
 2. ____ Abstraction
 3. ____ Both
 4. ____ None

 10b. Contemporary art:
 1. ____ Realism
 2. ____ Abstraction
 3. ____ Both
 4. ____ None

 10c. Old art:
 1. ____ Yes
 2. ____ No

 10d. Other _____

11. What is the most common subject?

 1. ____ Landscape
 2. ____ People
 3. ____ Still life
 4. ____ Abstract
 5. ____ Decorative art
 6. ____ Other _____
 88. ____ Don't know
 99. ____ No answer

12. What were your approximate gross sales of art work at this gallery for the previous 12 months?

 1. ____ None
 2. ____ Under $50,000
 3. ____ $50,000-$99,999
 4. ____ $100,000-$499,999
 5. ____ $500,000-$999,999
 6. ____ $1,000,000-$4,999,999
 7. ____ $5,000,000 and over
 88. ____ Don't know
 99. ____ No answer

13. What types of record keeping/inventory control do you use?

 1. ____ Manual
 2. ____ Computerized
 3. ____ Both
 88. ____ Don't know
 99. ____ No answer

Characteristics of Art Theft

14. How frequently do you think art theft occurs at New York galleries?

 1. _____ Very frequently
 2. _____ Frequently
 3. _____ Seldom
 4. _____ Never
 5. _____ Other _____
 88. _____ Don't know
 99. _____ No answer

15a. What do you think about the trend in art theft?

 1. _____ It will increase
 2. _____ It will remain stable
 3. _____ It will decrease
 4. _____ Other _____
 88. _____ Don't know (Skip to #16)
 99. _____ No answer (Skip to #16)

15b. Why do you think it will increase, decrease or remain stable?

 1. _____ Art prices will increase
 2. _____ More people will know art
 3. _____ There will be fewer but larger galleries
 4. _____ Demand exceeds supply
 5. _____ There will be more stealing-to-order
 6. _____ Other _____
 77. _____ Not applicable
 88. _____ Don't know
 99. _____ No answer

16. What do you think is the most important reason for people to steal art work?

 1. _____ Money
 2. _____ It's easy
 3. _____ They like art
 4. _____ They rarely get caught
 5. _____ They don't get serious sentences
 6. _____ Other _____
 88. _____ Don't know
 99. _____ No answer

17a. Do you think it is easy to sell stolen art?

 1. _____ Yes
 2. _____ No
 88. _____ Don't know (Skip to #18)
 99. _____ No answer (Skip to #18)

17b. Why do you think it is easy or difficult to sell stolen art?

 1. _____ If the thief has art fences or knows art collectors
 2. _____ It's difficult to find art buyers
 3. _____ If the thief does not know collectors or art fences
 4. _____ Unrecognizable works are easy to sell
 5. _____ Other _____
 88. _____ Don't know
 99. _____ No answer

18. What is the most important reason causing the losses of art work?

 1. _____ Poor alarm systems
 2. _____ Dishonest employees
 3. _____ No guards
 4. _____ Few salespersons/poor visual security
 5. _____ Infrequent inventory
 6. _____ Other _____
 88. _____ Don't know
 99. _____ No answer

19a. What is the most common type of art theft?

 1. _____ Shoplifting
 2. _____ Employee Theft
 3. _____ Burglary (Breaking & Entering)
 4. _____ Robbery (Armed)
 88. _____ Don't know (Skip to #20a)
 99. _____ No answer (Skip to #20a)

19b. Why do you think larceny, shoplifting, employee theft or burglary is the most common type of art theft?

 1. _____ Shoplifting doesn't require much skill
 2. _____ Most galleries don't have adequate security during business hours
 3. _____ Most galleries don't have adequate security for after-hours protection
 4. _____ It's difficult to control employee theft
 5. _____ Inventory control is very difficult
 6. _____ Other_____
 77. _____ Not applicable
 88. _____ Don't know
 99. _____ No answer

Appendix A

20a. Who do you think may steal art work most often?

 1. _____ Common thieves
 2. _____ Professional thieves
 3. _____ Professional art thieves
 4. _____ People who know or like art
 5. _____ Other _____
 88. _____ Don't know (Skip to #21a)
 99. _____ No answer (Skip to #21a)

20b. Why do professional thieves, common thieves, professional art thieves, or art lovers steal art work most often?

 1. _____ It's their career
 2. _____ They have access to the gallery showroom
 3. _____ They like art
 4. _____ They know collectors or fences
 5. _____ Other
 88. _____ Don't know
 99. _____ No answer

21a. What type of art theft creates the most financial loss to art galleries?

 1. _____ Employee theft
 2. _____ Shoplifting
 3. _____ Burglary
 4. _____ Robbery
 5. _____ Other _____
 88. _____ Don't know
 99. _____ No answer

21b. Why does employee theft, burglary, shoplifting, or robbery create the greatest financial loss to art galleries?

 1. _____ The thief knows art buyers and the value of art work
 2. _____ They steal the most recognizable works
 3. _____ They steal-to-order
 4. _____ They take advantage of any opportunity to steal
 5. _____ Other _____
 77. _____ Not applicable
 88. _____ Don't know
 99. _____ No answer

22a. Do you think most art thieves know art?

 1. _____ Yes
 2. _____ No
 88. _____ Don't know (Skip to #23a)
 99. _____ No answer (Skip to #23a)

22b. Why do you think most art thieves know or don't know art?

 1. _____ They seem to pick objects at random
 2. _____ They seem to know what they are selecting
 3. _____ They steal because there is an opportunity to steal
 4. _____ They must know art to be profitable
 5. _____ Other _____
 77. _____ Not applicable
 88. _____ Don't know
 99. _____ No answer

23a. Do you think most art thefts are the result of planning or are spur of the moment?

1. ____ Planning
2. ____ Spur of the moment
3. ____ Both
88. ____ Don't know (Skip to #24a)
99. ____ No answer (Skip to #24a)

23b. Why do you think most shoplifting are the results of planning or are spur of the moment? (Check all that apply)

1. ____ The thief must have a reason to steal
2. ____ The thief must be familiar with the gallery in order to steal art work
3. ____ The thief must now whether or not he/she will be able to sell the stolen art
4. ____ The thief must know whether or not the opportunity to steal is available
5. ____ The opportunity to steal happens to present itself
6. ____ Other _____
77. ____ Not applicable
88. ____ Don't know
99. ____ No answer

24a. What kind of art objects do you think are taken most often?

 1. _____ Small items
 2. _____ Large items
 3. _____ Other _____
 88. _____ Don't know (Skip to #25)
 99. _____ No answer (Skip to #25)

24b. Why are these small items taken most often?

 1. _____ They are easy to conceal/carry
 2. _____ They are easy to sell
 3. _____ Other _____
 77. _____ Not applicable
 88. _____ Don't know
 99. _____ No answer

25. In terms of value, which items are most often targeted for theft?

 1. _____ The most marketable works
 2. _____ The less marketable works
 3. _____ The most valuable works
 4. _____ The less valuable works
 5. _____ Anything
 6. _____ Other _____
 88. _____ Don't know
 99. _____ No answer

26a. To what extent does the art price sticker affect art theft?

 1. ____ Substantially
 2. ____ Moderately
 3. ____ Insignificantly
 4. ____ No difference
 88. ____ Don't know (Skip to #27)
 99. ____ No answer (Skip to #27)

26b. Why do think the art price sticker substantially, moderately, or insignificantly affect, or not affect art theft?

 1. ____ The thief can look at the price sticker to decide what to steal
 2. ____ The selection of the theft has nothing to do with the price
 3. ____ Expensive art work does not necessarily mean saleable work
 4. ____ A thief must know art buyers to continue to steal art objects
 5. ____ It confirms the value of the work
 6. ____ The thief already knows the value of the work that he or she selects
 88. ____ Don't know
 99. ____ No answer

27. What do you think is the most important reason affecting the increase in art theft?

 1. _____ Increase in art prices/publicity of record breaking prices on newspapers and TV
 2. _____ Ineffectiveness of the police
 3. _____ Increased demands for stolen works
 4. _____ Ineffectiveness of security systems
 5. _____ Most people know art
 6. _____ Other _____
 88. _____ Don't know
 99. _____ No answer

28a. What time of the day do you think most dealers suffer art theft?

 (During business hours #1-#5)
 1. _____ Lunch time (12 p.m. to 2 p.m.)
 2. _____ Dinner time (5 p.m. to 7 p.m.)
 3. _____ In the morning
 4. _____ In the afternoon
 5. _____ Don't know what time during business hours
 6. _____ Don't know what time during closing hours
 7. _____ 6 p.m. to midnight
 8. _____ Midnight to 6:00 a.m.
 88. _____ Don't know (Skip to #29a)
 99. _____ No answer (Skip to #29a)

28b. Why do you think most thefts happen at that time?

 1. _____ Less visual coverage on the floor
 2. _____ Customers are in the gallery
 3. _____ On one is in the gallery
 4. _____ Nighttime security is less adequate than daytime security
 5. _____ Other _____
 77. _____ Not applicable
 88. _____ Don't know
 99. _____ No answer

29a. Is there a particular time of the year in which you notice there are a lot of art thefts?

 1. _____ No particular time
 2. _____ Before Christmas
 3. _____ Other _____
 88. _____ Don't know (Skip to #30)
 99. _____ No answer (Skip to #30)

29b. Why do you think before Christmas or there is no particular time, etc.?

 1. _____ Thieves go stealing all year round
 2. _____ People need more money during Christmas
 3. _____ It's the busiest season of the year
 4. _____ Other _____
 77. _____ Not applicable
 88. _____ Don't know
 99. _____ No answer

30. What do you think is the result of the publicity surrounding a theft for a victimized gallery?

 1. _____ More thefts
 2. _____ Recovery
 3. _____ No difference
 4. _____ Other _____
 88. _____ Don't know
 99. _____ No answer

31. What do you think is the most significant factor in most gallery thefts?

 1. _____ Having access to the storeroom
 2. _____ Familiarity with the showroom
 3. _____ A professional burglar or ring of thieves researches objects to steal
 4. _____ Chance
 5. _____ Other _____
 88. _____ Don't know
 99. _____ No answer

32a. Where do you think most art thefts occur?

 1. _____ Gallery showroom
 2. _____ Storage
 3. _____ Warehouse
 4. _____ While on loan
 5. _____ Other _____
 88. _____ Don't know
 99. _____ No answer

32b. Why do most art thefts occur at this place?

 1. _____ Security is poor there
 2. _____ That's where most works are (Skip to #33)
 3. _____ Showrooms are open to the public (Skip to #33)
 4. _____ Other _____ (Skip to #33)
 77. _____ Not applicable
 88. _____ Don't know (Skip to #33)
 99. _____ No answer (Skip to #33)

32c. Why is security poor there?

 1. _____ Only employees are allowed to go there
 2. _____ Effective management of the inventory procedure is very difficult
 3. _____ We pay more attention to the showrooms
 4. _____ Other _____
 77. _____ Not applicable
 88. _____ Don't know
 99. _____ No answer

33. How do you think most thefts are discovered?

 1. _____ Inventory
 2. _____ Can't find the art work in the drawer/storeroom
 3. _____Information from other sources such as_____
 4. _____ Empty place! It's not there in the showroom
 5. _____ Other _____
 88. _____ Don't know
 99. _____ No answer

34. What do you think is the most common reason for some dealers not to report art theft?

 1. _____ Objects uninsured
 2. _____ Fear of increase of insurance premiums
 3. _____ Avoid confrontation with the suspected employee
 4. _____ Fear that publicity would lead to other thefts
 5. _____ Responsible for the theft
 6. _____ Object on consignment or loan, thus handled by owner
 7. _____ Lack of proof; nothing could be done
 8. _____ Police wouldn't be able to do anything about it
 9. _____ Other _____
 88. _____ Don't know
 99. _____ No answer

35a. In your opinion, who may most often buy stolen art?

 1. _____ Artists
 2. _____ Curators
 3. _____ Amateur collectors
 4. _____ Private collectors
 5. _____ Private dealers
 6. _____ Second-hand dealers
 7. _____ Other
 88. _____ Don't know (Skip to #36)
 99. _____ No answer (Skip to #36)

35b. Why do professional collectors, private dealers, artists, art lovers etc., buy stolen art most often?

 1. ____ They want to collect, but the works are too expensive
 2. ____ Works are not available
 3. ____ It's business profit: Untraceable, little risk
 4. ____ Other _____
 77. ____ Not applicable
 88. ____ Don't know
 99. ____ No answer

36. How often do art dealers receive offers to buy stolen art?

 1. ____ Very often
 2. ____ Often
 3. ____ Rarely
 4. ____ Never
 88. ____ Don't know
 99. ____ No answer

37. Where do you think is the would-be prime market for stolen art in New York?

 1. ____ New York City
 2. ____ Elsewhere in the U.S.
 3. ____ Europe
 4. ____ Japan
 5. ____ Oil producing countries
 6. ____ Other _____
 88. ____ Don't know
 99. ____ No answer

Extent of Art Theft

38. Which of the following best describes the problem of art theft in your gallery?

 1. _____ A serious problem
 2. _____ A significant problem
 3. _____ A problem
 4. _____ An insignificant problem
 5. _____ A potential problem
 6. _____ Not a problem
 88. _____ Don't know
 99. _____ No answer

39. How many thefts have you experienced during the last 12 months?

 1. _____ None
 2. _____ Thefts: **Fill out the incident report, Part 2: Victimization Survey**
 88. _____ Don't know
 99. _____ No answer

***After filling out the incident report**

40. Over the last five (or _____) years, the incidents of theft in this gallery have:

 1. _____ Increased
 2. _____ Been stable
 3. _____ Decreased
 77. _____ Not applicable
 88. _____ Don't know
 99. _____ No answer

41. In the last five (or _____) years, what do you think spurred most thefts from this gallery?

 1._____ Publicity about the gallery's thefts
 2. _____ Publicity about the gallery's business
 3. _____ Increase in art prices
 4. _____ Dishonest employees
 5. _____ Other _____
 77. _____ Not applicable
 88. _____ Don't know
 99. _____ No answer

42. What do you think is the result of the publicity surrounding the theft of your gallery?

 1. _____ More thefts
 2. _____ Fewer thefts
 3. _____ Recovery
 4. _____ No difference
 5. _____ Other _____
 77. _____ Not applicable
 88. _____ Don't know
 99. _____ No answer

43. What is the percentage of your photographed inventory during the last 12 months?

 1. _____ Under 25%
 2. _____ 25% to 50%
 3. _____ 50% to 75%
 4. _____ 75% to 100%
 88. _____ Don't know
 99. _____ No answer

44. What do you consider the risk of acquisition or handling of stolen objects at this gallery to be?

 1. _____ A potential problem
 2. _____ A serious problem
 3. _____ An unlike problem
 4. _____ Not a problem (Skip to #48)
 88. _____ Don't know
 99. _____ No answer

45. Have you ever been offered stolen art to buy?

 1. _____ Yes
 2. _____ No (Skip to # 48)
 77. _____Not applicable
 99. _____ No answer

46a. During the last 12 months, how many times were you asked to buy stolen art objects?

 _____Time(s).

46b. How did the offender conduct his/her business?

 1. _____ By phone
 2. _____ In person
 3. _____ By both of the above
 4. _____ Other _____
 77. _____ Not applicable
 88. _____ Don't know
 99. _____ No answer

47. What is the fluctuation of the thief's solicitation during the last five years?

 1. _____ Increase
 2. _____ Stability
 3. _____ Decrease
 77. _____ Not applicable
 88. _____ Don't know
 99. _____ No answer

48. What (would or did) you do (if or when) you were offered to buy suspected stolen art?

 1. _____ I'd buy it anyway (I bought it)
 2. _____ I'd decline to buy it, but mind my own business (I declined to buy it, but minded my own business)
 3. _____ I would notify the police (I notified the police)
 4. _____ Other _____
 88. _____ Don't know
 99. _____ No answer

Exposure to Thefts

49. What types of insurance do you have? (Check all that apply)

 1. _____ Blanket coverage for works owned by the gallery
 2. _____ Works owned by the gallery while on our premises
 3. _____ Only works owned by the gallery while off our premises
 4. _____ Objects on loan or consignment to the gallery
 5. _____ No insurance
 6. _____ Through an escrow account
 88. _____ Don't know: Handled by the corporation (Skip to #53)
 99. _____ No answer

50. What is your insurance deductible?

　　　_____ Dollars
　　88. _____ Don't know
　　99. _____ No answer

*51. **Without theft** _____ How was your insurance premium during the last five years in which you have not had any reported theft?

　　1. _____ Increased (Skip to #52b)
　　2. _____ Reduced (Skip to #52b)
　　3. _____ Stable (Skip to #52b)
　　77. _____ Not applicable: Had thefts
　　88. _____ Don't know (Skip to #53)
　　99. _____ No answer

*52a. **With theft** _____ How was your insurance premium during the last five years in which you have reported thefts?

　　1. _____ Increased (Skip to #52b)
　　2. _____ Reduced (Skip to #52b)
　　3. _____ Stable (Skip to #52b)
　　4. _____ Other _____
　　77. _____ Not applicable: Had no thefts
　　88. _____ Don't know (Skip to #53)
　　99. _____ No answer

52b. Why was it increased, reduced or stable?

 1. _____ No thefts
 2. _____ Inflation
 3. _____ New appraisal of art work
 4. _____ We had thefts
 5. _____ Other _____
 77. _____ Not applicable
 88. _____ Don't know
 99. _____ No answer

53. Have you tried to improve your security during the last five years?

 1. _____ Yes
 2. _____ No (Skip to #52a)
 77. _____ Not applicable
 88. _____ Don't know
 99. _____ No answer

54. How was your insurance premium affected after you improved your security measures?

 1. _____ Reduced
 2. _____ Increased
 3. _____ Stable
 77. _____ Not applicable
 88. _____ Don't know
 99. _____ No answer

55a. Do you think adequate security measures can deter art theft?

 1. _____ Yes (Skip to #56)
 2. _____ No
 88. _____ Don't know (Skip to #56)
 99. _____ No answer (Skip to #56)

55b. Why do you think adequate security measures cannot deter art theft?

 1. _____ Professional thieves are too clever
 2. _____ Employee theft is hard to control
 3. _____ It's impossible to have a business outlet that is totally protected from thefts
 4. _____ Inventory control is very difficult
 5. _____ Other _____
 77. _____ Not applicable
 88. _____ Don't know
 99. _____ No answer

56. To what extent can security measures deter art theft?

 1. _____ Substantially
 2. _____ Moderately
 3. _____ Insignificantly
 4. _____ Other _____
 88. _____ Don't know
 99. _____ No answer

Appendix A

57a. Do you think spending a lot of money on security is a good business practice?

 1. _____ Yes (Skip to #58)
 2. _____ No
 88. _____ Don't know (Skip to #58)
 99. _____ No answer (Skip to #58)

57b. Why do you think spending a lot of money on security isn't a good business practice?

 1. _____ There isn't enough theft to worry about
 2. _____ Inventory shrinkage is tax deductible
 3. _____ Prices of art work can be increased to cover the losses
 4. _____ It's impossible to control all thefts
 5. _____ If the amount of money spent on security exceeds the value of the losses
 6. _____ Other _____
 77. _____ Not applicable
 88. _____ Don't know
 99. _____ No answer

58. Approximately, how much money do you think is a lot of money to spend on security?

 1. _____ Under $10,000
 2. _____ $10,000-$24,999
 3. _____ $25,000-$49,999
 4. _____ $50,000 and over
 88. _____ Don't know (Skip to #60)
 99. _____ No answer

59a. Are you security conscious when you choose locations to display your art objects?

 1. _____ Yes (Skip to #60)
 2. _____ No
 88. _____ Don't know (Skip to #60)
 99. _____ No answer (Skip to #60)

59b. Why aren't you security conscious when you choose locations to display your art objects?

 1. _____ It's more important for the gallery to display art objects at aesthetically proper places.
 2. _____ We are not concerned about it
 3. _____ Other _____
 77. _____ Not applicable
 88. _____ Don't know
 99. _____ No answer

60. What security measures do you take at this gallery? (Check all that apply)

 1. _____ Small items are displayed where salespersons can easily see them
 2. _____ Good design of the inventory system
 3. _____ Alarm system-outside ringing
 4. _____ Burglar alarm-inside ringing
 5. _____ Central alarm
 6. _____ Reinforcing devices, grates, gates, bars on window
 7. _____ Guards
 8. _____ Movement detectors
 9. _____ Camera/TV monitors
 10. _____ Mirrors
 11. _____ Locks
 12. _____ Lights-outside or additional inside
 13. _____ Lobby guard
 14. _____ Buzzer
 15. _____ Other _____
 99. _____ No answer

61. How many square feet do you think this gallery has?

_____ Square feet

62. What is the minimum price of the artwork in this gallery?

_____ Dollars

63. What is the maximum price of the artwork in this gallery?

_____ Dollars

64. What is your position?

 1. _____ Owner
 2. _____ President or manager
 3. _____ Assistant manager
 4. _____ Partner

65. How many years have you been in business?

 _____ Years _____ Months

66. How many years have you been at this location?

 _____ Years _____ Months

Appendix A

Part 2: Victimization Survey

Incident Report # _____

Respondent # _____

1. What was the nature of the theft?

 1. ____ Shoplifting
 2. ____ Burglary
 3. ____ Robbery
 4. ____ Employee theft
 5. ____ Other _____
 88. ____ Don't know
 99. ____ No answer

2. In what month and year did this incident happen?

 1. ____ January 6. ____ June 11. ____ November
 2. ____ February 7. ____ July 12. ____ December
 3. ____ March 8. ____ August 88. ____ Don't know
 4. ____ April 9. ____ September 99. ____ No answer
 5. ____ May 10. ____ October

3. On what day of the week did this incident happen?

 1. ____ Monday 6. ____ Saturday
 2. ____ Tuesday 7. ____ Sunday
 3. ____ Wednesday 8. ____ Workday
 4. ____ Thursday 88. ____ Don't know
 5. ____ Friday 99. ____ No answer

4. About what time did it happen?

 (During business hours #1-#5)
 - 1. ____ During lunch time (12 p.m. to 2 p.m.)
 - 2. ____ During dinner time (5 p.m. to 7 p.m.)
 - 3. ____ In the morning
 - 4. ____ In the afternoon
 - 5. ____ Don't know what time during business hours
 - 6. ____ Don't know what time during closing hours
 - 7. ____ 6 p.m. to midnight
 - 8. ____ Midnight to 6 a.m.
 - 88. ____ Don't know
 - 99. ____ No answer

5. Where did this incident take place?

 - 1. ____ In the showroom
 - 2. ____ In the storage
 - 3. ____ On delivery
 - 4. ____ On loan
 - 5. ____ Other _____
 - 88. ____ Don't know
 - 99. ____ No answer

6. Is the location of crime occurrence visible by police patrol?

 - 1. ____ Yes
 - 2. ____ No
 - 88. ____ Don't know
 - 99. ____ No answer

7. Were you or any employees present while this incident was occurring?

 1. _____ Yes
 2. _____ No (Skip to #14 if burglary, #17 if larceny)
 88. _____ Don't know (Skip to #16)
 99. _____ No answer

8. Did you or anyone else see the offender? (Check all that apply)

 1. _____ Respondent
 2. _____ Employee
 3. _____ Customer
 4. _____ Other
 5. _____ No one (Skip to #14 if burglary, to # 17 if larceny)
 77. _____ Not applicable
 88. _____ Don't know (Skip to #14 if burglary, to # 17 if larceny)
 99. _____ No answer

9. (With employee theft) How do you know it's employee theft?

 1. _____ The theft was noticed
 2. _____ The theft was discovered after he/she quit
 3. _____ Other _____
 77. _____ Not applicable
 99. _____ No answer

10. How many persons were involved in the crime?

 1. ____ One
 2. ____ Two
 3. ____ More than two
 77. ____ Not applicable
 88. ____ Don't answer
 99. ____ No answer

11. How old would you say the person(s) was?

 1. ____ Under 18
 2. ____ 18-24
 3. ____ 25-30
 4. ____ 31-35
 5. ____ Over 35
 77. ____ Not applicable
 88. ____ Don't answer
 99. ____ No answer

12. Was the person male or female?

 1. ____ Male
 2. ____ Female
 77. ____ Not applicable
 88. ____ Don't know
 99. ____ No answer

13. What was his/her/their race(s)?

 1. _____ White
 2. _____ Black
 3. _____ Hispanic
 4. _____ Other
 77. _____ Not applicable
 88. _____ Don't know
 99. _____ No answer

*14. If burglary, how did the offender get in or try to get in?

 1. _____ Through unlocked door or window
 2. _____ Had a key
 3. _____ Forced door or window
 4. _____ Other _____
 77. _____ Not applicable
 88. _____ Don't know
 99. _____ No answer

15a. Was the alarm on?

 1. _____ Yes (Skip to #16)
 2. _____ No
 3. _____ Other _____
 77. _____ Not applicable
 88. _____ Don't know
 99. _____ No answer

15b. Why wasn't it on?

 1. _____ We didn't turn it on
 2. _____ We forgot to turn it on
 3. _____ It didn't work
 4. _____ Other _____
 77. _____ Not applicable
 88. _____ Don't know
 99. _____ No answer

16. If larceny, what was the offender's method of shoplifting?

 1. _____ Grab and run
 2. _____ Other _____
 77. _____ Not applicable
 88. _____ Don't know
 99. _____ No answer

*17. Did the thief have a weapon?

 1. _____ Yes
 2. _____ No (Skip to #19)
 88. _____ Don't know (Skip to #19)
 99. _____ No answer (Skip to #19)

18. What was the weapon?

 1. _____ Knife
 2. _____ Gun
 3. _____ Other _____
 77. _____ Not applicable
 88. _____ Don't know
 99. _____ No answer

19. How did the offender(s) leave?

 1. _____ By the front door
 2. _____ By the back door
 3. _____ Other _____
 77. _____ Not applicable
 88. _____ Don't know
 99. _____ No answer

20. What kind of art did the offender(s) take?

 1. _____ Painting
 2. _____ Drawing
 3. _____ Sculpture
 4. _____ Print
 5. _____ Craft
 6. _____ Collectible
 7. _____ Other _____
 88. _____ Don't know
 99. _____ No answer

21. How many pieces did the offender(s) take?

 _____ Piece(s)
 88. _____ Don't know
 99. _____ No answer

22. What is the description of the lost object?

 a. Size:
 1. _____ Small
 2. _____ Medium
 3. _____ Large
 4. _____ Mixed
 b. Type:
 1. _____ Old
 2. _____ Modern
 3. _____ Contemporary
 c. Subject:
 1. _____ Landscape
 2. _____ Still life
 3. _____ People
 4. _____ Abstract
 5. _____ Other _____
 88. _____ Don't know
 99. _____ No answer

23. What was the total value of the loss?

 _____ Dollars (Each: _____)
 88. _____ Don't know
 99. _____ No answer

24. How was the value determined?

 1. _____ Original cost
 2. _____ Market value
 3. _____ Appraiser value
 4. _____ Other _____
 88. _____ Don't know
 99. _____ No answer

25a. Was the stolen art covered by insurance?

 1. _____ Yes (Skip to #26)
 2. _____ No
 88. _____ Don't know (Skip to #26)
 99. _____ No answer

25b. Why wasn't it insured?

 1. _____ Insurance covers only works owned by the gallery while on our premises
 2. _____ Insurance covers only works owned by the gallery while off our premises
 3. _____ Insignificant value
 4. _____ Insurance is too expensive
 5. _____ Other _____
 88. _____ Don't know
 99. _____ No answer

26. How did you discover the theft?

 1. _____ Inventory
 2. _____ Not there
 3. _____ Other _____
 77. _____ Not applicable
 88. _____ Don't know
 99. _____ No answer

27. Were any security measure taken after this incident to protect this gallery from future thefts?

 1. _____ Yes
 2. _____ No (Skip to #29a)
 88. _____ Don't know
 99. _____ No answer

28. What were these security measures?

 1. _____ Hired a guard
 2. _____ Tightened up the inventory process
 3. _____ Improved alarm systems
 4. _____ Other _____
 77. _____ Not applicable
 88. _____ Don't know
 99. _____ No answer

29a. Did the gallery report this incident to the police?

 1. _____ Yes (Stop)
 2. _____ No
 88. _____ Don't know (Stop)
 99. _____ No answer (Stop)

Appendix A

29b. Why didn't you report it to the police?

 1. ____ Fear of increase in insurance premium
 2. ____ Avoid confrontation
 3. ____ The police won't be able to do anything about it
 4. ____ Other _____
 77. ____ Not applicable
 88. ____ Don't know
 99. ____ No answer

Go to Part 1: Dealers' Opinion Survey, Question # 40

Appendix B
Coding Form

Police Complaint Report # _____

1. Complaint number: _____

2. Precinct: _____

3. Month of occurrence: _____

 Undeterminable: _____

4. Day of week: _____

 Undeterminable: _____

5. Year of occurrence: _____

 Undeterminable: _____

6. Time of occurrence:

 1. _____ Morning (6-12)
 2. _____ Afternoon (12-18)
 3. _____ During day time
 4. _____ 6 p.m. to midnight (18-24)
 5. _____ Midnight to 6 a.m. (0.1-6)
 6. _____ During night time
 7. _____ Undeterminable time

7. Offense:

 1. _____ Burglary
 2. _____ Grand larceny
 3. _____ Shoplifting
 4. _____ Employee Theft
 5. _____ Robbery
 6. _____ Fraud
 7. _____ Petit larceny

8. Means of entry:

 1. _____ No forced entry
 2. _____ Cutting
 3. _____ Forcing or breaking
 4. _____ Attempt of forced entry
 77. _____ Not applicable

9. Type of weapon used/possessed:

 1. ____ None
 2. ____ Handgun
 3. ____ Knife
 4. ____ Other weapons used _____
 5. ____ Other weapon possessed _____
 77. ____ Not applicable

10a. Type of ownership:

 1. ____ Individual
 2. ____ Corporate
 3. ____ State

10b. Owner's age:

 99. ____ Missing

11. Perpetrator identification:

 1. ____ Can't identify
 2. ____ Stranger
 3. ____ Acquaintance
 4. ____ Other _____

12. Point of entry:

 1. _____ Door
 2. _____ Floor
 3. _____ Window
 4. _____ Roof
 5. _____ Wall
 6. _____ Other _____
 77. _____ Not applicable

13. Photo identification:

 1. _____ Yes
 2. _____ No

14. Type of location:

 1. _____ Art gallery
 2. _____ Showroom
 3. _____ Storeroom
 4. _____ Storage/Warehouse
 5. _____ Office/Business establishment
 6. _____ Car parked on the street/driveway
 7. _____ Apartment
 8. _____ House
 9. _____ Hotel/Club
 10. _____ Church
 11. _____ Other _____

Appendix B

15a. Area:

 1. _____ East NYC
 2. _____ West NYC
 3. _____ Soho
 4. _____ Other _____

15b. Location:

 1. _____ Street
 2. _____ Ground floor
 3. _____ Upper floor

16. Visible by patrol:

 1. _____ Yes
 2. _____ No

17. Case status:

 1. _____ Open
 2. _____ Closed
 3. _____ Closed with arrest
 4. _____ Closed with recovery
 5. _____ Closed with arrest and recovery

18. Vehicle used:

 1. _____ Yes
 2. _____ No

19. Type of property:

 1. ____ Business
 2. ____ Personal
 3. ____ Both

20. Total value: _____

21. Quantity: _____

22. Articles:

 1. ____ Painting
 2. ____ Print
 3. ____ Lithograph
 4. ____ Serigraph
 5. ____ Silkscreen
 6. ____ Craft
 7. ____ Sculpture
 8. ____ Drawing
 9. ____ Antique
 10. ____ Other _____

23. Number of perpetrators: _____

24. Suspect # 1's status:

 1. ____ Wanted
 2. ____ Arrested
 77. ____ Not applicable

25. Suspect #1's sex:

 1. ____ Male
 2. ____ Female
 77. ____ Not applicable

26. Suspect #1's race:

 1. ____ Black
 2. ____ White
 3. ____ Hispanic
 4. ____ Other _____
 77. ____ Not applicable

27. Suspect #1's age: _____

 77. ____ Not applicable

28. Suspect # 2's status:

 1. ____ Wanted
 2. ____ Arrested
 77. ____ Not applicable

29. Suspect #2's sex:

 1. ____ Male
 2. ____ Female
 77. ____ Not applicable

30. Suspect #2's race:

 1. _____ Black
 2. _____ White
 3. _____ Hispanic
 4. _____ Other _____
 77. _____ Not applicable

31. Suspect #2's age: _____

 77. _____ Not applicable

Notes

Chapter 1 - The Crime

1. Laurie Adam, *Art Cop* (New York: Dodd, Mead & Co., 1974), p. 45.
2. Ibid, pp. 32-48; Charles Salzberg, "The Biggest Heists from New York's Art Museums," *New York Magazine*, March 26, 1979, p. 12.
3. Jennifer Landes, "Stolen Art Found in Lawyer's Home," *IFAR Reports*, July-August 1996, pp. 5-6.
4. _____ "Trial Date Set for Former New Hampshire Assistant Attorney General," *IFAR Reports*, July 1997, p. 4.
5. Michael Brenson, "Boston Thieves Loot a Museum of Masterpieces," *The New York Times*, March 19, 1990, A1, C16.
6. Hugh McLeave, *Rogue in the Gallery* (Massachusetts: David R. Godine, 1981), p. 2.
7. Hugh Trevor-Roper, *The Plunder of the Arts in the Seventeenth Century* (London: Thames and Hudson, 1970), p. 7.
8. Richard F. Shepard, "Why and How They Stole the Mona Lisa," *Art News*, February 1981, pp. 125-127; McLeave, *Rogue in the Gallery*, pp. 14-24.
9. McLeave, *Rogue in the Gallery*, pp. 24-30.

10. Trevor-Roper, *Plunder of the Arts*, p. 10.

11. Jeremy Mass, *Gambert-Prince of the Victorian Art World* (Great Britain, Essex: The Anchor Press Ltd., 1975), p. 48.

12. Laura de Coppet and Alan Jones, *The Art Dealers* (New York: Clarson N. Potter, 1984), pp. 13-15.

13. Ibid, pp. 35-39; McLeave, *Rogue in the Gallery*, p. 3.

14. Trevor-Roper, *Plunder of the* Arts, pp. 7-28; Aline Saarinen, *The Proud Possessors* (New York: Random House, 1956).

15. McLeave, *Rogue in the Gallery*, pp. 4-5.

16. Milton Esterow, *The Art Stealers* (New York: McMillan Publishing Co., 1973), p. 7.

17. de Coppet and Jones, p. 14.

18. McLeave, *Rogue in the Gallery*, p. 6.

19. Karl Meyer, *The Plundered Past* (New York: Atheneum, 1973) p. 4.

20. Ibid, pp. 5-6.

21. J. W. "The Demand Continues for Old Masters," *Art News*, January 1984, p. 21.

22. Esterow, *Art Stealers*, p. 7.

23. Geraldine Keen, *Money and Art* (New York: G. P. Putnam's Sons, 1971), pp. 17-32.

24. Richard W. Walker, "New Horizons for Collectors," *Art News*, Summer 1984, p. 68.

25. Meyer, *Plundered Past*, pp. 9-10.

26. German Seligman, *Merchants of Art* (New York: Appleton-Century Crofts, 1961), p. 219.

27. J. W. , "Demand Continues," p. 23.

28. Valerie F. Brooks, "The Thrill of a Lifetime," *Art News*, May 1985, p. 19.

29. Edie L. Cohen, "Corporate Art," *Interior Design*, November 1979, pp. 208-213; George Savage, *The Market in Art* (The Institute of Economic Affair, England: Kent), p. 16.

30. Valerie F. Brooks, "An Equitable Solution," *Art News*, May 1984, pp. 20-22.

31. _____ "Confessions of the Corporate Art Hunters," *Art News*, Summer 1982, pp. 108-109.

32. Scott Hodes, *The Law of Art & Antiques* (New York: Oceana Publications, 1966), pp. 80-84.

33. Keen, *Money and Art*, p. 27.

Notes

34. Richard W. Walker, "IRS Cracks Down on Appraisal Abuses," *Art News*, December 1984, p. 21.

35. Richard W. Walker, "Generosity will Cost More, IRS Tells Donors," *Art News*, March 1985, pp. 25-26.

36. Lee Rosenbaum, "The Lawmakers Left the Task... by Ducking It," *Art News*, January 1986, p. 96.

37. "Appreciated Property Deduction Reinstated," *AVISO*, September 1993, p. 1; Richard W. Walker, "Donations in Decline," *Art News*, October 1990, p. 49.

38. Terry Trucco, "Insiders' Guide to the Art Market," *Art News*, April 1981, p. 78.

39. Adams, *Art Cop*, p. 7.

40. Trucco, "Insiders' Guide," p. 91.

41. Bonnie B. Stretch. "Back to Reality," *Art News*, September 1990, p. 35.

42. Valerie Brooks, "1.98 Million De Kooning Tops Contemporary Sales," *Art News*, January 1985, p. 20.

43. J. W. "Demand continues," p. 20.

44. Suzanne Muchnic and Bonnie B. Stretch, "Irises: Profit or Loss," *Art News*, May 1990, p. 57.

45. McLeave, *Rogue in the Gallery*, p. 7.

46. J. W. "Demand continues," p. 20.

47. Bonnie B. Stretch, "Launching a $300 million Art Fund," *Art News*, May 1989, pp. 37, 39.

48. Ibid, p. 39.

49. Lisbet Nilson, "A 'Once -in-a-Lifetime' Picture," *Art News*, May 1982, p. 9.

50. Stretch, "$300 million Art Fund"

51. Meyer, *Plundered Past*, p. 4.

52. Suzanne Zwarun, "Rogues' Gallery," *Macleans*, March 6, 1978, pp. 18-19.

53. Meyer, *Plundered Past*, pp. 5-6.

54. Daryl F. Gates and William E. Martin, "Art Theft-A Need for Specialization," *The Police Chief*, March 1990, p. 60; John Winsor, "The Case of Scotland Yard's Squad," *Art & Antiques*, February 1996, p. 46.

55. Elizabeth Zeschin, "A Special Agent Speaks Out," *Art & Antiques*, November 1986, p. 59; Robert Volpe, "Art Theft Investigation," manuscript, Art and Antique Investigation Unit, 1972, p. 1.

56. M.I.O. "The Yard to Revive Antiques Squad," *IFAR Reports*, February 1989, p. 6.

57. Donald Mason, "Art Theft Investigations," *FBI Law Enforcement Bulletin*, January 1979, pp. 14-18; John B. McPhee, Jr., C. Thomas Spitzer, and Robert P. Sundin, "The National Stolen Art File," *FBI Law Enforcement Bulletin*, March 1983, pp. 16-23.

58. Reuters, High-Tech Art Sleuths Snare Thieves, *Criminal Justice International*, 9 (1993), p. 6; Staff, "Do You Know about IFAR?" *IFAR Reports*, December 1995, p. 28; Jonathan Player, "Computers Can Give Detectives a Lineup of Stolen Art Objects," *The New York Times*, December 23, 1992, D6.

59. Paul Chutkow, "The Great Budapest Heist--How Interpol Really Works," *Connoisseur*, October 1984, p. 127.

Chapter 2 - Art Theft in New York City

1. Laurie Adam, *Art Cop* (New York: Dodd, Mead & Co., 1974), pp. 11-116.

2. *Detective Guide* (New York City Police Department, 1981), p. 10.

3. Harry Scarr, *Patterns of Burglary* (U.S. Department of Justice. Washington, D.C.: Government Printing Office, 1972), p. 20.

4. "Interim Order," New York City Police Department, 1988.

5. Leon Radzinowicz and Jean King, *The Growth of Crime: The International Experience* (New York: Basic Books, 1977), pp. 47-48.

6. "Interim Order."

7. Milton Esterow, "Confessions of an Art Cop," *Art News*, May 1988, pp. 134-137.

8. *The New York Times*, February 3, 1995, B3.

9. Bonnie Burnham, *Art Theft: Its Scope, Its Impact, and Its Control* (New York: The International Foundation for Art Research, 1978), p. 16.

10. Cherif Bassiouni, "Reflection on Criminal Jurisdiction in International Protection of Cultural Property," *Seracuse Journal of International Law*, 10 (1983): 281-322.

11. John Windsor, "The Case of Scotland Yard's Art and Antiques Squad," *Art & Antiques*, February 1996, p. 47.

12. Robert Volpe, "Art Theft Investigation," manuscript, Art and Antique Investigation Unit, 1972, p. 5.

13. *The New York Times*, March 2, 1982, B2.

Notes

14. "Caveat Emptor," *African Art*, July 1968, p. 68.

15. Ralph Blumenthal, "A Stolen Homer Returns Home, but Less Authentic than Before," *The New York Times*, February 15, p. c9, c14; A.L. "Homer's Odyssey'" Art News, April 1995, p. 58.

16. Milton Esterow, "Confessions of an Art Cop," *Art News*, May 1988, p. 135.

17. M.I.O., "The Yard to Revive Antiques Squad," *IFAR Reports*, February 1989, p. 6.

18. Volpe, "Art Theft Investigation," p. 4.

19. Frank Rasky, "The Interpol Mountie Who Sleuths down Fake, Forged and Stolen Art," *Art Magazine*, November-January 1981-82, p. 73.

21. For a discussion of detectives' case loads, see William B. Waegel, "Case Routinization in Investigative Police Work" in Stan Stojkovic, John Klofas, and David Kalinich (Eds), *The Administration and Management of Criminal Justice Organizations* (Illinois: Waverland Press, 1990): 369-386.

22. Richard Lyons, "Art May Be Full of Mystery But It Better Not Be a Crime," The *New York Times*, November 3, 1991, p. 56.

23. Daryl F. Gates and William E. Martin, "Art Theft – A Need for Specialization," *The Police Chief*, March 1990, p. 62.

23. Edward Moat, *Memoirs of an Art Thief* (London, England: Arlington Books, 1976), pp. 111-112; Milton Esterow, p. 136.

24. Survey of art gallery directors.

25. *The New York Times*, January 6, 1986, A1 and April 11, 1987, L31.

Chapter 3 - Rogues in the Galleries

1. "Annual Guide: Galleries, Museums, Artists (1988-1989)," *Art News*, 1988, pp. 132-168.

2. Ibid; also see dealer survey questionnaire in Bonnie Burnham, Art Theft: Its Scope, Its Impact, and Its Control (New York: The International Foundation for Art Research, 1978), pp. 161-164.

3. Bonnie Burnham, "The Black Market in Art," Art News, January 1976, pp. 82-87.

4. Paul Gardner, "SoHo, Downtown Boomtown," *Art News*, March 1987, pp. 129-133.

5. Robert Volpe, "Art Theft Investigation," manuscript, Art and Antique Investigation Unit, 1972, p. 6.

Chapter 4 - A New Breed of Criminals

1. Robert J. McCartney, "Huge Heist at Mexico Museum," *Sacramento Bee*, December 26, 1985, A1.
2. Milton Esterow, "Confessions of an Art Cop," *Art News*, May 1988, p. 137.
3. Bonnie Burnham, "The Black Market in Art," *Art News*, January 1976, pp. 80-85.
4. Paul Chutkow, "The Great Budapest Heist - How Interpol Really Works," *Connoisseur*, October 1984, p. 127.
5. J. R. Kirshner, "Thieves Like Us," *Art Forum*, Spring 1982, p. 41.
6. *The New York Times*, December 1, 1988, B3.
7. John Conklin, *Art Crime* (New York: Preager), p. 125.
8. M.I.O., "Over 100 items Recovered in Mexico City Theft," *IFAR Reports*, July 1989, p. 6.
9. Art and Antique Investigation Unit, NYPD Case 72-A, 1988.
10. Margaret I. O'Brien, "Restorer's Collection Taken in Armed Robbery," *IFAR Reports*, September 1989, p. 5; Art and Antique Investigation Unit, NYPD Complaint Report File, 1989.
11. Edwin Sutherland, *The Professional Thief* (Chicago: The University of Chicago Press, 1937); John Barelli, "On the Business of Art and Antique Theft" (Ph.D. diss., Fordham University, 1985), p. 152.
12. Carl Klockars, *The Professional Fence* (New York: The Free Press, 1974).
13. Barelli, *Art and Antique Theft*, p. 188.
14. Margaret I. O'Brien, "New York Police Department Busts Art Theft Gangs," *IFAR Reports*, October 1990, p. 5; M.I.O., "Colnaghi Gallery Recoveries," *IFAR Reports*, October 1990, p. 5.
15. _____"La Jolla Museum Theft," *IFAR Reports*, February-March, 1991, p. 7.
16. *The New York Times*, January 28, 1983, A10.
17. Constance Lowenthal, "Picasso and Margritte Recovered in New York," *IFAR Reports*, June 1991, p. 4.
18. Edward Moat, *Memoirs of an Art Thief* (London, England: Arlington Books, 1976), pp. 53-240.

Notes

19. Robert Volpe, "Art Theft Investigation," manuscript, Art and Antique Investigation Unit, 1972, p. 6.

20. Barelli, *Art and Antique Theft*, p. 190.

21. "The Homer Caper," *Art News*, October 1974, p. 31.

22. *The New York Times Magazine*, July 22, 1979, p. 62; Philip Greenberg, "Art Theft Is Becoming Sophisticated Business," *The New York Observer*, February 26, 1990, p. 1, p. 9.

23. Chutkow, "Great Budapest Heist," p. 27.

24. William Sherman, "The Drug Cartel: Fences, Informers, and Stolen Art," *Art News*, March 1991, pp. 121-127.

25. Watham M. Adams, "The Case of the Missing Rembrandt," *Readers' Digest*, May 1980, pp. 221-263.

26. Jonathan Turner, "Titian's Pizza Connection," *Art News*, September 1988, p. 14.

27. _____ "Masterpieces and the Mob," *Art News*, October 1995, pp. 122-123.

28. Ibid, p. 125.

29. Constance Lowenthal, "Vatican's Medieval M.S. Leaves Recovered," *IFAR Reports*, July 1995, p. 6; Constance Lowenthal," Retired Professor Pleads Guilty in Vatican Case," *IFAR Report*, July-August 1996, p. 2.

30. _____ "Former Anglican Priest in Arizona Charged with Theft and Fraud," *IFAR Reports*, June 1996, p. 3.

31. Cathleen McGuigan with Elaine Shannon, Ray Wilkinson, and Maggie Malone, "The Booming Trade in Smuggled Art," *Newsweek*, May 30, 1983, p. 86.

32. *The New York Times*, March 2, 1982, B2.

33. R. Phalon, "You Want It, I'll Get It for You," *Forbes*, April 16, 1979, p. 58.

34. Michel Clamen, "Museums and the Theft of Works of Art," *Museum (UNESCO)* V. 26, 1974, p. 12; Bonnie Burnham, *The Art Crisis* (New York: St. Martin's Press, 1975), pp. 37-52.

35. Richard W. Walker, "The Louvre vs. Sherman Lee," *Art News*, September 1984, pp. 19-21.

36. Thomas Hoving, *King of the Confessors* (New York: Ballantine Books, 1981).

37. McGuigan et al., "Booming Trade;" Francis Celoria, "Archaeology: Looters at Work," *The Geographic Magazine*, December 1976, p. 204.

38. Bonnie Burnham, *Art Theft: Its Scope, Its Impact, and Its Control.* (New York: The International Foundation for Art Research, 1978), p. 7.

39. Caroline Goeser, "Stolen: Original Dick Tracy and Prince Valiant Comic Strips," *IFAR Reports*, August 1989, pp. 6-7.

40. "Former Museum Director Sentenced," *AVISO*, July 1983, p. 1.

41. Art and Antique Investigation Unit, NYPD Case 6-A, 1986.

42. Truc-Nhu Ho, "Art Theft, a White Collar Crime," paper presented at the annual meeting of the American Society of Criminology, Miami, Florida, November 12, 1994.

Chapter 5 - Portrait of an Art Thief

1. John Barelli, "On the Business of Art and Antique Theft" (Ph.D. diss., Fordham University, 1985), p. 192.

2. David Leitch, *The Discriminating Thief* (Holt, Rinehart and Winston, 1969).

3. Michael Ryan, "How to Find a Stolen Painting," *Parade Magazine*, January 26, 1992, pp. 18-20.

4. *The New York Times*, November 23, 1984, p. 24.

5. John Conklin, *Art Crime* (New York: Preager, 1994), p. 132.

6. Caroline Goeser, "One of Iowa's Best 'Libraries'," *IFAR Reports*, November 1990, pp. 5-7; Library and Archival Security, 9, (3-4), 1989.

7. Caroline Goeser, "The Robin Hood of Chinese Export Porcelain," IFAR Reports, July 1991, p. 6.

8. Ibid, p. 7.

9. *The New York Times*, December 19, 1991, C11.

10. John Quentin Feller, "Confession of an Art Bandit," *Art & Antiques*, January 1993, p. 55.

11. Cathleen McGuigan with Elaine Shannon, Ray Wilkinson, and Maggie Malone, "The Booming Trade in Smuggled Art," *Newsweek*, May 30, 1983, p. 86.

12. Milton Esterow, *The Art Stealers* (New York: McMillan Publishing Co., 1973). p. 14.

13. Ibid., p. 20.

14. Test Gest and Margaret Murray, "Art Theft: A Rich and Booming Craft," *U.S. News and World Report*, November 11 1985, p. 60.

15. "Artful Dodgers," *Time,* May 6, 1974, p. 41; "Renegade Debutante, *Time,* May 20, 1974, p. 57

Notes

16. Milton Esterow, "Confessions of an Art Cop," *Art News*, May 1988, p. 137.

17. Margaret O'Brien, "Cincinnati, OH," *IFAR Reports*, March 1989, p. 6.

18. Ginger Danto, "God Heard Us," *Art News*, March 1991, p. 40.

19. AJK, "Grandma Moses Painting Destroyed," *IFAR Reports*, April, 1995, p. 8.

20. *The New York Times*, April 13, 1983, B2; Conklin, *Art Crime*, p. 147.

21. _____ January 5, 1984, p. B2.

22. Virgie D. Day, "Misfeasance, Malfeasance and Theft Uncovered at Brigham Young University," *IFAR Reports*, June 1988, p. 5.

23. "Former Museum Director Sentenced," *AVISO*, July 1993, p. 1.

24. Truc-Nhu Ho, "Art Theft, a White-Collar Crime," paper presented at the annual meeting of the American Society of Criminology, Miami, Florida, November 12, 1994.

25. Florence Swanstrom, "Key in Recovery of Petrus Christus," *IFAR Reports*, May-June 1994, p. 6.

26. *Time*, June 3, 1974, p. 32.

27. William M. Carley, "Brassy Caper," *The Wall Street Journal*, February 21, 1990, A1 and A6; Margaret O'Brien, "Cincinnati, OH," *IFAR Reports*, March-April 1989, pp. 5-6.

28. F.S., "Munch Theft," *IFAR Reports*, February-March 1994, p. 5.

29. Art and Antique Investigation Unit's file.

30. Florence Swanstrom, "Stockholm Theft: Picasso and Braque," *IFAR Reports*, November 1993, p. 5.

31. Lynn Person, "Two Convicted in Theft of Antiquities from Warehouse," *IFAR Reports*, June 1987, p. 5.

32. Margaret I. O'Brien, "Armed Gang Arrested after Dyansen Gallery Theft," *IFAR Reports*, October 1990, pp. 5-6.

33. M.I.O., "Armed robbery at the Rodin Museum Philadelphia, Pennsylvania, *IFAR Reports*, December 1988, pp. 10-11.

34. _____ "Icon Stolen in Armed Robbery," *IFAR Reports*, December 1989, p. 9.

35. Nancy Cooper with Edward Behr, "The Marmottan Job," *Newsweek*, November 11, 1985, p. 2; A.P. and U.P., "Five Monets Seized in Paris Art Theft," *San Francisco Chronicle*, Oct 28, 1985, p. 1.

Chapter 6 - The Trojan Horse

1. A.J.K., "An Inside Job: Former Gallery Employee Charged in Theft," *IFAR Reports*, August-September, 1991, p. 7.
2. Michael Daly, "The Collector," *New York*, May 31, 1982, pp. 28-35.
3. Stretch, B, "Buy Boldly, Sell Slowly," *Art News*, October 1991, pp. 57-59.
4. Margaret I. O'Brien, "Leger Stolen from the Weintraub Gallery," *IFAR Reports*, November 1990, p. 8.
5. David E. Pitt, "$6 Million in Art Stolen from Gallery on the Upper East Side," *The New York Times*, Feb 10, 1988, B1; Art and Antique Investigation Unit's file.

Chapter 7 - The Missing Artifacts

1. Fictitious name.
2. M.I.O., "New York, NY," *IFAR Reports*, March-April 1989, p. 9.
3. Margaret O'Brien, "Himalayan Hoard Recovered," *IFAR Reports*, January 1990, p. 3.
4. Reuters, "High-Tech Art Sleuths Snare Thieves," *Criminal Justice International*, 9 (1993), p. 1.
5. Edward Lucie-Smith, *Dictionary of Art Terms* (Great Britain: Thames and Hudson, 1984), p. 9; Robert C. Lamm, Neal M. Cross, and Rudy H. Turk. *The Search for Personal Freedom*, Vol. 2 (Iowa: Wm. C. Brown Publishers, 1984).
6. Michael Daly, "The Collector," *New York*, May 31, 1982, p. 28.
7. Caroline Goeser, "Church Organist in New York for Theft of Liturgical Objects," *IFAR Reports*, February-March, 1992, p. 9.
8. Bonnie B. Stretch, "Buy Boldly, Sell Slowly," *Art News*, October, 1991, p. 59.
9. Art and Antique Investigation Unit, NYPD Case 72-A, 1988.
10. An application of the routine activities theory in Lawrence Cohen and Marcus Felson, "Social Changes and Crime Rate Trends: A Routine Activity Approach," *American Sociological Review*, 44 (1979): 588-608.
11. Ronald Clarke and Derek Cornish, "Modeling Offenders' Decisions: A Framework for Research and Policy" in Michael Tonry and Normal Morris (Eds), *Crime and Justice*, Vol. 6 (Chicago: The University of Chicago Press, 1985): 147-185.

Notes

Chapter 8 - Partners in Crime

1. Anna J. Kisluck, Traffic Accident Leads to Recovery. *IFAR Reports*, September 1992, pp. 4-5.

2. Neil Shover, "Structures and Careers in Burglary," *The Journal of Criminal Law, Criminology and Police Science,* 63, 1972, p. 545.

3. Karl Klockars, *The Professional Fence* (New York: G.P. Putnam's Sons, 1974).

4. Michael Ryan, "How to Find a Stolen Painting," *Parade Magazine*, January 26, 1992, pp. 18-20.

5. Mary McIntosh, "Thieves and Fences: Markets and Power in Profession Crime, " *British Journal of Criminology* (1976) Vol. 16, pp. 257, 262.

6. Elizabeth Hayt-Atkins, "Rouault Recovery: IFAR, NYPD, LAPD and Christie's Collaborate, *IFAR Reports,* November 1987, p. 4; "Rouault Recovery Update," *IFAR Reports*, December, 1987, p. 4.

7. Bonnie Burnham, "The Black Market in Art," *Art News,* January 1976, pp. 81-82.

8. Thomas J. Baker, "Combating Art Theft: International Cooperation in Action," *The Police Chief,* October 1996, p.19.

9. Shover, "Careers in Burglary," pp. 544-545.

10. Burnham, "Black Market in Art," p.82: Thomas J. Baker, "Combating Art Theft: International Cooperation in Action," *The Police Chief,* October 1996, p. 19.

11. Larry Rohter, "Police Foil 18 Million Art Theft," *The New York Times*, January 6, 1986, A1, C1; Art and Antique Investigation Unit's file; Lynn Stowell Pearson, "Two Convicted in Theft of Antiquities from Warehouse," *IFAR Reports,* June 1987, pp. 4-5.

12. Burnham, "Black Market in Art," p. 80.

13. Susan Pennell, "Fencing Activity and Police Strategy," *Police Chief* 46 (9), p. 72; McIntosh, "Thieves and Fences," pp. 492-493.

14. McIntosh, Ibid, pp. 263-264.

15. Ibid, p. 264.

16. Burnham, "Black Market in Art," p. 81.

17. Anna J. Kisluk, "Botero and Dubuffet Sculptures Recovered," *IFAR Reports*, October 1992, p. 5.

18. Margaret O'Brien, "Recoveries in the 'Rash of Museum Thefts'," *IFAR Reports*, March-April 1989, pp. 3-4.

19. Constance Lowenthal, "News from the Criminal Court," *IFAR Reports*, May 1990, p. 4: "Six Months in Prison for Buyer of Stolen Art," *IFAR Reports*, February-March 1991, p. 6.

20. Karl Meyer, *The Plundered Past*. (New York: Atheneum, 1973), pp. 100-101.

21. James Mc Kinley Jr., "Financier Found Guilty of Buying Stolen Work", *The New York Times*, August 26, 1995, B3.

22. Christopher Dickey, "Missing Masterpieces," *Newsweek*, May 29, 1989, p. 67; John Conklin, *Art Crime*. (Connecticut: Preager, 1994), pp. 197-199; Jonathan S. Kaufman, "DeWeerth Redux," *IFAR Reports*, May-June 1994, p. 5. For a New York Court's decision relating the recovery of stolen art, see Franklin Feldman, "The Guggenheim Gets its Day in Court to Recover Chagall Gouache," *IFAR Reports*, February-March 1990, pp. 6-7.

23. A.J.K., "Two Guilty Pleas in Los Angeles," *IFAR Reports*, April 1992: p. 8.

24. Art and Antique Investigation Unit, NYPD Case 16A; Elizabeth Hay-Atkins, "The Set Up," *IFAR Reports,* March-April, 1988, p. 4.

25. Andrew Decker and Bonnie B. Stretch, "A Return to Reason," *Art News*, January 1991, p. 39.

26. Karl Meyer, *Plundered Past*, p. 15.

27. Milton Esterow, "Confessions of an Art Cop," *Art News*, May 1988, p. 135.

28. Anna J. Kisluk, "IFAR Reports Helps Recover Jupiter," *IFAR Reports*, April 1991, p. 6.

29. Survey of art gallery directors.

30. Caroline Goeser, "Museum Volunteer Spots Stolen Sculpture," *IFAR Reports*, December 1991, p. 10.

Chapter 9 - The Hunt for Art Vultures

1. Art and Antique Investigation Unit, NYPD Case 61-A, 1985; Douglas McGill, The New York Times, June 6, 1985.

2. Susan Pennell, "Fencing Activity and Police Strategy," *Police Chief* 46 (9), p. 74.

3. Margaret O'Brien, "New York Police Department Busts Art Theft Gangs," *IFAR Reports*, October 1990, p. 5.

4. Robert Volpe, "Art Theft Investigation," manuscript, Art and Antique Investigation Unit, 1972, p.3.

5. Daryl F. Gates and William E. Martin, "Art Theft-A Need for Specialization," *The Police Chief*, March 1990, p. 61.

Notes

6. In the early 1970s a New York City police detective, Frank Serpico, discovered serious corruption among fellow officers and superiors. He reported it to higher authorities within the department, but no action was taken. Frustrated, he released the information to the press, resulting in the creation of the Knapp Commission, which unveiled the existing police corruption in New York City and recommended measures to avoid it in the future. See *Knapp Commission Report on Police Corruption* (New York: George Braziller, 1973).

7. Mark Pogrebin, "Some Observations of the Detective Role," *Journal of Police Science and Administration* 4 (3), p. 283.

8. Michael Volkovitch, "Rodin Recovery" *IFAR Reports,* March-April 1989, p. 5.

9. Lynn Stowell Pearson, "Two Convicted in Theft of Antiquities From Warehouse," *IFAR Reports,* June 1987, pp. 4-5.

10. Florence Swanstrom, "Audubon Birds Back in Vermont," *IFAR Reports*, August 1994, pp. 6-7.

11. William M. Carley, "Brassy Caper," *The Wall Street Journal*, February 21, 1990, A1, A6, also in Margaret O'Brien, "Cincinnati, OH," *IFAR Reports*, March-April, 1989, pp. 5-6.

12. A. P. and U. P.,"Five Monets Seized in Paris Art Theft," *San Francisco Chronicle*, October 28, 1985, p. 1.

13. Ginger Danto, "God Heard Us," *Art News*, March 1991, p. 39.

14. William Sherman, "The Drug Cartel," *Art News*, March 1991, p. 125.

15. Ibid, pp. 123-7.

16. Kenneth A. Weiner, Christine K. Stephens, and Donna L. Besachuk, "Making Inroads into Property Crime: An Analysis of the Detroit Anti-Fencing Program," *Police Science and Administration*, 11, 1983, pp. 311-313.

17. Pennell, "Fencing Activity," p. 173.

18. Nathan M. Adams, "The Case of the Missing Rembrandt," Readers Digest 116 (May 1980), pp. 223, 250-263; "Matching Wits with World's Art Thieves," *US News*, May 7, 1979.

19. Anna J. Kisluk, "DEA Operation Nets 3 Pictures," *IFAR Reports*, December 1995, pp. 6-8.

20. Sherman, "Drug Cartel," p. 124.

21. Thomas Baker, "Combating Art Theft: International Cooperation in Action," *Police Chief*, October 1996, p. 19.

Epilogue

1. Andrew Decker and Bonnie B. Stretch, "A Return to Reason," *Art News*, January 1991, p. 39.
2. Geraldine Norman, "Seasons in Review," *Art &Antiques*, October 1993, p. 104.
3. Decker and Stretch, "Return to Reason."
4. _____ "The Lure of the Unknown," *Art & Antiques*, April 1993, pp. 86-87; J.W., "The Demand Continues for Old Masters," *Art News*, January 1984, p. 20.
5. Margaret I. O'Brien, "New York, NY," *IFAR Reports*, November 1990, p. 8.
6. Jonathan S. Kaufman, "Museum Theft Now Federal Crime," *IFAR Reports*, October 1994, pp. 3-4.
7. *The New York Times*, July 6, 1991, L13.
8. AJK "Louvre Struck Again," *IFAR Reports*, February 1995, p. 6.
9. Pavel Jirasek, "Institutions Form Network to Fight Art Theft in Czech Republic," *IFAR Reports*, January-February 1966, pp. 7-8.

Index

Adam 58

Alex Sabo 59, 155,164

Alvin Gittins 35

America Today 13

Andrea del Sarto 54

Andrew Mellon 9

Annunciation 12

Anthony Davolos 73

Anthony Melnikas 60

Appraisers 63

Archaeologist 63

Aristotle Contemplating the Bust of Homer 14

Art and Antique Investigation Unit 16, 17,164,21,22, 26, 27, 29, 32, 34, 58, 82, 148, 155, 164

Art and Antique Loss Register 16

Art Dealers Association of America 37

Art fence 129, 132, 133, 135, 148

Art Loss Register 113

Art market 14, 161,163,164

Art theft by burglary 27,28, 120

Art theft by larceny 27,120

Art Theft Detail 16

Art-theft investigation 22, 132

Au Moulin de la Galette 14

Auctioneers 63

Auguste Rodin 85

Barry Trupin 137

Beef 145,146,147

Benjamin Altman 9

Berthe Morisot 78

Blue-collar criminals 54

Bottero 135

Boy in a Red Waistcoat 10
British Antique Dealers' Association 32
British Rail Pension Fund 15
Brueghel 140
Buddy Novak 61
Burglar alarms 82, 107, 126
Burglars 52, 54, 55,57
Buzzers 43,94,95,198,102
Calgary 15
Cali Drug Cartel 160
Cali Mafia 159
Caligero Migliore 140
Carlos Trevino 52
Cathedral of Padua 60
Cézanne 10, 164
Charles Koczka 31
Chelsea 39
Chester Gould 64
Chinese export porcelain 73
Chris Lewis 140
Christ 131
Christ as the Man of Sorrows 80
Christmas Eve 53
Chuck Carlo 158
Church garage sales 52
Cleopatra 7
Colnaghi Gallery theft 55
Commercial art gallery directors 38
Common thieves 50, 51 53, 54, 77
Confidential informants 149, 150, 151, 156
Consignment 44, 46, 160

Contemporary art dealer 38, 39, 89, 96, 104
Corporate art dealer 38, 39
Corsica 155
Craig Warner 112
Criminal receiving 132
Customs officials 63
Cyprus 139
Cyrus Vance Jr. 34
Dale Cletcher 56
Daniel Cardebat 84
Daniel Kohl 133
David Hockney 14
David Orwin 111, 123, 124, 125, 126
De Pape 140
DEA 156
Decision making 124, 125, 126
Detective Martin 113
Dick Tracy's comic strips 64
Dieric Bouts 12
Dr. Gachet 14
Dr. Jane Werner 112
Dubuffet 135
Early Spring at Mount Washington 5
Earnest McLeod 15
East Side 39, 40, 42, 43, 124
Edvard Munch 83
Employee theft 27, 42, 45, 64, 66
Farhad Keshmiri Zadh 130
FBI 16, 24, 53, 55, 56, 60, 72, 73, 75, 78, 122, 153, 143, 150, 154, 157, 158, 161
Felice Maniero 60

Index

Fence 57, 129, 130, 131

Fencing ring 133

Field of Tulips 78

Fifty-Seventh Street 39, 40, 41, 43

Flea markets 52

Fra Angelico 55

Francis Bacon 14

Frank deMichele 145

Frans Hals 76

Fuller Building 95, 93

Gallery thefts 42, 44

Gary Evans 152

Gennarino Fasolino 158

George Blumenthal 9

George Jay Gould 9

German Expressionist prints 95

Giordano Garuti 31

Good faith purchaser 139

Govaert Flinck 6

Goya 77

Grab-and-run 81, 94, 97, 98, 102

Grandma Moses 78

H. H. Howe 5

Hard-core criminals 85

Hartley 129

Holy Family on the Step 63

Horace R. Burdick 5

House of Tasha 158

Houshang Mahboubian 33

IFAR Reports 16, 66, 81,113

Impression, Sunrise 86

Incorporated galleries 41

Insurance deductible 46

International Foundation for Art Research 16, 111, 131, 136

Interpol 16, 59, 149

Irises 14

Isabella Stewart Gardner Museum 5

J. Pierpont Morgan 9

Jacob Schott 82

Jan Vermeer 6

Jill Greenberg 66

Joel Shapiro 71

John Barelli 69

John Feller 73

John Kelly 20, 145, 164

Joseph Keenan 59

Laundering 160, 161 162

Le Petit Concert 137

Leon Smith 145

Leroy Neiman 84

Lloyd's of London 16, 33, 156

Lorenzo Zorza 31,59, 62

Louis Beroud 7

Louis Carducci 140

Louis Hillen 71

Lowell Collins 85

Madonna and Child 60

Mafia 60, 159

Magritte 57

Manet 6, 10, 52

Marbadori Holy Family with Saint John, Saint Elizabeth, and Saint Joseph 54

Marc Chagall 137

Marie Cerile 3

Marmottan Museum 1, 78, 86, 154

To Catch an Art Thief

Mask of the Man with the Broken Nose 85
Michael Bell 130
Michael Dongarra 61
Michel van Rijin 138
Missing reports 23, 29
Mona Lisa 7, 8
Moscardini 20, 23, 145, 151, 164
Motion- detector devices 108
Museum administrators 63
Museum Curators 29, 63, 80
Mysterious disappearance 42, 44
Naruse 86
National Crime Information Center 16
National Stolen Art File 16, 150
Nativity with Saint Francis and Saint Lawrence 60
Nedjatollah Sakhai 34
Nepalese 112
New York City Police Department 1, 11, 16, 22, 26, 27, 148, 150, 155, 156
New York Observer 142
Nonprofit 16, 36, 40, 149
North Moat, Autumn 5
Norton Simon 137
Occupational crime 63, 66
Off Gloucester Harbor 31
Official valuers 63
Operation Dinero 159
Patrick Houlihan 78
Peg L. Goldberg 138
Perugia 8
Peter Juvelis 31
Picasso 57, 84, 88, 129, 137, 142, 160

Portrait of a Cavalier 77
Portrait of Madame Louis Prat 146
Potthast 153
Poussin 63
Pre-Columbian artifacts 49
Pre-Columbian Mayan cylinder vase 56
Precontemporary art dealer 38, 39, 104, 121
Price stickers 51, 70, 92
Print dealer 38, 39, 101, 144
Private art dealer 38, 39, 132
Professional thieves 50, 54, 56
Property crimes 30
Psychological need 71
Ramon Garcia 52
Randy Klucker 130
Raphael Soyer 83
Raymond Hertzog 15
Rembrandt 6, 14, 59, 145, 158
Renoir 9, 10, 14, 66, 76, 86, 145, 146, 147, 164
Robert Singer 131
Robert Volpe 19, 20, 50, 52
Rose Dugdale 76, 77
Rouault 131
Royal Academy 9
Russian icons 85
Ryan Gallery 53
Safe, Loft, and Truck Squad 19, 20, 155, 164
Saint John the Baptist and Saint Anthony Abbot 61

Index

Saint John the Baptist as a Young Man 62

Salon des Refusés 9

Scotland Yard 19, 30, 31, 59

Seashore with Women and Children at Play 153

Security devices 107

Sherman Krisher 64

Sherman Lee 63

Shiva 137

Shoplifters 27, 42, 50, 52, 54, 57

Smugglers 62

Soho 39, 40, 42, 44, 51, 70, 81

Sotheby's 10, 144

Stephen Blumberg 71

Storm on the Sea of Galilee 6

Surveillance team 147

Sybil Andrews 53

Ted Rudder 154

Teniers 140

Ter Borch 140

The Birds of America 152

The Concert 6

The dark figures of crime 44

The Martyrdom of Saint Peter 59

The Rabbi 59, 158

The reliquary of Saint Anthony 60

The Scream 83

The Three-Penny Opera 29

Theft rate 42, 43, 44

Thomas Benton 13

Thomas Hoving 63

Thomas McShane 159

Thomas Moscardini 11, 17, 18, 19, 20, 21, 22, 23, 29, 32, 34, 53, 55, 66, 77, 87, 120, 132, 140, 141, 145, 146, 147, 148, 149, 151, 155, 164

Tibetan 112

Tiffany 130

Trisha Conroy 66

Tuzzolo 147

T-V monitor 95, 124

Undercover agents 147, 159, 160

van Gogh 10, 14, 164

Vatican 60, 61, 82

Vincent Del Peschio 62

Virginia Malloy 56

Vlaicu Ionescu 54

Vranckz 140

W.C. Whitney 9

Wally Findlay Gallery 146

Wesley Burnside 64

Warehouse 28, 33, 84, 152

William Porter 56

Winslow Homer 31

Winterthur Museum 73

Woman in a Mantilla 77

Woman with Large Breasts 88

Woman Writing a Letter 76

Young Girl at the Ball 78

About the Author

Vivian T-N Ho is the artist and pen name of Truc-Nhu Ho, PhD. Dr. Ho moved from Vietnam to the United States in 1965. Her education includes a BA in French (University of Michigan at Ann Arbor), three years of painting, drawing, and art history (University of Utah), an MA in criminal justice (California State University at Sacramento), and a PhD in criminal justice (Rutgers University). She has been published in criminal justice and art related journals. Retired after twenty years of research and university teaching, she now devotes her time to painting and writing. Her painting received the Best of Show Award at the Sugar Land and Katy Area Artists 2013 exhibition in Richmond, Texas. She lives in Sugar Land, Texas.

Made in the USA
Charleston, SC
08 November 2014